GLOUCESTERSHIRE
300
YEARS AGO

ALAN PILBEAM

The
History
Press

Cover illustrations. Front, above: Cirencester from above Roman fort. (Courtesy of Richard Bird Photography). *Front, below*: Jan Kip's engraving of Cirencester. *Back*: Scowles in the Forest of Dean. (Photograph courtesy of Martin Latham)

First published 2011

The History Press
The Mill, Brimscombe Port
Stroud, Gloucestershire, GL5 2QG
www.thehistorypress.co.uk

© Alan Pilbeam, 2011

The right of Alan Pilbeam to be identified as the Author of this work has been asserted in accordance with the Copyrights, Designs and Patents Act 1988.

British Library Cataloguing in Publication Data.
A catalogue record for this book is available from the British Library.

ISBN 978 0 7524 5259 3

Typesetting and origination by The History Press
Printed in Great Britain

Contents

Preface

The year 2012 marks the tercentenary of the publication of Sir Robert Atkyns' *The Ancient and Present State of Glostershire*. The book was published posthumously as Atkyns had died in 1711. Since the time of its publication it has been a major source of information for historians tracing the ownership of manors, the lineage of the county's gentry and the details of early monastic holdings. Samuel Rudder often quoted it word for word when treating these matters in his *A New History of Gloucestershire*, published in 1779. The book is also of great value to historical geographers because it contains information on such topics as land use, population totals and housing numbers for each parish of the county, as well as providing details of the principal houses, markets, industry and commerce of the time.

Because Atkyns followed a parish by parish survey and was concerned with the particulars of each parish rather than with a county-wide sweep, it has often been necessary to scan all 859 pages to gain an impression of the state of Gloucestershire at the time. So in celebration of his work an attempt has been made to collate and synthesise his information and to present it thematically, considering in turn the background of the main features that contribute to our image of the landscape in the early eighteenth century. The landscape is continually changing and the scene in Atkyns' day was just one stage in its long development. Some attention has therefore been given to the 'ancient state' of the county, where possible using Atkyns' book as a primary source. Thus one chapter has been devoted to the Domesday survey and another to the monastic holdings in the county, chapters which are largely supported by his assembled records. He writes little about Saxon and Norman Gloucestershire, and for chapters on these periods other sources have been required, including visible features in the present-day landscape.

Atkyns wrote before the impact of turnpike roads, canals and then railways had been felt; Parliamentary Enclosure of the common open fields had scarcely begun; Cheltenham consisted of a single street, and industry depended essentially on hand

labour and water power. It was a very different world from today's, yet the legacy of Atkyns' Gloucestershire is still with us and wherever possible attention has been drawn to what remains from those far-off days. A thematic approach to the present-day landscape, as distinct from that of the early eighteenth century, is provided in my *Landscape of Gloucestershire*, published by Tempus in 2006.

Atkyns' book, once scarce and very expensive, is now widely accessible because the Gloucestershire County Library has made copies of the 1974 reprint available to all its branch libraries.

There have been many adjustments to the county boundary since 1712: some parishes, particularly in the north and east of the county, have been transferred to other counties and others have been added to Gloucestershire. To simplify comparisons with statistics for the present day, the county considered here is the one established in the 1974 reorganisation. Those parishes which were then lost to Avon have not been included, and it has not been possible to include much information on the parishes added to the county since *The Ancient and Present State of Glostershire* was published because there is no equivalent source to Atkyns'. In all, 243 parishes have been included in this study.

Gloucester was by far the most important settlement in the county in the early eighteenth century and Atkyns devotes the first quarter of his book to that city. The remainder of the county he treats in an alphabetical arrangement of parishes. In his own preface he explains some of his reasons for writing and to this we turn in the first chapter.

1

Sir Robert Atkyns

The south transept of St Kenelm's Church, Sapperton, is dominated by the huge floor-to-ceiling memorial to Sir Robert Atkyns. His stone effigy is life-size and represents him reclining in an elegant pose. Beneath his left hand is a book, much smaller than the folio size of his own, and he is surrounded by flamboyant decoration, which includes figures symbolising Justice and Prudence (fig. 1). The inscription behind the effigy pays tribute to his character and influence, and ends with a prophetic reference to that 'more durable memorial *The Ancient and Present State of Glostershire*'. An engraving of Sir Robert by Michael van der Gucht, who produced engravings of many notable people of the day, is included in the book and shows him as plump, full faced, bewigged and clean shaven (fig. 2). The effigy in the church bears a good likeness to it.

The ownership succession of the county's manors is a prominent theme in the book and Atkyns records the lineage of many landowning families. His own ancestry included several distinguished lawyers, some of whom held high legal positions in the country. The family came from Monmouthshire and the earliest reference is to a Thomas Atkyns, who died in 1401. A fourth generation descendant of his, David, a merchant from Chepstow, moved to Tuffley on the south side of Gloucester and died there in 1552. His son, also named Thomas, a judge, acquired the manor of Brickhampton in Churchdown parish, and the latter's son, Richard, bought two more manors, one on either side of the River Severn at Hempstead and at Morecot in Minsterworth parish, as well as other lands in the county. He died in 1610 and was buried in Hempstead church. His colourfully painted stone effigy, portraying him in judge's robes, rests on a table tomb bearing the Atkyns' coat of arms. A grandson, another Richard, was the last to live in Tuffley. He was educated at the Crypt School in Gloucester and became a colonel in the army of Charles I, raising his own troop of cavalry. Financial problems forced him to sell the estates, which were then purchased by an uncle, Sir Edward Atkyns. Edward's eldest son, Robert, became Chief Baron of the Exchequer and was knighted in 1660. He died in

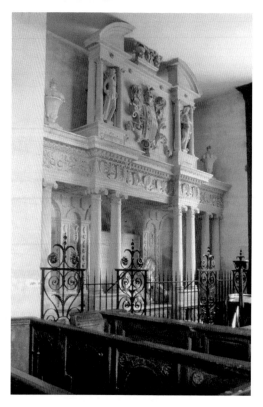

Fig. 1 Sir Robert Atkyns' huge memorial in the south transept of St Kenelm's Church, Sapperton.

Fig. 2 The title pages to *The Ancient and Present State of Glostershire*. The engraving of Sir Robert Atkyns is by Michael van der Gucht who came to London from Antwerp in the 1680s and engraved portraits of many important people, including Charles II and Daniel Defoe.

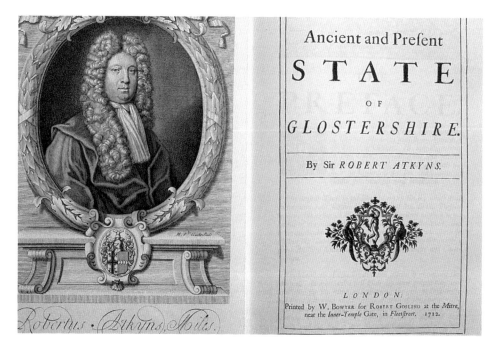

1709, aged 88, and his son was the Sir Robert Atkyns whose writings we are considering. The latter was born in 1647 at Monken Hadley in Hertfordshire, at a time when the visible, social and political effects of the Civil War were still fresh. He matriculated at St Edmund Hall, Oxford, in 1663 and in that same year was knighted by Charles II. He was called to the bar at Lincoln's Inn in 1668 and became the MP for Cirencester from 1679 to 1685, and then for Gloucestershire between 1685 and 1687. After the change in government in 1688, his retirement from public office gave him the leisure time to prepare for writing his book. He often stayed in London and was able to put his legal expertise and privileged position to good use in extracting much information on landownership and family succession from records held in various archives in the city. His epitaph records that his death at Westminster on 29 November 1711 was caused by dysentery. He had married Louise Carteret of Hawns (or Haynes) in Bedfordshire in 1669. She outlived him by five years and had the splendid monument to his memory erected in Sapperton church. They had no children.

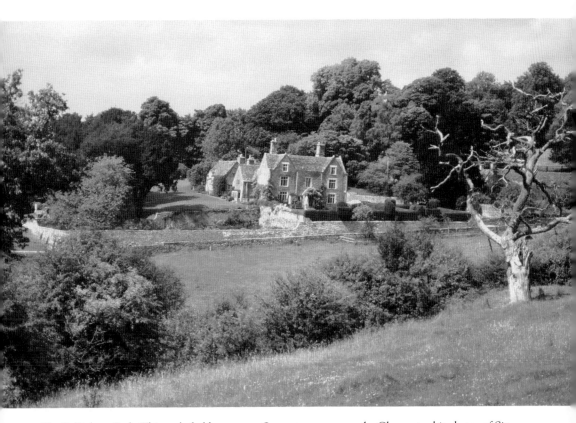

Fig. 3 Pinbury Park. This secluded house near Sapperton was once the Gloucestershire home of Sir Robert Atkyns.

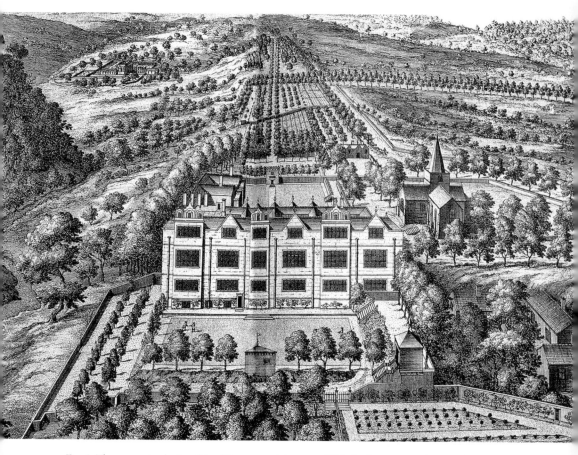

Fig. 4 The engraving by Jan Kip of Sapperton Manor in 1712. Its features are discussed in the text.

Sir Robert Atkyns briefly inherited much of his father's estate, though the two did not agree on political and other matters. At different times the family had held manors at Coates, Daglingworth, Hempstead, Lower Swell, Minsterworth, Pinbury, Sapperton, South Cerney and Tuffley, and Sir Robert Atkyns had himself bought the manor of Bisley and shared the ownership of the island of Sark. He was a well-to-do country gentleman.

While writing his book, Atkyns' Gloucestershire residence was Pinbury Park, a secluded small country house (fig. 3). Today, it is hidden a mile away from the nearest road, but then an old road from Cirencester to Gloucester, via Bisley and Painswick, passed within sight of the house. It is in a beautiful wooded setting, overlooking the upper Frome valley, just over a mile from Sapperton village where his father's house stood.

His father's home, Sapperton Manor, was originally built for the Poole family in the early seventeenth century and then bought from Sir Henry Poole in c.1660 by Sir Robert Atkyns (sen.), together with several other manors. It is illustrated in *The Ancient and Present State of Glostershire* by an engraving by the Dutch artist Jan Kip (fig. 4).

The engraving shows it to have been a very grand building, rather overpowering in its setting. Of its three-storey frontage of six bays, three bays project slightly and rise to unusual curved finials; the other three have typical Cotswold gables. At the rear are five gables, and a service wing with numerous chimneys has been built on the valley side. The lawn in front of the house is shown as a bowling green and from this level ground the land slopes down to the River Frome. On the far side of the meandering river the woods rise steeply, as they do today. Close to the house the much smaller church is carefully drawn, with its transepts and recessed spire, and behind the house and beyond

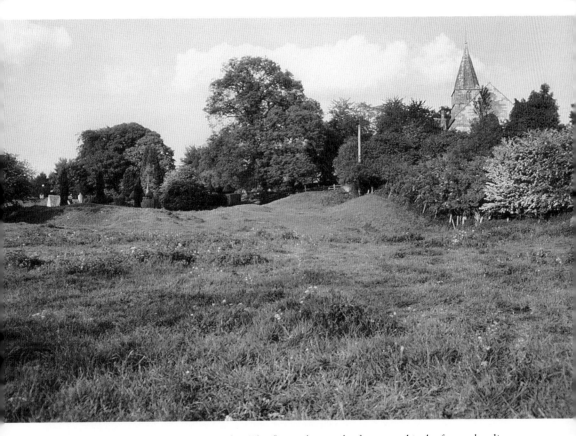

Fig. 5 The site of Sapperton Manor today. The flat surface in the foreground is the former bowling green and the low grassy mound is all that remains of the house. The church has a broach spire, which the engraving shows as recessed.

the gardens and gatehouse, a tree-lined avenue extends far into the distance. There is a similar avenue at right angles to this, now known as the Bishop's Walk. The cottage to the rear of the church is probably the same property that, in 1903, the craftsman/ architect Ernest Barnsley adapted for his own home, Upper Dorvel House. Two other small cottages mark the track that led down to Sapperton Mill, and beyond these another country house occupies a site further up the valley and quite near to the valley floor. There is no house like it today and it probably represents Pinbury Park, incorrectly located. The bridleway north-east of Sapperton church is shown as a rutted road, with Kip's trademark 'coach and six' approaching the village. Atkyns' typical reference is to a 'large stone house near the church'.

Sapperton Manor was demolished in the early 1730s, only two decades after the engraving was made, and a grassy mound of rubble behind the church marks its former site (fig. 5). The unusually flat surface beside the mound was the bowling green in the engraving. Some of the Jacobean woodwork of the manor house is now in the church and some of its stonework, including window and door frames, was reused by Lord Bathurst in constructing the folly, Alfred's Hall, in Cirencester Park.

Part of the stimulus to write *The Ancient and Present State of Glostershire* came from Atkyns' access to the notes of the Revd Dr Richard Parsons. Parsons was vicar of Driffield and between 1677 and 1711 was also Chancellor of the Gloucester diocese. He had collected information on the parishes of the diocese by sending questionnaires to its clergy and by recording his own observations made on his frequent travels, but poor health had prevented him from publishing his findings. So he passed the information in almost incoherent note form to Atkyns for sorting and completion. In Atkyns he found a like-minded collaborator, sympathetic to the cause of the established church, and not only able to handle the mass of disorganised information loaned to him, but also to extract further details from documentary sources and to add his own from 'message information'. Unlike Parsons, there is no evidence that Atkyns personally visited all the places he refers to, and his methodology and data presentation are the same whether treating parishes he must have known very well, such as Lower Swell and Sapperton where he had lived, or places less accessible to him on the far west of the county beside the River Wye.

In the preface to his book Atkyns explains that some of its content (particularly that collected by Parsons) would be useful to the Church authorities. The book draws attention to the tithes that should have been received by the Church, the inadequacy of some clergy incomes, the state of church fabric, and places where new church buildings would be advantageous to the local population and also where they might 'suppress sedicious conventicles'. Atkyns was not in favour of Dissent or of its leaders and, although he recognised that dissenting teachers had gained respect by the way they lived, he thought they had neither the 'sense or learning', nor so good a cause, as

the Anglican clergy. He quoted with approval the deliberately Protestant statement in the will of Sir William Tracy of Toddington, 'so that I accept none in heaven or in earth to be mediator between me and God, but only Jesus Christ; and all other to be but as petitioners in receiving of grace, but none able to give influence of grace; and therefore I will bestow no part of my goods for that intent'; and notes that when these words, which implied no bequests to the Church for prayers for the dead, came to the notice of the authorities in 1532, Tracy was viewed as a heretic and his body was exhumed and burnt. Atkyns, like Sir William Tracy, was an advocate of the reformed faith.

There is an entry in his book for every parish in the county and for most parishes he discusses the meaning of its place name. He thought that this would delight the reader by its variety and would 'recapture antiquarian traditions from oblivion'. Frequently, the meanings Atkyns gives are no more than guesswork; 'chimerical' Samuel Rudder called them, but they are still delightfully memorable. His own translations of extracts from *Domesday Book* are included in many parish entries, as are the relevant parts of Camden's *Britannia*. Information on the former monastic connections of parishes was provided by translations of Dugdale's *Monasticon Anglicanum*. Atkyns also includes the transcripts of ancient grants and charters, which he thought would be 'acceptable to all favourers of learning'. The parish entries conclude with details, where available, of trade, battles and curiosities, which would 'yield speculation to the naturalist, diversion to the inquisitive, and profit to the industrious'. The preface ends with his prayer for the peace and happiness of his county.

Atkyns was strongly patriotic and a staunch supporter of the Stuarts. He confidently expressed the opinion that 'King James I was the most learned king, King Charles I was the most religious king, King Charles II was the best natured king, and King James II was the best friend'. Furthermore, his loyalty to his county is shown by the submission of his book 'with pious affection to his neighbours and countrymen'. The book was clearly meant to appeal to the county's gentry, hence its major emphasis on genealogy and the descent of manor ownership. For historians this assembling of so much family information into a relatively accessible form has been the principal reason for the great value placed on the book. The leading landowning families in the county, the Berkeleys, Giffards, Pauncefootes and Tracys, figure prominently. But Atkyns also wished to convey to his prospective readers a high moral tone. He aimed to do this by recording the names of the benefactors to each parish, with details of the money, land and property given to support the Church and the poor, and to provide education for children and apprenticeships for young men. This was designed, at least in part, to encourage others to charitable actions and to shame those who, in Atkyns' view, had avoided their responsibilities.

By the early eighteenth century the writing of county histories had become fashionable. Sir William Dugdale's on neighbouring Warwickshire had been published

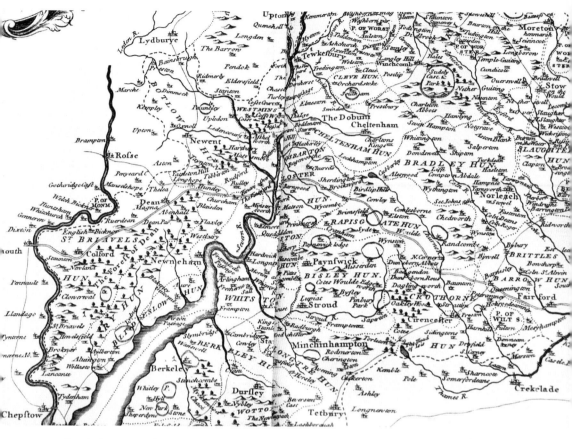

Fig. 6 An extract from a map of Gloucestershire, probably drawn by Robert Morden, and used by Atkyns.

in 1656 and Dr Robert Plot's on Oxfordshire in 1677, and many others soon followed. But none were more beautifully printed and produced than Atkyns' work and, through his executors, he was willing to bear the cost of printing the book.

For each parish he treats, Atkyns begins by describing its location. He does this, he says, in order to assist both the traveller and the home reader. Actually, both types of reader would have some difficulty in finding the place by simply following his instructions. The distances and directions of each parish from Gloucester, the county town, and from the two nearest market towns are given. So Abenhall, the first parish listed, is located by Atkyns at 1 mile south of Dean (i.e. Mitcheldean), 2 miles north of Newnham and 8 miles west of Gloucester. In fact, Little London in Longhope parish is 8 miles west of Gloucester, Flaxley is 2 miles north of Newnham, and Abenhall is south-east, not south, of Mitcheldean. Atkyns' directions, using the

four cardinal points of the compass, are very approximate and he was writing before the length of the mile had been standardised. Statute miles were not established until 1766, and Atkyns' miles are about one and a half times longer than statute miles. It seems likely that he was using a small-scale map to obtain these details, because some places near the lower Severn are located with reference to market towns on both sides of the river. Thus Lydney is located by miles measured directly from Newnham and Berkeley, Berkeley being on the opposite side of the river; and Saul is located by reference to Newnham and Dursley, Newnham being on the right bank of the river. To actually travel by road between them would have meant a much longer journey to cross the river upstream at Gloucester. It has been suggested that he used Robert Morden's county map in order to make these measurements of mileage and to ascertain directions. This map is included with the collection of engravings in *The Ancient and Present State of Glostershire* and had been originally published in a later edition of Camden's *Britannia* (fig. 6).

Twenty-three market towns within the county and ten from outside are used as parish location reference points. Gloucester is used for all parishes and the other most popular reference points are Cheltenham (43 times), Cirencester (39 times), Northleach (38 times) and Winchcombe (32 times). Cheltenham's central place status is surprising because it was smaller than many other towns, ranking thirteenth in the county at the time, with a population of only 1,500, and the new turnpike roads to Cheltenham, which significantly improved its accessibility, were still a century away.

A traveller in the early eighteenth century could occasionally find help from signposts at road junctions. These were just beginning to appear, having been officially ordered in 1697. But local benefactors had already provided some for the benefit of travellers, and the oldest surviving example is Nathaniel Izod's finger post on the London to Worcester road, now the A44, near Chipping Campden. This had been erected in 1669, again with non-statute miles. Another, the stone pillar signpost at Teddington Hands, was originally erected by Edmund Attwood in 1676 (see plate 1). Atkyns also mentions, as a reference point, the Four Shire Stone near Moreton-in-Marsh (see plate 32), which marked the boundary between the counties of Gloucestershire, Oxfordshire, Warwickshire and Worcestershire – the latter being represented by the parish of Evenlode, which was transferred to Gloucestershire in 1931. Milestones were not generally introduced until the establishment of turnpike roads and were then often used as a means of familiarising local people with statute miles.

Place names provided another early way of locating places. Many of these names were originally descriptions of the physical appearance of the place and, as the late Margaret Gelling has often indicated, a traveller understanding the place name would know when he or she had arrived. Naturally, when the name included a reference to land use this applied primarily to the time when the name was first given, but patterns

of land use often continued for centuries. As noted above, Atkyns normally gives the derivation of the place name using his knowledge of the Saxon language. In some cases he is accurate but other suggestions are wildly speculative, such as Akeman Street referring to the road to Bath, where those with aches and pains could find a cure. Interestingly, Defoe, writing a few years later, gives the same interpretation, that of a man of aching limbs travelling to Bath or 'Achmanchester' for treatment. Atkyns realised that some early interpretations of place names were purely fictitious, such as the derivation of Lechlade from the teaching of Latin to complement the teaching of Greek at Cricklade. But he is mistaken in thinking that a place name with the suffix -field implies a former battlefield, and that the suffix -comb means a hill. Witcombe does not mean a white hill but a wide valley, and can be recognised as such in the landscape. Neither does the prefix win-, as in Winstone, imply a former successful battle, nor does Dymock mean a shaded oak wood. Winstone is derived from the Saxon 'Winna's stone' and Dymock is thought to be a Welsh name referring either to a pigsty or possibly a fort.

He also gives the name of the hundred in which the parish was located. Hundreds were subdivisions of the county and notionally of 100 hides, a hide being 120 acres or the area an eight-ox plough team could cultivate. At the time there were twenty-three hundreds in the county but they were not always compact, and some, such as the Berkeley hundred, had scattered parishes, with Ashleworth and Coberley particularly distant examples. Wherever possible he also names the river that flows through or beside the parish.

The condition of road surfaces in the early eighteenth century was generally poor. The first turnpike road, which had been opened between Gloucester and Birdlip in 1698, was established specifically because the earlier road was 'so bad' and the turnpike was designed to raise money to pay for its repair. One bequest for road repairs that Atkyns records was made by a benefactor from Ashchurch, near Tewkesbury. Above the pulpit in St Nicholas' Church is a monument to William Ferrers, who was born in the parish but made good in London, and died there in 1625. The inscription giving details of his bequests to the parish includes these words: 'to ye mending of ye Highways abowt Fiddington ... £5 yearly for ever'.

A number of roads crossing the Cotswolds are referred to as 'great roads'. Their steep descent into the Severn valley was evidently more significant for Atkyns than the slow ascent, and he lists the succession of hills down which these difficult journeys were made. In a north to south sequence these were Campden Hill on the London to Worcester road, Winchcombe Hill between Stow and Tewkesbury, Crickley Hill on the Oxford to Gloucester road, Birdlip Hill on the London to Gloucester 'great road', Rodborough Hill between the Cotswolds and Purton Passage, and Nympsfield Hill on

the Bath to Gloucester road. Some of the names given to these steep descents are of settlements far distant from the actual hill.

Details of the passages across the River Severn are also included. These were at Tewkesbury (Lower Lode), Haw, Framilode, Newnham and Purton, and he mentions that Alvington had been of 'considerable account until the ferry moved to Beachley'. There was also a ferry across the River Avon at Twyning. Westgate Bridge at Gloucester was the lowest bridge on the River Severn. Other bridges he mentions are St John's Bridge, near the head of navigation of the River Thames at Lechlade; Chepstow Bridge, a high wooden bridge over the River Wye with half in Gloucestershire and half in Monmouthshire; Maisemore Bridge over the west branch of the River Severn; King John's Bridge over the River Avon at Tewkesbury; the stone bridge over the River Coln at Coln St Aldwyns; Battle Bridge at Chipping Campden, and Bearidge (Barrow) Bridge over the River Churn near Bagendon. Isaac Taylor's one-inch-to-the-mile map of Gloucestershire in 1777 shows many more bridges over Cotswold rivers than the four included in this list. At Tetbury, Atkyns refers to a very high, long bridge. This was probably the sixteenth-century causeway of the Wiltshire Bridge. The Bath Bridge at Tetbury dates from 1775, and replaced the packhorse bridge of 1622, which still remains down beside it. Most of these bridges have been rebuilt since the early eighteenth century, and some on more than one occasion.

Safety in travel was a major concern at the time and Atkyns informs his readers that the Forest of Dean had been 'a notorious harbour for robbers'. This was a long-standing issue, for the dense woodland had been a favoured hiding place for thieves, and there had been an Act of Parliament as early as 1426 to curb these outrages. There were already roadside inns to provide refreshment for both travellers and their horses. The inns specifically mentioned in the book include the long-gone Crown Inn in Northleach and the Frogmill at Shipton Solers on the Oxford to Gloucester road. Atkyns thought that Newent derived its name from a New Inn, which provided accommodation for travellers to Wales (the name is now thought to mean a new place), and he tells of the theft of a carved figure from St George's Church at Cam, to be used as a sign for a George Inn on the road to London. There was also a George Inn recorded at Haresfield and another inn built by Sir Giles (Parsons names him Miles) Tame at Barnsley. The number of inns increased after the roads were turnpiked and coach travel expanded.

The other means of long-distance transport was by boat. Atkyns informs us that the River Severn was navigable through the county and that from Lechlade, Cheshire cheeses, corn and other commodities were sent to London by boat along the River Thames – why Cheshire cheese rather than Double Gloucester cheese is not explained (see plate 29). There were no canals as yet, although some thought was being given to straightening river channels in order to improve navigation.

Atkyns makes no attempt at describing the appearance of the county and was very restricted in his use of adjectives to convey an impression of its landscape features, but his survey of all the parishes includes so much detail that it is possible to reconstruct a general understanding of the county's varied appearance in the early eighteenth century. The engravings by Jan Kip, which accompany the text, give good architectural details of the principal houses and often include nearby features and so help in this task of reconstruction. But before we can begin this reconstruction from Atkyns' contemporary information some preliminary phases of landscape development need to be considered, the first being that of the Saxon era.

2

The Saxon Imprint

In his own day Sir Robert Atkyns was concerned with the ancient as well as the present state of Gloucestershire, and so in the next four chapters we will look at the most significant of these earlier development phases. The first, on the formation of the Saxon landscape, will also assist in understanding the information contained in *Domesday Book*, which will be discussed in the following chapter.

Atkyns writes little about the legacy of Saxon times, other than in his fallible interpretation of the meanings of Saxon place names. Descriptive place names are of great value in reconstructing past landscapes for two main reasons. First, the names are likely to have been given by neighbours rather than by residents of the places, who had no need of a reference name for their home, and as a result are more objective. They do not have the bias of some historical documents and the names may even have distinctly uncomplimentary meanings – neither Quedgley (a dirt clearing) nor Slimbridge (a bridge over a slimy place) were attractive names. Secondly, they provide an even distribution of information across the whole county, without the gaps that would appear if surviving documents were the only available resources. The main wooded, arable and pasture areas, places noted for particular types of tree, crop or livestock, as well as places with significant physical features, may all be identified by their Saxon names. Common place name suffixes of -ley (a clearing), -ton (a farm or estate) and -field (an open pasture) and prefixes referring to cattle and sheep, trees and crops give typical land use information, and the suffixes -don (a low round hill), -combe (a short steep-sided valley) and -dean (a long tapering valley) describe common landforms.

Endings in -ley are often found along the Cotswold escarpment and near to the Forest of Dean and, because the clearings usually refer to clearings in woodland, they indicate that these areas were at one time heavily wooded. Both the Cotswolds and the Vale have many place names ending in -ton, where the prefix may indicate the farming emphasis as in Shipton (sheep) or Barton (barley).

19

Atkyns also makes brief references to several Saxon rulers, but he was not concerned with the way in which their decisions may have contributed to the evolution of the man-made landscape. Yet, as we shall see, the patterns of markets, monasteries and the oldest churches, landscape elements with which he was certainly interested, as well as such features as ancient hedgerows, early parish boundaries and the ridge and furrow now seen in old pastureland, were initiated in this period. Most villages and many footpaths have their roots set firmly in the Saxon landscape. So it was a very formative period for the visual appearance of the county.

Once Christianity had been given imperial support by Constantine in the early fourth century, its spread was officially unhindered throughout the Roman world. And it is likely that there was some limited continuity into post-Roman Gloucestershire of the Christianity of the late Roman world, especially in the towns of Cirencester and Gloucester and on the Cotswold villa estates. However, the sixth-century invasion by pagan Saxons and the survival of earlier folk religion meant that, three centuries after the collapse of Rome, most of the evangelising of Saxon Gloucestershire came from outside the area rather than from within the county. Contrasting ecclesiastical practices as well as architectural features were thereby introduced, some coming from the Roman tradition of the south-east of England and others from the Irish tradition via Iona and Northumbria. Highly significant to this early growth of Christianity was the welcome given to missionaries by the ruling Saxon royal families. By the seventh century, cultural and economic links had been established between these rulers and both southern Europe and the western islands and peninsulas of Europe, whence the two traditions of Christianity had spread.

Between the seventh and early tenth centuries impressive visible signs of Christianity began to appear in the landscape. These were the minsters, usually referred to as 'monasteria' in contemporary documents. Minsters were communities of varied combinations of priests, monks and nuns, living in enclosed and consecrated areas, each with its church or several axially aligned churches, living accommodation, workshops and farms. They were usually endowed by Saxon royalty or by their wealthy thegns. Both minsters in Gloucester had royal endowments. St Peter's, the forerunner of the cathedral, was founded in 679 by Osric, sub-king of the Hwicce, with his sister Kyneburga as abbess, and the minster that later became St Oswald's Priory was founded in c.900 by Aethelflaeda, daughter of King Alfred (see plate 2). The minster at Winchcombe was founded in 798 by King Kenulf, with his daughter Quendryth as abbess, and a previous minster there had been endowed by King Offa in 787. These early kings valued Christian learning and morality, and the minsters they endowed were expressions of that appreciation. Saxon kings also granted land to thegns for founding smaller and lay dominated minsters. The latter were rather despised for their lack of clerical status by the contemporary ecclesiastical historian Bede, as is indicated by this

sharp comment about them in one of his letters: 'wasps can make combs but store poison in them not honey'.

Initially, the minster may have been primarily for the benefit of the founder and his or her family, perhaps as a long-term investment to avoid taxes, but pastoral care was soon extended to include the local population, and the territories served by the first minsters expanded until, in some instances, they corresponded to the later hundreds, the large units of land which incorporated several parishes. At that stage, within a radius of 3 to 5 miles, the minster provided pastoral care for the whole district. Priests travelled from the minsters to the surrounding rural settlements to preach the gospel and to teach the people, and to the minsters the local population came for the baptism of their children, to celebrate the mass and to bury their dead. So the minster's location was often selected with this purpose in mind. We know of about twenty minsters in the territory of present-day Gloucestershire, some in the fertile lowlands of the Severn Valley and others on the Cotswolds. Along the Severn, from north to south, they were at Ripple, just over the county boundary in Worcestershire, Twyning, Tewkesbury, Deerhurst, two at Gloucester, and Berkeley; near the foot of the Cotswolds were those at Winchcombe, Bishop's Cleeve, Cheltenham (possibly Prestbury), Dowdeswell and Frocester; and scattered across the Cotswolds, some in the valleys and others on the hilltops, were those at Blockley, Stow-on-the-Wold, Daylesford, Withington, Bibury, Cirencester, Bisley and Tetbury. There may have been others west of the River Severn.

The actual sites for minsters were chosen and the land consecrated after prayer and fasting, and the sites are often found to possess common features. Typical physical site factors are small hills within generally sheltered valleys, where the present-day church stands on land above the surrounding houses, most notably at Winchcombe and Withington; fertile and well-drained river terraces above the flood plain of the Severn, as at Twyning, Tewkesbury and Deerhurst, where even the severe flooding of July 2007, despite much nearby property damage, scarcely reached the church doors; and locations with easy access to navigable rivers, as at Twyning, Tewkesbury, Gloucester and Berkeley. Human site factors include places clearly associated with Roman ruins, as at Cirencester, Frocester and Gloucester; sites adjacent to or within prehistoric remains, such as the Iron Age forts at Stow-on-the-Wold and Tetbury; and the meeting places of earlier pagan cults. These human factors gave to the minsters a sense of continuity with the past, which often incorporated folk status, and in the case of Roman ruins, provided readily available building materials for the new churches. The latter point should not be stressed, however, as building materials from Roman sites were often transported considerable distances.

The ditches and earthen banks enclosing the minsters were sometimes those of an Iron Age fort, as at Tetbury, but most were newly formed and were symbolic of separation from the world, rather than designed for defence. Although the place name

suffix -bury, from the Anglo-Saxon 'burh', frequently means a fort, it can also mean an enclosed space and thus may signify a former minster, especially if it is linked to a female name prefix. As examples, the name Tetbury, Tette's burh, comes from the Tettan burig or Tettan monastirium of seventh-century documents, and Bibury comes from Beagan burig, where in the eighth century the Bishop of Worcester made a grant of land to Beage, daughter of Earl Leppa. If the enclosure was walled or fortified, often using older Roman structures, the suffix -ceistir was used, as in Cirencester, Frocester and Gloucester. The shapes of the minster enclosures were sometimes square or rectangular, as the earthen banks at Deerhurst still show, and sometimes circular, as is probably indicated by the lane which surrounds the church and its cluster of related buildings at Bisley.

With their concentrations of population and buildings, minsters soon became economically significant. Here the local agriculture, which provided food for the minster's population, became more intensive, and the occasional surplus produce could be sold. Early technology was developed for the watermills, which processed the minster's corn, and crafts were expanded to produce useful domestic items and tools. Trade in salt, transported along the various saltways, was also stimulated, and soon many minsters became market places. Marketing brought income to the minster or to its secular lord. So minsters became the first Saxon central places, although it should be noted that their religious functions predated their economic importance. The five market towns of Gloucestershire that are recorded as such in *Domesday Book* – Berkeley, Cirencester, Gloucester, Tewkesbury and Winchcombe – had all been minsters, another five minster sites had market charters at a later date, and the other manors that had minsters were usually those with large landholdings and high values in the Domesday record.

The sphere of influence of a Saxon minster has been identified in some parts of England by marking the settlement place names ending in -ton that surround a central -bury, but this does not seem to apply to Gloucestershire. Invariably the area included several neighbouring settlements, where dependent local churches were later erected and to which early paths were developed. Bisley well illustrates this point, as will be discussed later. Nearby place names ending in -cote and *Domesday Book* entries with a large proportion of bordars (smallholders) also imply central settlements with significant early economic activity. Such economic prosperity further attracted the attention of royalty and thegns. So Earl Odda acquired a plot of land beside Deerhurst minster and at an earlier date King Kenulf had come to reside at Winchcombe, in both cases after the original minsters had been established.

It was in the late Saxon period that the local churches, the ancestors of many parish churches, were established. The majority were originally timber-framed, with wattle and daub infill, and were then rebuilt in stone in the eleventh and twelfth centuries.

A two-cell structure, with chancel or apse for the priest and nave for the people, was an important architectural and ritual development at this time. Today, overlap churches between pure Saxon and Romanesque Norman are found in several clusters on the Cotswolds, and are dated between 1050 and 1120. It is unlikely that their survival in clusters reflects the original Saxon distribution pattern, but rather a lack of desire or need for complete rebuilding in subsequent centuries in these places. The list of such churches includes those of Ampney Crucis, Ampney St Peter, Coln Rogers, Daglingworth (see plate 3), Duntisbourne Rous, Edgeworth, Miserden, Somerford Keynes and Winstone. The diagnostic architectural features of these churches and of the surviving parts of minster churches are various combinations of mortared rubble walls with megalithic corner stones known as 'longs and shorts', double splayed windows, decorative strip work known as pilasters, and Saxon inscriptions, sculptures and sundials. The arches over doorways and windows were sometimes cut from a single stone, as with the narrow north door at Somerford Keynes and the north chancel window at Coln Rogers. Such ornamentation and the structural improvements to these buildings would have increased their local prestige, and eased the shift in loyalty from the minster or mother church to these newer ones.

The parishes of local churches were eventually formed by subdividing the territories of the minsters, and 2 miles to church became the approximate limit of a parish. These smaller parishes were gradually established over time, as a result of the coalescing of the spheres of influence of different community activities, such as working for the manorial lord who built the local church, receiving the ministry of its priest, using the newly built watermill and participating in the religious processions. There is some evidence to suggest that the original size of a parish was in inverse proportion to the productivity of its land, for more fertile soil could support a given population from a smaller area than less productive land. But generally, the parishes of the minster churches were better understood than those of local churches and they retained their official status until after the Norman Conquest. They were larger, multi-focal, yet still spatially coherent, and socially and economically more diverse. The roots of the greater independence, social mobility and early Dissent, that were expressed centuries later in these former minster parishes, may be traced back to their larger sizes and to their scattered settlements in the Saxon period.

In addition to church building, the tenth century was a time of very significant and widespread agricultural landscape changes, possibly as marked as the changes associated with the fourteenth-century Black Death or with the Parliamentary Enclosures of the eighteenth century. Small, scattered settlements and isolated farms, at sites which have been recently revealed by field walking and the use of geophysical techniques, were being replaced by larger nucleated villages, and at the same time key features of the open field system of farming were introduced. In Northamptonshire, archaeological

research into the distribution of the broken pottery that was spread on the fields with manure has identified a difference between the types of pottery found within the soil of ridge and furrow and that found beneath these early ploughing features. Tenth-century pottery is only found within the soil of ridge and furrow, and not beneath it, which implies that ridge and furrow date from this time. The formation of ridge and furrow is considered further in chapter 10, but several related developments also occurred at the same time. The large, fixed mould board ploughs that have produced the ridge and furrow features could be used to cultivate heavy clay soils, and so agriculture was able to spread on to these areas from the lighter, well-drained soils, to which it was previously largely restricted. Such ploughs could be used more efficiently when working long strips of land, where fewer turnings were needed in a day's work, than with the small fields associated with the criss-cross ploughing of prehistory. They also required more oxen to pull them than the individual peasant farmer could supply, and so farmers pooled their resources to provide the oxen for a plough team. It was easier to assemble the oxen if the farmers lived close together, as they did in the larger nucleated villages. So nucleated villages, co-operative farming involving eight-ox plough teams, the cultivation of long narrow strips of land in open fields and the resulting ridge and furrow features, are linked together in the formation of the tenth-century Saxon rural landscape.

At the same time as these new developments in agriculture were taking place, careful surveys and fresh delimitation of land units, possibly based on strips of land, were being made for taxation purposes. A hide had now become a unit of taxation, rather than simply the area of land needed to support a family and its dependents, and a hundred, notionally a hundred hides, became an administration area. Population increase and the operation of new market forces had stimulated these tenth-century changes, but only the co-ordinating authority of the minsters, the Saxon royal families and the more wealthy thegns enabled nucleated villages, open field farming, manor houses and new churches to rapidly appear in a landscape that had remained largely unchanged by human activity since Roman times.

Soon, parishes also became the areal units for collecting a range of local taxes, such as the churchscot, churchbot and tithes – taxes which were necessary to sustain the local church, its buildings and its ministry. And once a parish had become the basis for tithes and for social and economic obligations, the precise delimitation of its boundary was of great importance. Early parish rogation processions merely went into the fields to bless the crops, but now they were extended to become complete parish boundary perambulations. Such annual perambulations were designed partly to reinforce parish boundary limits and were thought to be essential until accurate plans and fixed field boundaries had been established. Parish boundary paths were strictly maintained for this purpose, and the hedgerows which were planted beside them

are generally the oldest in the parish. Their richer shrub species list, often including ten to twelve different types of shrub in a 30-metre length of hedge, indicates their Saxon origins.

The Saxon Church absorbed some aspects of pagan culture by adapting them to Christian use, as for example with the original rogation processions, which were developed from rain-making rituals. Wells, trees and stones, which had previously possessed pagan religious significance, were given Christian meanings. Before the widespread use of fonts in churches, wells dedicated to saints were used for infant baptism, although adult baptism often took place in rivers. Crosses, first wooden, then of stone, marked important land boundaries, road junctions and old routes, as is still the case with the Lypiatt Cross near Bisley. Burials, which had formerly been in re-opened ancient barrows or in large pagan cemeteries, now took place in minsters or in their churchyards, and the Saxon churchyard became an important new landscape element. It is thought that the earliest churchyards were circular, such as may be observed at Ozleworth and Hewelsfield, and were places associated with pre-Christian worship. Osric, Aethelflaeda and Aethelred had minster burials in Gloucester, and Kenulf and Kenelm at Winchcombe. At the same time, the bones of saints, which were believed to ensure the living interest and help of the saint, were enthusiastically collected by minsters and enshrined as relics. From the late Saxon period a pilgrimage to such a shrine became a popular practice, and within the county the Saxon shrines of St Kenelm at Winchcombe and St Oswald at Gloucester attracted many such visitors.

About a dozen sites in the county have yielded important archaeological or architectural evidence for Saxon occupation, some with documentary support, and because they have provided insights into the wider Saxon landscape they will be briefly reviewed here.

A short distance from the massive ramparts of the Iron Age fort at Uley Bury (see fig. 26 on p. 75), and not far from the Neolithic long barrow of Hetty Pegler's Tump, excavations on West Hill, Uley, have revealed a second-century Roman temple, dedicated to Mercury. This had been replaced by a small, timber-framed church, which was rebuilt in stone in about the year 600. It is one of the earliest examples of post-Roman Christianity in the county, small and insignificant compared to its impressive prehistoric neighbours, but a marker for the monuments to come.

In Gloucester, the present church of St Mary de Lode is the latest in a succession of churches built on a historic site. The first building here is thought to have been the Roman baths, sited close to the western approach to Glevum and to the quayside of a nearby branch of the River Severn. Its mosaic floors and painted plaster walls, with rooms around a central courtyard, probably indicate that it was a public building. The building was burnt down, and in the late fourth or early fifth century a timber

structure for a mausoleum was constructed on its site, and aligned to the Roman remains. Significantly, the burials in the mausoleum were orientated east–west. This latter building was also burnt, and then replaced by the first Saxon church.

The exact site of Osric's St Peter's minster nearby is not known, but it was probably within the north-west corner of the old walled Roman city, where part of the cathedral now stands, and the Saxon church of St Mary was built on the same axis but outside the walls. After the Danish occupation of Gloucester and the burning of St Mary's in c.880, the rebuilt town was laid out with a new street pattern, together with the additional minster of St Oswald's and a rebuilt St Mary's Church. The large parish of St Mary's was then subdivided to provide some of the land endowment for St Oswald's.

Bibury is situated within the steep-sided, but shallow, valley of the River Coln. Here, close to the river, was a Saxon minster and the stonework of the parish church still retains Saxon features. The aisles are later additions, but the high nave, rather like that of Deerhurst, and the western half of the chancel are Saxon. On the outside of the north wall of the chancel is a finely sculptured Saxon gravestone, used as a pilaster, and there is another pilaster on its south wall. Inside, the chancel arch has been cut through a Saxon string course, and high on the inside wall of the north aisle are the tops of other Saxon pilasters, showing that this wall was the original outer north wall of the nave of the minster church, a wall which was later pierced to give several arches (see plate 4). Other Saxon sculptures have been found here, and replicas are displayed in a recess of the south aisle. A high round window near the south porch has the typical double splay.

St Michael's Church at Withington is probably on the site of the former minster. Documents record that in 704 two nuns, Dunne and her daughter Buege, were granted twenty hides of land by King Aethelred to establish a minster. Twenty hides, notionally 2,400 acres, is a typical area for a minster's support, and in the later Middle Ages the church at Withington still had oversight of neighbouring parish churches, reflecting its earlier extensive minster territory. On the far side of the River Coln, which generally forms the eastern boundary of this and other parishes downstream, is a large block of land between Ravenswell Farm and Cassey Compton, which is now included within the parish. The historian H.P.R. Finberg, following a study of the Saxon documents of Withington, has suggested that this piece of land corresponds to the 800 acres of a late eighth-century bequest to the minster. Most of the present village of Withington is on the east side of the Coln in this parish extension.

At Longney, just above the alluvial flood plain of the River Severn, is St Laurence's Church. It stands close to a pond, and between the church and the pond is a low mound. This may have been the site of a controversial nut tree mentioned in a Saxon document. The church was built by the thegn Elfsige and was dedicated by Wulfstan,

Bishop of Worcester, in 1070. The pond was fed by a spring, and the earlier dedication of the church to St Helen, a saint who was often associated with holy wells, is entirely appropriate.

The minster church at Bisley was similarly close to a spring, now supplying water to the wells below the churchyard, and the lane that encircles the church probably follows the boundary of the minster enclosure. Radiating paths and tracks led to the surrounding settlements of the Bisley hundred where several local churches still retain Saxon features. The churches at Edgeworth, Miserden and Winstone each possess blocked Saxon doorways on their north walls. The eighth-century Lypiatt Cross, beside the road from Bisley to Stroud, now severely weathered and damaged, was no doubt linked to the minster at Bisley and it is likely that it is in its original position, marking a boundary of the minster's land. It still shows traces of carved figures in the arched niches of its sides, with figures of Christ on the two main faces (fig. 7).

At Deerhurst is the very special combination of a Saxon minster and a late Saxon chapel. Their respective enclosures have been marked out by nearby low earthen banks, although some of these have been masked by a very recent flood defence scheme. The original church incorporated Roman bricks in its fabric, and the present church, dated between the seventh and eleventh centuries, retains many Saxon features (fig. 8). Here are herringbone masonry walls, a triangular-headed double window, beast head stops to several arches, about thirty extant or blocked Saxon doors and windows, early sculptures of Mary and of an angel (perhaps the symbol of St Matthew), pilasters on the south wall of the apse and a prokrossos – the stone projecting from the west wall of the tower and originally sculptured as an animal head. There is also a well-preserved and finely decorated ninth-century font. The church is above the flood level of the Severn, on the main terrace, but easily accessible to the river. Nearby Odda's Chapel, also above flood level, is precisely dated at 1056 by a stone inscription. It has rubble walls, longs and shorts, and double splayed windows (fig. 9). These two Saxon buildings at Deerhurst are of national importance.

In the Abbey Grounds at Cirencester, close beside the parish church, is an outline in the grass of the shape of the great abbey church founded in 1133 by Henry I. Excavations here have also revealed the earlier Saxon church, probably built in the early ninth century, using Roman materials, and with the same alignment as the abbey church. The scale of this building was much greater than that of the other Saxon churches in the county. It was one of the largest, if not the largest, in the whole country, the nave and apse being 179ft long and 28ft wide, and more in keeping with the then visible legacy of the town's massive Roman structures.

Some of the other churches with Saxon architectural features have been mentioned in the general section of the chapter. The visitor's attention may be drawn to the three churches of simple dignity in the valley of the small Dunt stream at Winstone,

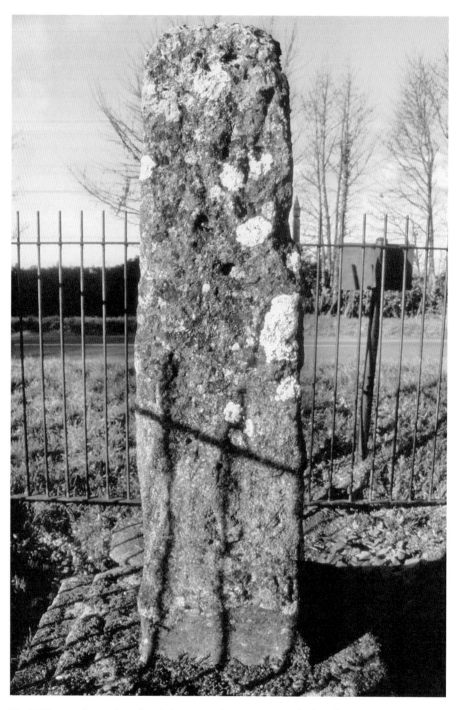

Fig. 7 The much-weathered eighth-century Lypiatt Cross, which still stands beside the road from Bisley to Stroud.

Fig. 8 St Mary's Church, Deerhurst. One of the finest Saxon churches in the country. Notice the herringbone masonry of the Saxon wall.

Fig. 9 Odda's Chapel, Deerhurst. Odda was a Saxon earl and the chapel, which was later incorporated into the farmhouse behind, is precisely dated at 1056.

Duntisbourne Rous and Daglingworth, the latter with its primitive but evocative Saxon sculptures and a Saxon sundial within the fifteenth-century porch.

With reference to Saxon towns, it was along the main streets of Saxon Gloucester, which differed in their east/west layout from the earlier Roman grid pattern, that most of the city churches were sited and where most people lived. Within the former Roman city walls and away from these main streets were open spaces. Thus the later building of the Norman castle, although it occupied a large space in the south-west of the city, only required the demolition of sixteen houses. There was also plenty of room for the expansion of St Peter's and for the settlement of the Franciscans in the south-east corner of the walled town.

Winchcombe became a royal borough in Saxon times, and the palace of the Mercian king Kenulf is thought to have been where the Lloyds TSB bank is sited in Queen Square. Earthworks that mark the defensive rampart of the borough still remain beside Back Lane, but all traces of the Saxon minster have gone.

Atkyns was aware of Saxon influences at Berkeley, Cirencester, Deerhurst, Gloucester, Tewkesbury and Winchcombe, but his knowledge was based on documentary evidence rather than on observations of extant features in the landscape of his day. Yet that landscape, with its open fields around nucleated villages, extensive commons and scattered woods, labour intensive arable farming and vibrant market places, was much closer in appearance to the Saxon landscape than to that of the twenty-first century. The countryside Atkyns knew had a strong Saxon foundation, to which he makes little direct reference. He did, however, make a detailed translation of those parts of *Domesday Book* which applied to the county, and although some important information was overlooked, he included most relevant extracts in his parish entries. The 1086 Domesday survey is best understood as a document summarising conditions at the end of the Saxon period, rather than giving an impression of early Norman influence, and to this work we turn in the next chapter.

3

Interpreting Domesday Book

A tkyns appreciated the value of *Domesday Book* as a significant source of information for the early history of the county. This 'most venerable record' he calls it and for most parish entries he includes details extracted from the Domesday survey. Until recently, Atkyns' book was the most accessible source for this information. He made his own translation of the Latin text, and apart from a few errors in transcribing Roman numerals into Arabic the translation is generally accurate. He calls leagues miles, but, as we have noted above, Atkyns' miles were not the same as statute miles and were, in fact, much closer to leagues. He includes the numbers of hides and of plough teams, but for some reason omits most population details. There are no references in *The Ancient and Present State of Glostershire* to the numbers of villeins, bordars and serfs in the manors, or to burgesses and reeves, information that is prominent in *Domesday Book*. Priests are sometimes recorded but few other occupations are given and the values of mills are also omitted. These omissions are surprising since Atkyns includes the parish population figures for his own day and gives many financial details, even discussing the changes in the value of money between Saxon and Norman times and the early eighteenth century.

Some of the more notable deficiencies in his treatment of the Domesday survey concern misplaced entries. Thus the entry for Aston-sub-Edge is given under Aston Blank, that for Cowley under Withington, for Hewelsfield under Woolaston, for Meysey Hampton under Minchinhampton, for King's Stanley under Staunton, and for Wick Rissington under Little Rissington. The entries for Upper and Lower Slaughter are reversed, entries for the parishes of Bagendon, Bourton-on-the-Water, Hampnett, Painswick, and Westonbirt are missed altogether, and for the complex Domesday entry for Berkeley, Atkyns quotes Camden's summary. Samuel Rudder, in his *A New History of Gloucestershire* 1779, was rather scathing in his review of Atkyns' handling of *Domesday Book*, but most of the errors he lists are of minor significance or are understandable when Domesday spellings such as *Hantone* (Hampton), *Sciptone*

(Shipton) and *Stantone* (Stanton) are the same for several manors. Rudder gives the full Domesday text and the recent reprint of his book is now a much better source for these eleventh-century details. As is usual with his statistical information, Atkyns makes no comment on the significance of the Domesday figures. He was not concerned with analysis or interpretation, only with a simple presentation to his readership of the content of historical documents. His readers were left to process this information for their own purposes. The synthesis of the Domesday record that follows in this chapter is based on the original Latin text and on the commentaries of recent scholars, but most of the generalisations we make could have been derived straight from Atkyns' work.

A typical Domesday entry for a manor, in this case for Brockworth (fig. 10), reads as follows:

Hugo Lasne ten de rege BROCOWARDINGE. Ibi v hidae. Turchil tenuit de rege E. In dnio sunt II car. VIII villi. Vi bord. pbr. II libi hoes pposit. Int oms hnt XV car. Ibi IIII servi. molin de II solid. Silva una leuua Ig dim lat. Valuit Vi lib. m C solid.

This may be translated as: 'Hugh Donkey holds Brockworth from the king. Here are five hides. Torkell held it from King Edward. In the demesne are two ploughs. There are eight villeins (villagers), six bordars (smallholders), a priest, two free men and a reeve. Between them they have fifteen ploughs. Here are four slaves, a mill valued at two shillings, and woodland one league long and a half league wide. Its value was £6, now 100/-.'

Atkyns' translation reads: 'Hugh Lane held Brocowardinge in the reign of William the Conqueror. It was taxed at 10 hides; there were 17 plow tillages, whereof 2 were in demean; there was a watermill, and a wood a mile long and half a mile broad. It paid a yearly rent of £6 in the reign of King Edward, it paid only £5 a year in the reign of King William.' (Notice the hideage error, which may have come from the text Atkyns copied.)

From this single manor entry, the value of *Domesday Book* for reconstructing the appearance of the landscape of the period can be readily appreciated, even using Atkyns' condensed version.

The background to *Domesday Book* is well known. In Gloucester, in the winter of 1085, King William met with his advisers, his Witan. In those days the court moved regularly between Westminster, Winchester and Gloucester. One outcome of this particular meeting was that a survey was ordered of landownership, population distribution and economic resources for the whole country. Commissioners were then sent to make circuits of groups of counties in order to collect the data. They were required to report back by the end of 1086. At Winchester the recorded information

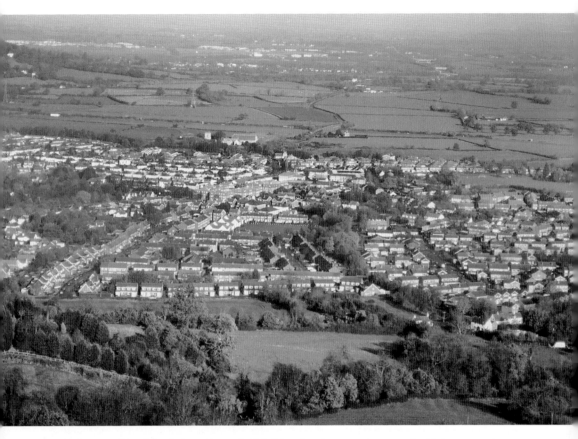

Fig. 10 A view of Brockworth from Cooper's Hill. The church, manor house and mill site are on the far side of the sprawling settlement. The pattern of estate housing fits the former field pattern and it has been suggested that some of the field boundaries may date from Roman times.

was collated and later published in the two-volume *Domesday Book*. Four commissioners were used to collect the information for Gloucestershire, which was part of the Midland circuit of counties.

The type of information that was requested for each vill or manor can be deduced from the published report. First, the manor's name is recorded, and since its spelling in *Domesday Book* is often the earliest recorded spelling, Domesday is very important for investigating the meaning of the place name. Corruptions of spellings over the following centuries have necessitated the recovery, where possible, of the original Saxon name, and *Domesday Book* is the usual source for this. More than 300 place names are recorded within the area of the present-day county and almost all have been identified. Usually the names are now applied to villages but in a few cases they relate

to hamlets or even to isolated farms (see fig. 23 on p. 70). The name of the hundred in which the manor was located was also required and there were at the time thirty-one different hundreds in the county.

The holders of the manor at the time of King Edward in 1066 and twenty years later in King William's reign are also noted, thus giving the king useful information on the size and distribution of the holdings of the most powerful landlords, men who might at some future date challenge his authority. Then the numbers of hides are given. A hide, as we have seen in chapter 2, was notionally the area of land that an eight-ox plough team could cultivate, but more generally it represented the land required to support a leading family with its dependent tenants. From William's point of view it was a basis for taxation. Sometimes the smaller units of land area, known as virgates, are recorded, a virgate being the size of a traditional peasant farm of 30 acres. More rarely the total number of acres are given. Atkyns copied all these details.

The next sets of statistics are for ploughs and for people. Eight-ox plough teams were normal for cultivating heavy soils in the eleventh century and a distinction was made between those plough teams in demesne, i.e. on the land farmed by the lord of the manor, and those belonging to the tenant villagers and others. The manor's population was usually divided into three categories: villeins (villagers or tenant farmers), bordars (smallholders), and serfs (landless servants or slaves). Frequently, male and female slaves are recorded separately. Useful comparisons may be made between some of these manor statistics. For example, relating the number of plough teams to the number of hides gives an indication of the significance of arable farming to the manor, and relating population figures to hideage gives a measure of the manor's population density. For a more realistic interpretation of the population statistics, an assumption is made that the numbers given in Domesday, apart from those of female slaves, refer to the heads of households. So the figures are conventionally multiplied by five to give a better estimate of the actual population density. In addition to these three categories of population, details are given of burgesses in the market towns of Gloucester and Winchcombe, and of radchenistres (riding messengers), priests, reeves, and men of French and Welsh nationalities. A few men with particular occupations, such as potters at Haresfield, smiths at Pinbury and Quenington, and swineherds at Forthampton, are also recorded.

Major resources, including meadowland (measured in acres), woodland (measured by length and breadth in leagues and furlongs), and watermills with their values, are given for most manor entries, and a few also have details of pasture, fisheries and salt pans. Finally, the values of the manor are given for 1066 and for 1086, usually in £ s d, but sometimes in kind, such as loaves of bread for the king's hounds, wool for the queen, sesters of honey, and numbers of cows and pigs.

With this review of the scope of the Domesday survey, we are now in a position to examine the spatial patterns of the information collected. With regard to landownership, we first notice that King William held the largest estate in the county in 1086, with about 500 hides of land, generally well dispersed, but with two concentrations near Berkeley and Tewkesbury. His total estate comprised about a quarter of the county's land area. Local abbeys, such as St Peter's Gloucester, St Mary's Winchcombe, St Mary's Worcester and St Mary's Evesham, more distant abbeys at York and Westminster and other abbeys in northern France such as St Denis in Paris, Coutances and Lisieux shared between them just over another quarter of the county's land. The king usually left this monastic land untouched. The other large estates were held by Norman landowners – supporters of William. Most Norman lords had been granted widely scattered manors, rarely were they given large contiguous blocks of land. This decision by William may have been for strategic reasons. As an example of the type of estate granted to a Norman landowner, we may take the lands of Roger de Lacy from Calvados. He had the following manors: in Botloe hundred Kempley, Oxenhall and Carswall; in Salmonsbury hundred Icomb, Upper Slaughter and Wick Rissington; in Holford hundred Temple Guiting; in Rapsgate hundred Duntisbourne Abbots; in Bisley hundred Painswick and Edgeworth; in Twyford hundred Madgett and Tidenham; in Brightwells Barrow hundred Quenington, Eastleach Turville and Hatherop; in Barrington hundred Windrush; and in Cirencester hundred Stratton, Siddington, and Oakley. Most of these manors are scattered across the Cotswolds, two are by the Rivers Severn and Wye, and three are in the extreme north-west of the county. He held land in other counties as well – in Berkshire, Shropshire and especially in Herefordshire and Worcestershire – and in total he had 116 manors. Roger rebelled against the king soon afterwards and was banished from the country and his lands given to his brother Hugh.

Maps prepared by Prof. H.C. Darby, who became the country's leading authority on the geography of the Domesday survey, have shown that the density of plough teams was highest to the east of the Cotswolds between Bibury and Fairford, and also in three areas of the Vale – in the lower Frome valley, around Gloucester, and around Winchcombe. Areas fringing the Forest of Dean had the lowest density. When adequately drained, the deeper soils of the east Cotswold valley floors and the clay lowlands of the Vale had the greatest inherent fertility and the plough team distribution reflects this quality. If we plot a graph showing the number of plough teams against number of hides in the different manors, we may expect to find a simple positive relationship, with one plough team for each hide, and the number of plough teams increasing proportionately to the increase in hideage. However, the number of plough teams generally far exceeds the expected number, although the scatter plot does show a marked concentration in

the 1-5 hides / 1-7 plough teams quadrant of the graph. It has been suggested that whereas a plough in demesne could correspond to 100 acres, a tenant plough may only correspond to half this area. There is a noticeable frequency of estates assessed at five and ten hides, which suggests that the hideages of at least some manors were very rough calculations. We also find that with these two particular sizes of manor there are large ranges in the numbers of plough teams – from three to seventeen in five-hide manors and from six to twenty-four in ten-hide manors. Of the larger holdings there are fewer plough teams than expected at Bishop's Cleeve and Prestbury, two manors north of Cheltenham, and at Kemble and Long Newnton, close to the Wiltshire border, but the reasons are not obvious. The manors possessing significantly more plough teams than expected include such widely scattered examples as Twyning, Bisley and Badgeworth, while the Painswick entry with fifty-three plough teams in a manor recorded as having one hide is likely to have been a copyist's error!

Darby's population distribution map shows a remarkably similar pattern to that of plough density, with the same areas of high and low densities. Population distribution and arable farming were clearly related. The adjusted population figures give densities of between six and eleven persons per square mile, apart from in and around the Forest of Dean, where the figure is about two persons per square mile. Present-day densities in the less accessible agricultural or estate parishes, without significant commuter or retirement populations, are about ten times this figure.

Forty-five settlements are recorded as having priests. Most of these are on the Cotswolds, and the three churches which are mentioned in the Domesday survey are at Tidenham, Cheltenham and Stow-on-the-Wold. By now it is likely that the establishment of local churches had diminished the role of the Saxon minsters, so we do not find the concentrations of priests of earlier times, and it is possible that Danish pillaging had focused on the wealth of the minsters further reducing their status. Twenty-one settlements had representative burgesses in Gloucester or Winchcombe, with eighty burgesses in Gloucester and sixteen in Winchcombe. These two places were the chief towns in late Saxon times and having burgesses there gave the smaller surrounding settlements improved market access. The main settlements from which the burgesses came were Deerhurst (32), Bisley (11) and Tewkesbury (8) (note the connection with the earlier Saxon minsters), and on a smaller scale Kempsford (7) and Brimpsfield, Broadwell, Temple Guiting and Withington (each with 5). Markets were also recorded at Berkeley, Cirencester and Tewkesbury, but without burgesses.

Meadow was very valuable at this time, perhaps three times that of arable land. It was not only used for the late summer grazing of livestock, but also for the hay crops which formed the animals' winter feed. Neither root crops nor cereals were grown as fodder crops for farm animals in Norman times. About one-third of manor entries in *Domesday Book* include an acreage of meadow, a few indicate that there

was meadowland but do not give its size, and three record it as hay for oxen or for plough teams. The largest concentrations are along the River Severn, at Gloucester and upstream at Deerhurst, Tewkesbury and Twyning, and along the River Thames at Kemble, Poole Keynes, Somerford Keynes and Kempsford. Meadows are also recorded along all the Cotswold tributaries of the Thames, the Rivers Churn, Coln, Windrush, Evenlode, Leach and Ampney Brook. All the acreages of meadow are small, only at Tewkesbury is a meadow as large as a hide, and of the hundred or so records of meadowland the majority are of 10 acres or less. It has been suggested that the scarcity of meadows along the Severn south of Gloucester, where they are most abundant today, was because this low-lying land was frequently inundated by the tidal and floodwaters of the river estuary. Some of the meadows may have been water meadows, as is mentioned with the Deerhurst entry. Several manors also have entries for pasture, and it is likely that the original survey collected such information from all manors but this was generally omitted in the summary reports.

There are references to woodland, or forest, in sixty-eight entries. The largest number occurs along the Cotswold escarpment, which today is still noted for its fine beechwoods. Another cluster lies north of the Forest of Dean, which at this date occupied a more extensive area than it does now. Several entries for manors around the edge of the Forest of Dean refer to the Dean or the King's wood. These are at Hewelsfield, Lower Redbrook, Staunton, Mitcheldean and Taynton, but no details are given of the area or quality of woodland. There is also a wide scattering of mostly small woods on the Cotswolds. Presumably, in this period of general self-sufficiency, woodland was a necessity for timber and fuel in all manors. By far the most common size of woodland is one league by a half league, again suggesting rough estimates. The largest woods are at Painswick (5 leagues x 2 leagues), Forthampton (3 leagues x 3 leagues) and Sudeley (3 leagues x 2 leagues). The distribution of Saxon place names with the suffixes -ley and -hurst, *hurst* meaning a wooded hill, supplements the Domesday record and reinforces the emphasis on woodland along the Cotswold edge. There are also indications of other hunting areas from references to enclosures for deer at Newent and Churcham, and hawks' eyries at Avening and Forthampton.

Most of the 230 watermills listed are along the Cotswold river valleys, reflecting both the more important corn-growing areas here and rivers that were suitable for harnessing for water power. In a few manors there are clusters of mills. At Blockley there are twelve mills, at Minchinhampton eight, at Sudeley six and at Bisley five. The most valuable mills are the two at King's Stanley, valued at 35/-, and the two at Long Newnton, valued at 30/-. About a third of the mills are valued at either 10/- or 5/-, but values could be as low as 6d at Saintbury and 12d at Badgeworth and Southam. Once a mill site had been selected, it is likely to have retained this use for centuries, often until water power was displaced by steam power in the nineteenth century or

by diesel and electricity in the twentieth century. Watermills may have remained at these places for more than a thousand years (fig. 11). We gain some impression of the significance of watermills through the *Domesday Book* record of twenty-two mills along the River Coln between Shipton Chamflurs, a lost village near Shipton Solers, and Fairford. Generally their values increase downstream. These early mills may have had horizontal water wheels, where water was directed by shoots on to the angled blades of the wheels and the millstones were in housing above the wheels. Such mills were small and their design avoided the need for gears, which became necessary when both overshot and undershot wheels were used. Windmills were not introduced until the twelfth century.

Seventeen manors have fisheries. Apart from Lechlade on the River Thames, where eels were caught, all the fisheries recorded are on the Rivers Severn or Wye. Tidenham

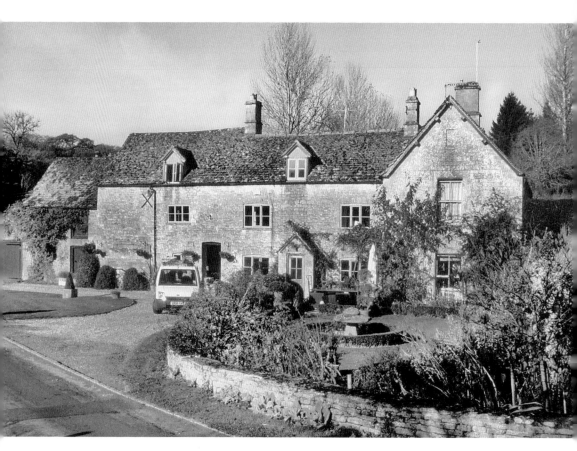

Fig. 11 Yanworth Mill. One of the county's 230 water mills recorded in *Domesday Book* was here, then valued at 40d.

has the majority of fisheries with sixty-five; most riverside manors have only one. The right bank of the Severn below Gloucester was the principal fishing zone and it is likely that salmon was the main species caught. St Peter's Abbey in Gloucester received an annual gift of sixteen salmon from the burgesses of the town.

Brine water from springs in the Mercia Mudstone at Droitwich was evaporated in lead vats to provide salt, the essential meat and fish preservative; 301 salt pans are recorded in the sections of *Domesday Book* dealing with Worcestershire manors. In Droitwich, 159 are held by local landowners and 73 are held by outside owners, some from Gloucestershire. The entries for six manors in Gloucestershire make reference to salt houses and five give details of their value in terms of either pack loads or measures of salt. The location of these entries, together with the place names incorporating the word 'salt', allow the reconstruction of the routes of the saltways, along which salt was carried by pack horses to Lechlade and then by boat to London or to other markets (fig. 12). Both Temple Guiting and Guiting Power have salt houses and so too does Toddington, Stanway and Tewkesbury. The salt house at Awre may have used salt water from the tidal Severn. At Chedworth a toll was charged for the passage of salt.

Some manors produced honey, measured in sesters (a liquid measure thought to be about 32 ounces). These are at Cirencester, Deerhurst, Bisley and Alvington. Miscellaneous entries include land for a castle at Sharpness (presumably for Berkeley Castle), a monastery at Stanway, a vineyard at Stonehouse (which Atkyns translates as orchard), pigs at Forthampton, hens at Temple Guiting and weys of ewe's cheese at Kempsford. It is likely that the returns of the commissioners contained much more similar information than the collators at Winchester have preserved.

In summary, the Domesday record indicates that settlement was spread widely and fairly evenly across the county, apart from within the Forest of Dean. All manors had cultivated land, but more intensive agriculture occurred in the east of the county and in the three areas of the Vale mentioned above. Population densities were also greater in these areas. Gloucester, and to a lesser degree Winchcombe, were the most developed towns, with other markets established at Tewkesbury, Cirencester and Berkeley. Roman roads were used, but the strategic Roman military roads did not well serve the needs of the Saxon population and other through routes, such as that for salt transport to Lechlade, were more important. The woodland of the Forest of Dean extended further north than today, and although many manors possessed small areas of wood, there were concentrations across the south of the county and along the Cotswold escarpment. Meadowland was found along the River Severn, north of Gloucester, and along the Cotswold river valleys, where watermills were also common. The west side of the lower Severn was most important for fisheries.

The Domesday entries in Atkyns' book are sufficient for most of this landscape reconstruction, apart from the population distribution. The processes of nucleation of

settlements and the development of the open field system of farming, which we have seen was initiated in late Saxon times, continued into the Norman period, but now with the new ownership recorded in *Domesday Book*. It was this new leadership that was the driving force behind the wider Norman impact on the landscape to be considered next.

4

The Landscape Impact of the Normans

eorganisation of landownership, with Normans displacing Saxons; fresh
injections of capital; renewed support for monasticism and a growth in the
popularity of hunting, were the chief factors that contributed to the visible
changes in the Gloucestershire landscape under Norman rule. The most widespread
and conspicuous of these changes concerned buildings, as castles, monasteries and
especially churches were built or rebuilt in the twelfth century.

Over a relatively short period of time, in village after village, new churches with
their distinctive Norman architecture began to appear. The visual impact must have
been immense and William of Malmesbury, writing in c.1120, conveyed this sense
when he reported that 'churches rise in every village'. St Wulfstan, who lived between
c.1008 and 1095, was one of the early promoters of the church-building programme
in Gloucestershire. He became Bishop of Worcester in 1062 and his diocese included
much of the present-day county. Wulfstan urged lords of manors to follow his own
example in building churches. He was primarily interested in plain, humble buildings
and it is said that he was 'little pleased with laboured or curious work'. When the new
Norman lords of manors responded to his requests, they naturally built next to their
own manor houses, and so the spatial link between church and manor house, which
had been hinted at in late Saxon times, became the normal pattern. This link was still
very evident in the early eighteenth-century landscape and frequently continues to the
present day.

Most parish churches were in existence by 1180, their number having doubled in the
previous century, and in addition to the newly founded churches, older timber-framed
churches were rebuilt in stone. The most common form was still the simple two-cell
structure of nave and chancel, the chancel having the same width as the nave but
about half its length. A bellcote was sometimes added at the west end. St Nicholas',

Fig. 12 A view along the Saltway, the pack horse route linking the brine pits at Droitwich with Lechlade at the head of navigation on the River Thames. The 'Sealt Straet' is recorded in a tenth-century charter for land at Hawling.

Condicote (see plate 5), and St Mary's, Upper Swell, retain this appearance, and are typical examples of the many small Norman churches which have survived to the present day. But other churches, from the very beginning, were more elaborate than this basic design. West towers were frequently added to Norman churches, possibly as status symbols, but All Saints', North Cerney, had a west tower from the twelfth century. Similarly, north and south transepts, which gave the cruciform plan and were fairly common later additions to accommodate larger congregations and to allow ritual processions, were incorporated in the original building of St Swithin's, Leonard Stanley, rare features for a purely Norman parish church. A central tower between the chancel and nave was another Norman elaboration. Examples occur across the county at Coln St Dennis, Staunton and Withington, while the supporting masonry of central towers that have been subsequently demolished is still visible at Elkstone and Hampnett.

Two Norman churches in Gloucestershire, which possess unusual hexagonal towers, are at the isolated south Cotswold settlement of Ozleworth and at Swindon to the north-west of Cheltenham. Occasionally, there was a narrow Norman aisle, as with the north aisle at Aldsworth.

As may be expected, there is a rough correlation between the size of the nave of a Norman church and the Domesday population of the manor. Later changes to church fabric reflect changes in the population totals of the parish and in the wealth of the parish benefactors, and these alterations have often masked the Norman features. But according to Pevsner's *Buildings of England – Gloucestershire*, fifty-four churches in the Vale and the outskirts of the Forest of Dean, and eighty-five on the Cotswolds, have Norman masonry. Atkyns has very little to say about the architectural details

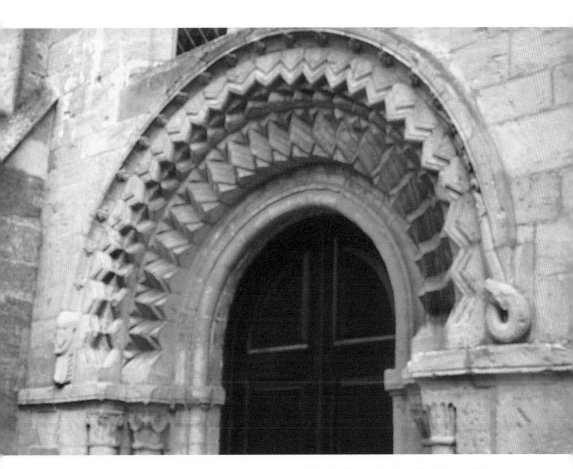

Fig. 13 Norman sculpture over the west door of St Michael and All Angels Church, Bishop's Cleeve. At one end of the hood mould is a dragon, at the other a serpent. The hood mould over the south door has dragons at both ends.

of churches in his parish surveys, and is generally content with a brief comment on their basic form, such as 'cruciform, with tower in the middle' for St Swithin's, Leonard Stanley. These basic forms will be considered in chapter 7, but here we discuss those Norman architectural features that would have been visible in Atkyns' time and have remained to the present day.

The Norman architecture in Cotswold churches is of national significance, and would have been very evident in the early eighteenth century. Of particular interest are the doorway and chancel arches with the chevron design. This zig-zag pattern in the stonework was developed in Normandy from about 1090. Some churches have the pattern both flush with the wall and also at right angles to it. There are many variations in the width and depth of carving, and at the old church of St Mary's, Kempley, the chevron pattern in the stonework of the chancel arch has been painted in keeping with the contemporary painting of the ceiling.

The west doorway of the church at Bishop's Cleeve possesses two good examples of Norman sculpture at each end of the hood mould. On one side is a dragon's head, with vicious-looking teeth, and on the other is a coiled serpent (fig. 13). Many church arches have dragon headstops, the dragon representing evil and acting as a warning

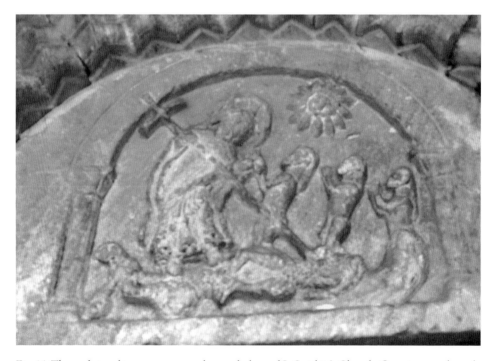

Fig. 14 The sculptured tympanum over the north door of St Swithin's Church, Quenington, the only sculpture Atkyns describes. It represents Satan, the dragon, being slain by the cross of Christ.

to all who enter the church thoughtlessly. Bishop's Cleeve church is dedicated to St Michael and All Angels, and parishioners passing through the doorway may have been reminded of the words of St John: 'And I saw an angel coming down out of heaven … he seized the dragon, that ancient serpent, who is the devil.' At least, it may have been in the mind of the highly skilled stonemason who carved it.

In several Cotswold churches the door mouldings are overlapped by carved beaks, which protrude from heads of various shapes. Some beakheads are identical copies of their neighbours, while others are richly varied, with heads of animals, birds, monsters and humans. At Quenington the animals include ox, horse and badger, and at both Elkstone and Siddington, hands coming from one beakhead clasp shut the beaks of its neighbours. There is humour in this stone sculpture, and the same craftsmen may have been involved. Good examples of beakheads may also be seen in the doorways of the churches at South Cerney and Windrush, and around a cottage doorway at Sherborne.

Frequently found between the lintel and the arch over a church doorway is a tympanum, and in some Norman churches this also is decorated. The pattern may be simple, with various geometrical designs, but occasionally the tympana have sculptured themes, such as the tree of life, the majesty of Christ, and the conflict between good and evil in the defeat of the dragon. Fine examples of sculptured tympana are in the churches at Dymock, Eastleach Turville, Elkstone, Quenington, Ruardean and Siddington. At Elkstone, the tympanum shows Christ seated in majesty, the hand of God above him, with fingers of blessing pointing downwards. On the sides are the carved emblems of the evangelists – an angel for St Matthew, a lion for St Mark, an ox for St Luke and an eagle for St John, and there is also an Agnus Dei on the left. Grotesque heads are at the top of the doorway and on the shafts at the sides. Also at Elkstone, on both the north and south exteriors of the nave, are corbels, which have been delightfully carved with mythical and living creatures. Within the church are other finely worked Norman features, including the two chevron arches that originally supported the tower, the western one with dragon headstops. The ribs of the chancel vault meet in a boss of four fanged grotesque heads buckled together. All these features not only expressed the skill of the stonemasons, they were clearly meant for the enjoyment of those who saw them. Today, this lovingly cared for church still expresses joy in its stonework. No wonder the angels on the fifteenth-century west tower are playing musical instruments! We may also notice that, as in other churches, the carvings are visible to people entering the church whereas plain stonework faces those leaving.

The modest church at Quenington, close to the court and the former watermill on the River Coln, has two impressive sculptured doorways. They are both weathered, but there is sufficient detail in the carving to arouse admiration. The tympanum of the north doorway shows an arch within which Christ slays Satan with the cross (fig. 14). Three souls rise in freedom from the serpent's head, and the light from the face in

the sun shines on the scene. The whole doorway is decorated with a variety of designs, including carved flowers and two green men on the shafts. This is the only doorway Atkyns mentions in the whole of his parish surveys. In fact, it is the only decorative feature for which he gives a detailed description. The description is copied from Parsons' notes but Atkyns may have visited Quenington to see it. The larger sculpture on the tympanum of the south doorway is of Christ crowning his mother, accompanied by two angels and the emblems of the evangelists. There is also a representation of a large temple at the side of this sculpture, similar to that on the famous Norman font at nearby Southrop. There may be links between the architecture of churches in manors belonging to the same lord of manor. The estate of the de Lacys included manors at Quenington, Eastleach Turville, Windrush and Siddington, and the churches in each of these villages are noted for their important Norman sculptures.

At South Cerney, the elaborately worked doorway is also rather weathered as the protective porch was only built in the nineteenth century. Very few church porches were built before the thirteenth century and Norman doorways have often been exposed to weathering for a long time. The carving at South Cerney continues down the shafts of the door frame. Above the door are sculptures of Christ in glory and the harrowing of hell, themes we have seen in the doorways at Quenington. And here again is that mixture of what was later described as sacred and secular, of Christian and popular culture. The grotesques are aberrations of natural orders and the green men, enveloped in foliage, symbolise man in the wild. As the geographer N.J.G. Pounds writes, 'the church may have been the peasant's Bible; it was no less the peasant's tabloid press'. These sculptures have survived unscathed from sixteenth and seventeenth-century iconoclasm.

Although the interior of the nave of Gloucester Cathedral is dominated by Norman stonework, most of the exterior of the building is of later construction. So for the largest, most solidly constructed Norman church in the county we must go to Tewkesbury Abbey. The nave and massive tower of the abbey were built in the first half of the twelfth century. The tower, which overshadows the town, is visible from miles away in the Severn valley and from the surrounding hills. On a clear day its size can be easily appreciated when viewed from Cleeve Hill or Leckhampton Hill, far away on the Cotswold edge. The abbey's tower is 46ft square and about 140ft high to the battlements. The lower stage is plain, with the distinct markings on all four sides of earlier roof ridges, but the upper part is decorated with three stages of arcades, the middle stage with beautifully moulded intersecting arches, the others with a chevron design. The great west window is framed by a moulding of six rolls, reaching 65ft high in the centre, and at the base, on the left, are the remains of a seventh arch, which was removed when the Norman west window was replaced. Most of the stone used in building the abbey was imported, some from Caen in Normandy, and by this west window a doorway well illustrates the contrast between the high quality of the

Fig. 15 Tewkesbury Abbey from the south, overlooking the recreation ground, which was once an important medieval vineyard. The great length of the nave can best be appreciated from this viewpoint.

abbey stone and the much-weathered local Lias limestone in the adjoining wall. It is a magnificent building and best viewed from the south across the recreation field, which was once the terraced vineyard of the Earls of Gloucester. From this viewpoint its exceptional length may be appreciated, and the keep-like tower is no longer the single dominant feature (fig. 15).

Inside, as with Gloucester Cathedral, is an impressive array of colossal pillars. Many Norman churches have round pillars along their arcades, but these are powerful symbols of strength and stability, measuring nearly 21ft in circumference in both churches. Atkyns' comment on the pillars at Gloucester is that they are 'round and plain, too large and bulky'. The pillars of both abbey churches bear similar masons' marks, scratched into the stone work. Tewkesbury Abbey and Gloucester Cathedral were churches of the Benedictine order of monasteries, built through the initiative of

two influential Normans, Robert Fitzhamon and Abbot Serlo respectively. Another former monastic church, this time built originally for an Augustinian priory, is St Swithin's at Leonard Stanley (fig. 16). Like Tewkesbury Abbey, it has a solidly square and dominant Norman tower, but the church is especially noted architecturally for the two carved capitals in the chancel. One portrays Mary washing Christ's feet, the other a nativity scene. There are other interesting sculptures in and above the north doorway, and a displaced tympanum in the chancel shows Adam and Eve, represented by animal forms, which also dates from the twelfth century. The high and wide chancel arch has large dragon head stops, similar to those of the doorway. Farm buildings to the south and west of the church incorporate architectural features from the earlier priory, here with some Saxon stonework.

The most significant architectural development of Norman churches was probably the rounded arch. These arches were larger than those of Saxon buildings, and are seen over windows and doors, in the vaults and entrances of chancels, and beneath the central towers. Ideally their height was half the space between the pillars of an arcade or the jambs of a doorway, and no doubt many collapsed with settlement. Arches gave the masons new opportunities for carved decoration, especially where the local stone was

Fig. 16 St Swithin's Church, Leonard Stanley, a church noted for its strong tower and Norman sculptures.

suitable for intricate work. Oolitic limestone was particularly suited to these sculptures, being soft to carve when freshly quarried and hardening later, but the sandstones of the west of the county were also favoured.

By the mid-thirteenth century, the responsibility for maintaining the fabric of the nave had passed to the population of the parish. It was then a multipurpose part of the building and was used for meetings and games, sometimes associated with gossip and uproar, as well as for worship, and in the larger churches for processions. Mentioned at the beginning of the chapter was the spatial link between Norman churches and manor houses. We may also notice the architectural parallels between the two buildings, with the nave and chancel of the church corresponding to the hall and solar of the manor house, and also their similar axial layouts and orientations. At Southrop, both church and adjacent manor house retain Norman features.

Churches were not the only Norman structures to survive to the eighteenth century, and which continue to contribute to the present-day landscape. Many of William's supporters were given permission to build castles, in order to better control the lands they had been granted. The earliest and most easily constructed castles were of the motte-and-bailey type, and these were probably the first Norman structures to appear in the landscape. Within a few weeks a motte or conical-shaped mound of earth and stone could be constructed, with material coming mainly from the ditch dug to surround it. Upon the motte a timber tower was quickly erected. Timber towers did not last long, however, and unless the castle tower was rebuilt in stone only the motte has remained. At a later date, an area beside the motte was enclosed, becoming the castle bailey or courtyard.

From the churchyard at Brimpsfield, there is a fine eastward view down over the source area of the River Frome. A low oval mound, planted with trees, is the earthen motte built for the Giffards. Osbern Giffard held the manor of Brimpsfield at the time of the Domesday survey. But much more impressive than this early motte are the massive earthworks of the Giffards' later castle. These are beside the churchyard, well sited to guard the surrounding countryside, including all passage along Ermin Street. Recent clearance of scrub has enabled a greater awareness of its imposing size and of the deep ditch around its bailey. Sir John Giffard rebelled against the Crown in 1321 and was hanged. Orders were then given to demolish his castle and Atkyns refers both to the castle and to Edward II's orders for its demolition. Some of its stonework may still be seen decorating the west wall of Brimpsfield House, including a piece of chevron carving, and other sculptured pieces in the small barn near the church may have come from the castle. Brimpsfield was an important place under the Giffards, and houses once stood where the field beside the church path is so uneven. The Norman church is dedicated to St Michael, as is common with hilltop churches, and within the chancel is a huge stone coffin lid with a sword in relief, no doubt a Giffard monument.

Lower down the Frome valley, at Miserden, is another equally large motte and bailey, now partly obscured after being planted with trees. The site of this castle allowed it to guard the valley, and is best appreciated from the hillside to the south, overlooking the lake. Kip engraved Misarden Park, and his drawing includes the fishing and boating lake and the steep-sided valley of the River Frome, but there are no signs of the motte among the trees of the walled park, although Atkyns says there were ruins here at the time. He records that it was the castle of the Musards, another Norman family, and correctly informs us that the village was originally known as Musarden, after the family name. There are other Norman mottes, widely scattered across the county, at Dymock, English Bicknor, Haresfield, Lasborough, Littledean, Lydney Park, Newington Bagpath, Taynton, Tewkesbury and Upper Slaughter, as well as documentary evidence for one at Hailes. The morphologies of the villages at English Bicknor and Upper Slaughter are still affected by these early castles, and roads curve round the castle sites. The sloping

Fig. 17 A Norman castle motte at Newington Bagpath. It is on the side of an isolated valley, next to a redundant Norman church.

fields near Upper Slaughter show apparent terracing. This is related to differences in the underlying geological strata, but the terracing in the centre of the circular road, at the heart of the village, is man-made. A grass-covered motte rises above a bailey, which may be best seen from the north side, across the small River Eye. This was a castle of the de Lacy family, another element in our landscape left by this influential Norman family. The site of the castle at Taynton lies in damp meadows, amid a complex assembly of earthworks, moats and ponds. Possibly the most romantic former castle site is at Newington Bagpath where, on the side of a remote valley, the motte with a deep surrounding ditch stands next to a redundant and boarded-up Norman church (fig. 17).

At Berkeley, stonework in the shell keep of the castle, built over the original motte, and in the east wall of the inner bailey, is also Norman, and the doorway to the keep, at the top of a flight of steps, has a much-weathered chevron arch. Beverstone Castle also existed in Norman times but was entirely rebuilt in the early thirteenth century. The important and strategically placed castle at Gloucester, guarding both the Severn crossing and the river quay, has long gone, having been replaced today by H.M. Prison. The motte of the earlier castle is shown as a rounded mound, the Barbican, in the Kip engraving of the city, with the later castle nearby (see fig. 59 on p. 157). At St Briavels, the castle dates from 1130, when there was a simple motte, and the first stone keep was built later in the century. The significance of this castle was that it became the seat of the constable-warden of the Forest of Dean, and was often used as a base from which royalty hunted in the Forest. A hunting horn carved in the stonework of a chimney recalls this former use.

The name Dean is recorded in *Domesday Book*, and under William the area became a royal forest. Although the previous land uses of forestry and farming continued more or less unchanged, the new legislation gave protection to deer within its perambulation. All the freely roaming deer within the Forest belonged to the king, who alone could give permission for them being taken for venison. The Forest of Dean perambulation was a legal boundary imposed by the king. It had no visible signs, no boundary markings, no earthworks or walls, which were essential features of the smaller Norman deer parks. The Forest then stretched from the River Severn to the River Wye and as far north as Newent, and Atkyns says that in Norman times it was the third largest forest in England. But the actual wooded area was more restricted than the legal area.

Oak was the predominant tree species growing here, and in later years various kings made gifts of oak timber from the Forest of Dean for monastic buildings. The Dominican friary in Gloucester received timbers as a gift from Henry III, and these timbers may still be seen in the roof of the Blackfriars. The same king gave 100 oaks for the construction of Hailes Abbey, and other abbeys, further afield, also received oaks from the Forest. But oak was not the only type of tree growing here; beech was

common, and at Welshbury chestnuts and small-leaved lime trees were abundant. Near the Speech House, and associated with ancient oaks in other parts of the Forest, are old gnarled holly trees. Holly is the only native evergreen tree that is edible to deer, and its value as winter feed for these animals may have contributed to its spread. Kings did not interfere with the local economy, other than to require accommodation in the area when hunting deer or wild boar. In the Forest of Dean, Flaxley Abbey, like St Briavels Castle, was used by royalty as a base for hunting. There were other Norman forests within the area of the old county. Wetmoor Wood near Wickwar, once part of Horwood Forest, is still divided into compartments that are separated by earthen banks and trenches, and Kingswood Forest once extended north into the area of the present county.

Rabbits, pheasants and fallow deer were all introduced or re-introduced into Britain by the Normans, the latter in about the year 1100. Fallow deer could be confined to parks, without causing the distress to the animals that emparking entails for the indigenous species of red and roe deer. In these parks they could be farmed for a meat supply, as well as hunted on a small scale. The more important Norman landowners set out their deer parks, usually of several hundred acres, on the edges of their manors, and frequently on unimproved land. The parks were enclosed by earthen banks, at least 4 or 5ft high but often much higher, which were surmounted by a paling fence of cleft oak stakes or a stone wall. Inside the bank was a ditch and the whole boundary structure was designed to prevent deer from escaping from the park but allowing them to enter. Old deer parks may be distinguished from medieval woods by these boundary earthworks, as the latter had a ditch outside the smaller bank. The circular or elliptical plan of the park reduced expenditure on the costly enclosure boundary. Within the parks were wooded areas and grassy glades, the latter known as launds, so providing the deer with both shelter and grazing. Young trees in the wooded areas were protected from browsing deer by being fenced off, and mature trees were pollarded. Old pollarded oaks often indicate former deer parks (see fig. 21 on p. 65). Earlier features, such as ancient earthworks, sunken tracks and stone quarries, remained within the newly created parks, while roads were diverted around their boundaries. Water holes were dug along the launds, and sometimes pillow mounds were made for rabbits. Pillow mounds are low, oval-shaped, man-made earthen mounds (fig. 18), where rabbits were allowed to burrow and where they could be caught by ferreting – an occupation popular with the ladies of the manor. Rabbits were valued both for their meat and for their fur. At a later date lodges were built for the park keepers, and these lodges were often replaced by country houses in the seventeenth century.

It has been estimated that there were about sixty deer parks in Norman Gloucestershire, one in every four or five manors. Circular walled enclosures, the cartographic symbols of deer parks, are marked on Saxton's map of the county in

Fig. 18 A pillow mound, a man-made mound to accommodate burrowing rabbits, in Misarden Park.

1577, and these show twenty-five in the same area. Field evidence for the cultivation of arable land up to the twelfth-century park boundary is occasionally seen in the juxtaposition of ridge and furrow and the earthen banks of the park. Curved hedgerows on substantial banks with adjacent ditches, smoothly curved parish boundary lines, as well as field and farm names including 'park' and 'lodge' and old pollarded oaks, are other landscape indicators of former parks. Old park boundaries may still be seen in the fields north-west of Climperwell Farm at Brimpsfield, on the higher ground south-west of Sherborne House, north of Minchinhampton on the roadside edge of the common, and on the north-west border of Oakley Wood at Cirencester. Whitcliffe Park near Berkeley and the former parks at Forthampton and Southam have good specimens of old parkland trees and give a fair impression of the appearance of the Norman parks, although some of their trees were planted at a much later date. There is a link between the distribution pattern of old deer parks and that of motte and bailey castles, as is seen

at Brimpsfield and Miserden, and also with the distribution of medieval moats. Parks, castles and moats were status symbols, as well as functional elements in the landscape, and they often went together.

Atkyns refers to parks in thirty parishes. He gives no indication of their age, and probably only a few were of Norman origin. Some were evidently ornamental in the eighteenth century and are described as 'pleasant', 'delightful', or 'well wooded'. Many, however, were deer parks and for three, Berkeley, Gatcombe near Avening and Sudeley, he mentions their stock of deer. In the case of Berkeley, where the entry is complex, twelve separate parks are listed, but this refers to the hundred of Berkeley, not just to the parish. In addition, the Kip engravings of country seats often include deer in the estate grounds, but these are probably symbolic and may have been designed to impress the viewer with the status of the landowner rather than to illustrate actual scenes.

With their churches and castles, forests and deer parks, the Norman landowners made significant changes to the appearance of the countryside, and much of this scenic legacy remains today. But in observing the forms and fabric of Norman churches, appreciating the sense of achievement of the builders and delighting in the skill of the stone sculptors, perhaps pondering on the meaning of the decorative features, it is easy for the visitor to forget that the building is only the shell in which, for the succeeding centuries, parishioners have gathered for worship. Similarly, we easily miss the fact that the low grassy mound of a motte was once the symbol of terror and oppression for some and of security and status for others. The earthworks of the boundary ditch and bank of a deer park framed the thrill of the chase and the satisfying taste of venison for its privileged owners, but kept out the peasants who had at one time grazed their animals here. Landscape changes often involve some form of conflict, with the wealthy and powerful achieving their aims at the expense of the poor and weak, and Norman landscape changes were no different in this respect.

5

Monastic Gloucestershire

In his survey of the county, Sir Robert Atkyns makes frequent references to abbeys, priories and a whole variety of other monastic possessions. Indeed, a parish without a past monastic connection is uncommon, and Atkyns' book is the most accessible source of information on these possessions. Whether it is for the ownership of a manor or of a particular piece of land, the rights to tithes or the patronage of a church, most parishes are recorded as having had monastic links. Some entries are quite complex, as is the case with Dumbleton, where the manor was held by St Mary's, Abingdon; tithes were received by St Mary's, Evesham, and St Peter's, Gloucester, owned land there. In this chapter we will consider the way in which monasticism made an increasing impact on the landscape in medieval times, leading up to the legacy that Atkyns documents for the early eighteenth century. Comments on the traces of the monastic landscape that may be seen today will also be made.

Monasticism, when it became established in England, was generally based on the sixth-century Rule of St Benedict. Often, the monastery was enclosed, self-contained and concerned almost entirely with the spiritual life, work and welfare of its own community, without the need for much contact with the surrounding population. Within the monastery, the monk's day was divided into the three activities of liturgical prayer (Opus Dei), private meditative reading and prayer (Lectio Divina), and manual or craft work (Opus Manuum). Later, as the different monastic orders of Augustinian, Benedictine and Cistercian developed, the emphases of the monasteries varied. In some, much attention was directed to the ritual of the daily offices; in others, to private meditation. Some abbeys had a strong involvement in the local economy following the practice of the Saxon minsters, and in the case of the mitred and peeral abbots of Gloucester, Cirencester and Winchcombe in the great affairs of state, while others were more introspective and by choice separated from the rest of society. In some abbeys heavy manual labour was undertaken by the monks, in others the delegation of such

work was to lay brothers. Some abbeys had great simplicity of lifestyle, others a degree of extravagance – the meals at some feast days included sixteen courses!

By 1170, after a century of Norman rule, it has been estimated that about a quarter of the wealth of the country and a quarter of parish churches were in the hands of the monasteries. With seven abbeys and eleven priories, Gloucestershire was richly endowed with monastic communities, sufficient to support an old saying, 'As sure as God's in Gloucestershire' – though Atkyns thought the saying was derived from the fact that both nouns begin with the same letter! Gloucestershire's religious houses also held land outside the county, and some monasteries in France and other parts of England and Wales had possessions within it. There were also orders of no fixed base, such as the Knights Templar and Knights Hospitaller, which possessed manors and lands within the county.

Monasticism was vibrant in Normandy at the time of the Conquest, and William was keen to encourage its development in his new kingdom. But he was naturally concerned about the loyalty of the existing abbots. The first established monasteries had developed from Saxon minsters, and as these were frequently linked to the Saxon royal houses, the abbots' loyalties were to these rather than to the invading king. The abbeys also had the control of large areas of land and great wealth. So for strategic reasons William began to introduce Norman abbots of outstanding ability to take leadership roles.

Under Serlo, the first Norman abbot to be appointed to St Peter's, Gloucester, who came from Mont St Michel in Normandy, the abbey church was rebuilt and consecrated in 1100. The abbey at the time of the Domesday survey held twelve manors in the county to provide for its material needs. Additional estates were steadily acquired, and by the 1260s it possessed about thirty manors within the county, from Saintbury in the north to Boxwell in the south, and from Oddington in the east to Churcham in the west, as well as several manors outside the county. This widespread distribution of manors gave the abbey access to the varied resources it needed, plus the opportunity to raise income from the sale of surplus produce. Its sheep grazing was mainly on the Cotswolds, its cattle grazing in the Vale, fishing rights for salmon and lamprey were on the River Severn, supplies of timber and fuel came from manors along the Cotswold edge (and no doubt from around the Forest of Dean), and local arable land was used for cereal growing, from which the grain required by the abbey was brought into the huge monastic barns at Frocester and Hartpury.

The wealth accumulated from the marketing of surplus produce, the rent from land let to tenants and entry fines when tenancy changed, and substantial gifts, enabled the rebuilding of the south aisle of the abbey church in the early fourteenth century. This was in a style different from Serlo's original plain design, with its dark interior. It was given the exuberant decoration of thousands of ballflowers around the windows, on the

buttresses and on the vaulted roof, a decoration also seen in a number of contemporary local churches. Then, with the gifts of pilgrims visiting the tomb of Edward II and donations from the Crown, the south transept and the choir were rebuilt in the new Perpendicular style between 1331 and 1350. In c.1350 came the great east window, possibly the largest in medieval Europe, with its canopied figures in red, white, blue and yellow glass, leading the eye upwards and designed to link earth and heaven in worship. Work on the fan-vaulted cloisters began a little later, but by this time the effects of the Black Death had slowed building progress. The majestic tower of the abbey church dates from the mid-fifteenth century. In the early eighteenth century, Gloucester Cathedral retained the most complete architectural setting for medieval monastic life in the county, and it still does (see plate 6).

There are traces of cloisters in the exterior stonework of the south wall of the nave of Tewkesbury Abbey, which was founded in 1109, the first monks coming from Cranborne in Dorset. Nothing remains standing of the other great Benedictine abbey at Winchcombe, and only the gatehouse survives of the Augustinian abbey at Cirencester, dedicated in 1131. The early sixteenth-century gatehouse is all that is left of Kingswood Abbey (see plate 7), a Cistercian abbey which was founded in 1139, with monks coming from Tintern. There are also a few remains within domestic property of the former Cistercian abbey at Flaxley, dated 1151.

The small Norman church at Hailes predates the nearby abbey and was associated with an earlier settlement and castle. Its chancel is almost as large as the nave, and was probably extended in the thirteenth century after the church had become linked to the abbey. Atkyns' brief reference is to a chapel of ease linked to Didbrook. Building work on the great Cistercian abbey began in 1246, and the abbey church was dedicated in 1251. It was richly endowed by Richard, brother of Henry III, as a thank offering for being saved from shipwreck off the Scilly Isles in 1242. The abbey's plan, which is now marked out on the ground by the remaining wall footings and other stonework, was typical of Cistercian monasteries. The cloisters were on the south side of the magnificent church, with the chapter house on their east and refectory on the south.

Cistercians required remote sites. A Gloucestershire contemporary, Walter Map, wrote: 'they choose a place fit for habitation, fertile, good for fruit, suitable for grain, buried in woods, abounding in springs, a horn of plenty, a place apart from the haunts of men'. These were their requirements, partly because Cistercian monasteries were to be economically self-sufficient and partly because of their desire for solitude in the countryside. A quotation from St Bernard, the most influential of Cistercian leaders, explains the latter interest. An old translation of one of his writings reads: 'Thou wilt find among the woods something that thou did'st never find in books. Stones and trees will teach thee a lesson thou did'st never hear from masters in the school.' In a wooded hollow of the Cotswold edge, opening on to the fertile Vale of Evesham, beneath

Fig. 19 The site of Hailes Abbey is at the foot of the Cotswold escarpment in the centre of the photograph. Wooded, fruitful and fertile lands, together with springs and seclusion, were Cistercian requirements.

springs from which water still flows through the abbey grounds, Hailes was an ideal site (fig. 19). Even today, the hillside above the abbey is used for apple production on a fruit farm and sheep graze in the fields at the top of the escarpment. Much of the abbey's later wealth came from sheep farming, but this could be undertaken from more distant estates managed from granges, such as at Longborough, 10 miles and more away. The only reservations about its situation were the existence of the long-established and important Benedictine abbey at Winchcombe, just beyond a nearby low hill, and the resident population at Hailes. The latter problem was overcome, as with some other Cistercian monasteries, by moving the local people, in this case to form the settlement at Didbrook.

Richard's son, Edmund, obtained a portion of the 'authenticated' blood of Christ on one of his travels on the continent and brought it back to Hailes, where it was displayed in a shrine specially erected for it in the abbey church. The east end of the church was rebuilt in the form of an apse with five chapels, rather like that of Tewkesbury Abbey, and the shrine was located at the centre. The relic brought fame to Hailes and pilgrims came from all over the country and from overseas to view it. Access roads were thronged, and the bridleway down to Hailes from Farmcote has what is probably the best surface of all the scarp-face tracks, with its carefully laid stone sets. Characteristically for the time, Atkyns discusses the sleight of hand of the monks at Hailes in extracting payment from pilgrims to the shrine.

St Oswald's Priory in Gloucester has already been mentioned in chapter 2, but there was another priory at Gloucester, known as Llanthony Secunda. This was established in 1136 when monks at the remote site of Llanthony in the Black Mountains of South Wales were attacked by their Welsh neighbours and decided to move here for safety. Llanthony eventually became the richest of all the Augustinian priories, with extensive manor estates, including twelve widely scattered manors in the county, and much property in Gloucester itself. Atkyns says that very great ruins could be seen in his day and that it was the burial place of the Earls of Hereford. Unfortunately, in the 1790s the Gloucester-Sharpness canal was cut through the ruins of its church so only a few walls of various priory buildings are still standing. On the north side are the remains of a large tithe barn and, on the west, a much-weathered gatehouse with benefactors' shields and a sixteenth-century brick precinct wall. The latter displays a geometrical pattern of darker bricks, which includes a wayside cross, marking the site of an earlier preaching cross. This is best seen from the opposite side of the road when the bricks are wet following rain.

The other priories in the county were at Brimpsfield, Deerhurst, Hazelton (a priory which was later moved to Tetbury because of lack of water), Horsley, Leonard Stanley, Newent and Poulton. Some of these have left delicately carved architectural features, such as windows and ornamental stonework, which have been incorporated in the farm buildings later erected on their sites. There is also documentary evidence of priories at Lechlade and Nympsfield. In addition to these, Atkyns refers to the ruins of monastic cells, which were still to be seen in manors formerly held by abbeys, but located at some distance from the parent house.

Not all religious were monks and nuns. Franciscan friars came to Gloucester in 1231. Their vow of poverty meant that they did not own property, and here their premises were held by the urban community on land granted by Thomas, Lord Berkeley. With varying degrees of success, they followed Francis' rule, which was a way of life imitating Christ in humble simplicity rather than through the rigid codes of behaviour usually associated with the monastic orders. Francis had a great sensitivity to beauty in all of

creation and a sympathy for the poor and needy. He was also aware of the shortcomings of the Church in his day, and his distinctive emphasis on absolute poverty, on rejecting ecclesiastical privilege and on renunciation of human learning addressed these faults. The simple life was to be followed everywhere and there was no desire for impressive buildings or secluded locations. The only requirement was for a small house among the people and this was often found in the poorer quarters of the towns.

The first Franciscans arrived in England in 1224 and immediately focused on the influential towns – the capital, the university towns and those that later became the county towns. The contribution Franciscans made to the welfare of these towns gained them support from the local leaders and from royalty. In Gloucester, they provided the city with its first piped water supply from Robinswood Hill. Later, the influential friary at Oxford gave an intellectual emphasis to the whole order, an emphasis that Francis had rejected, and Henry III gave to the Gloucester house the right to hold a school of theology in one of the towers along the town wall, as well as providing it with five oak timbers from the Forest of Dean. Henry III, as a boy of nine, had been crowned king in St Peter's Abbey in 1216 and had a number of connections with Gloucester. The original, simply constructed Franciscan church was rebuilt in 1518 by Maurice, Lord Berkeley, and its ruined nave and north aisle, with columns and window tracery, remain today as the Greyfriars (see plate 8). Most of the other buildings, which were secularised after the Dissolution, were damaged in the siege of Gloucester and subsequently removed. At one time the Franciscans occupied the whole south-east corner of the walled city, and their garden and orchard were particularly important to them as, unlike the monasteries, the friaries had no farm estates.

The house of the Blackfriars in Gloucester was founded in 1239 by Sir Stephen de Harnhill on the site of the outer bailey of the Norman castle, and here are the finest Dominican friary remains in the country. The friary was built around a square courtyard, with the church on the north side, chapter house and dormitory on the east, library on the south and refectory on the west. A raised stone slab in the centre of the church marks the position of the pulpit. Sixty-one oak roof timbers from the Forest of Dean, each 50ft long and 2ft in diameter, were given by Henry III, and the roof trusses with collar beams and scissor braces, using these timbers, are still visible. The library had twenty reading carrels, each lit by a small square window, and it is thought to have been one of the first libraries in England. Franciscans in their early days avoided scholarship, but Dominicans, from their beginnings, valued study. This was given priority in their daily routine. No manual work was undertaken and the liturgy was shortened in order to allow them more time for study. They were described as 'champions of truth and lights of the world' and aimed to master the theological learning of the age and then to teach it to the people. They, too, were located in strategic towns, and thirty towns in England had both Franciscan and Dominican

houses. Dominicans were also involved in diplomacy for most monarchs, especially for Edward II – a king who was finally linked with Gloucester through his burial in the cathedral. There was also a Carmelite friary in Gloucester, founded in 1268, outside the north-east corner of the city walls, where the old cattle market was formerly held, but there are no visible remains today.

At the Dissolution, abbey and priory buildings frequently became the sources of stone to be plundered and used in building late sixteenth- and seventeenth-century houses. Some materials were used in houses built on the sites of the monasteries; others were used nearby. As we have seen, stone from Winchcombe Abbey is to be found in Sudeley Castle and in at least two houses in the town; stone from Kingswood Abbey went to Newark Park, where carved pieces are on display, and in Cirencester the very large blocks of stone forming the plinths of 33 Gloucester Street are thought to have come from the abbey just along the road.

Atkyns refers to all these monastery, priory and friary buildings, and the monastic parish churches we will consider in chapter 7, but the impact of monasticism on the landscape was much greater than through its specifically religious buildings. Where the abbeys and priories possessed manors, all the produce from the demesne was theirs. In other manors, where they owned the parish church they received the church tithes. These tithes were classified into lesser, mixed and greater. Lesser tithes came from gardens, mixed tithes from animal produce and human labour, and the greater tithes came from the arable land and consisted of one sheaf of corn in every ten harvested. Where arable farming predominated, huge numbers of sheaves of wheat, barley, rye, and to a lesser extent oats, were collected and brought to the monastic barns. Here they were stored until they were needed for threshing for bread making, brewing or, on occasion, for animal feed. Some of these huge barns, divided into many bays, and much larger than the nearby parish churches, have survived to the present day. At Frocester and Hartpury are barns that belonged to St Peter's Abbey, Gloucester, the former built in c.1300 and the latter in 1490. The east side of the Frocester barn has two gabled porches and the west side shows the buttresses of thirteen bays. The barn at Hartpury, which now has a patterned tiled roof, is of eleven bays. At Stanway is the seven-bay barn of Tewkesbury Abbey, built in 1370, with its unusual coxcomb finials, hinting at the dedication of the adjacent church to St Peter. The converted barn at Calcot Manor Hotel was originally built in 1300 to serve a grange of Kingswood Abbey, and the barn at Ashleworth was constructed in 1490 for St Augustine's Abbey, Bristol. Grain stored at Ashleworth could be easily transported to Bristol by boat along the River Severn. Other monastic tithe barns have survived at Brockworth (recently restored after fire damage), Bishop's Cleeve, Postlip, Siddington, Southam and Upleadon, and so have a number of rectorial tithe barns, such as the one at Lower Dowdeswell.

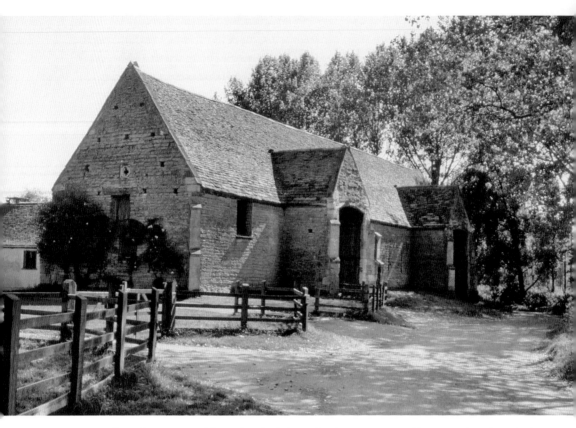

Fig. 20 The Tithe Barn at Ashleworth. This belonged to St Augustine's Abbey, Bristol, and was built in 1490. The nearby quay gave easy river access to Bristol.

Most barns have one or more opposite sets of doors through which the harvest wagons could enter and exit, the size of the door indicating the direction of wagon movement, with larger doorways for the loaded wagons and smaller for the empty. A draught of air through the open barn doors assisted in dispersing the chaff, when the corn was being winnowed on the stone threshing floor between the doors. Good ventilation was necessary to prevent the sheaves from going mouldy and from generating dangerous heat levels from decomposing straw. Slit vents or putlog-holes allowed the passage of air. The details of the massive oak roof frames may be easily inspected in these barns, and the barn at Ashleworth, which now belongs to the National Trust, is open to the public (fig. 20). Strictly speaking, the term tithe barn should only apply to barns where the tithe, or one-tenth of the yield, was stored. Those barns that stored the whole of a manor's demesne yield needed to have a much greater capacity, especially if they stored the grain from more than one manor. These very large barns were generally near to

their abbeys and stored grain for monastic consumption, but when the abbey possessed arable land at a distance the grain was usually sold.

For a Benedictine monk the basic food and drink allocation was a loaf of bread and a gallon of ale a day. A bushel of wheat produced sufficient flour for twenty loaves of bread and a bushel of barley produced malt for twenty gallons of ale. With low grain yields of about six bushels of wheat and seven bushels of barley per acre, which were typical in medieval times, it follows that nearly 6 acres of arable land were needed to meet the food and drink requirements of each monk. Where the two-field system of agriculture was followed on the Cotswolds, with each field producing grain in alternate years, a monk required effectively more than 11 acres of land to provide his food and drink. Even with the three-field system of the Vale the requirement was still more than 8 acres, though variations in soil quality and weather conditions inevitably affected yields. This land had to be fairly near to the abbey to reduce grain transport costs. So at Frocester, a manor belonging to St Peter's, Gloucester, four of the eleven plough teams recorded in *Domesday Book* were in the demesne, and in the same abbey's nearby manors of Barton, Barnwood and Tuffley, nine plough teams were for the demesne's arable land. In manors held by the abbey at some distance away, the ratio of plough teams in demesne to those of the manor's tenant farmers was much lower.

Other monastic buildings associated with manorial produce include dovecotes, as at Quenington and Frocester, and a wool store for Osney Abbey by the River Coln at Bibury. The latter was converted to the cottages of Arlington Row. One site requirement of Benedictine monasteries was for a mill within the enclosure, and many more were to be found on distant manors. These mills were partly for the abbey's own use, but were also an important source of income. Tenant farmers had to take their corn to the lord of the manor's mill, and a toll known as 'multure' was charged for its use. No monastic mills have survived to the present day, but the mill sites continued to be used long after the Dissolution and the name 'Abbey Mill' is still applied at Tewkesbury and Kingswood. Atkyns records mills belonging to St Peter's, Gloucester, at Eastington, Edgeworth, Kempsford, Standish and Temple Guiting. Some abbeys also had fulling mills for treating cloth. For Tewkesbury Abbey this was at Stanway, for Winchcombe Abbey at Sherborne, for Evesham Abbey at Bourton-on-the-Water and for Llanthony Priory at Aylburton. The fulling mill at Barton, which belonged to the Knights Templar, was the earliest recorded example in the country. These were all water-powered mills. Monasteries are also known to have possessed windmills at Gotherington, Hazleton, Mickleton and Througham, erected after this new technology had been introduced to the country.

Where abbeys were established in existing towns, they eventually acquired control or partial control of the markets, and thereby further increased their income. This

happened at Cirencester, Tewkesbury and Winchcombe. Abbots also sought grants of market charters from the Crown for their manors situated at a distance from the abbey, particularly where diverse agriculture and sites at road junctions gave good trade potential. Along the Fosse Way, Westminster Abbey established a market at Moreton-in-Marsh in 1226, Evesham Abbey had a market at Stow-on-the-Wold in 1107, and St Peter's Abbey, Gloucester, had a market at Northleach in 1219. The manor at Northleach (Lecce) was held jointly by St Peter's and the Archbishop of Canterbury at the time of *Domesday Book*, and in 1219 the abbot paid Henry III the sum of 100 shillings for the right to set up a market there. The chosen site was to the north-east of the earlier church and settlement, along the main Gloucester to London road, rather than on the Fosse Way. The first burgage plots, with frontages of about 30ft, were laid out on the south and north-east sides of a triangular market place and their pattern can still be seen from breaks in the roof line profile along the north side of the High Street. The wider plots to the east of the Market Place, along the London road, came later. In 1266/7 there were eighty burgages, and for each a rent of one shilling was paid. By the fourteenth century, Northleach had become a major marketing centre for wool and cloth, and was trading with Italian and Flemish wool merchants. It is still possible to recognise the boundary of the 50-acre market borough from a detailed map of Northleach, with its back lane, standard-size plots of land and even a house named Burgage End. Similar features may be seen in the layout of Stow-on-the-Wold, and the general development of markets will be considered further in chapter 8.

Abbots and priors also possessed country houses away from their abbey and priory precincts. Forthampton Court was the country residence of the Abbots of Tewkesbury; Frocester Court and Standish Court belonged to the Abbot of Gloucester. The fourteenth-century gatehouse of the latter still remains (see plate 10). Ashleworth Court belonged to the Abbot of St Augustine's, Bristol, and there were similar houses at Hempstead, Over and Stanway.

Monasticism affected the landscape by its impact on particular types of land use. In about 1120, William of Malmesbury described in glowing terms the famous view towards Gloucester from Barrow Wake. He wrote: 'from that city the whole district is called the vale of Gloucester. Everywhere the land is rich in crops and profitable in fruit. In some places the soil alone, in others careful cultivation achieves this, so that the idlest are incited to work upon the land where the reward is a hundredfold. The high roads are lined with fruit trees, planted by nature, not by man. The earth of its own accord breaks into fruit – and that the best in the land for appearance and flavour. The vines are more numerous, more fruitful and sweeter than anywhere else in England, and the wines they produce are little inferior to those of France. It is a land of populous towns, thickset villages and great abbeys.'

Fig. 21 Ancient oak trees in the former deer park at Forthampton. The estate belonged to the Abbots of Tewkesbury.

It is thought that the Romans introduced the vine into England, and the country may have become self-sufficient in wine production by c.300. In *Domesday Book* a vineyard of two arpents (acres) is recorded at Stonehouse, but this is the only such record in the county. By the end of the twelfth century, however, there were many vineyards. Average summer temperatures were about 1°C above the twentieth-century average, late spring frosts that can damage the blossom were rare, and Septembers were generally warm and dry. The vineyards were mainly sited on south or south-west facing slopes, but at Tewkesbury the vineyard, first recorded in 1195, was on a shallow, north-facing slope to the south of the abbey (see fig. 15). Viticulture is labour intensive in pruning, weeding and harvesting, so the labour shortages following the Black Death, combined with a deterioration in climatic conditions, caused the steady abandonment of the vineyards in the later fourteenth and fifteenth centuries. Bulk imports of more cheaply produced French wine was another contributory factor to the vineyard decline. It is estimated that one acre of vines could produce 400 gallons of wine. 'Verjuice', a

type of wine vinegar, and 'must', the newly pressed grape juice, were also produced. It is likely that vineyards were connected to all the monastic houses, and some have been identified from the shallow terraces on hill slopes, as at Hucclecote, a manor held by the Archbishop of York. Others are indicated from field and place names. Atkyns records a vineyard at Wotton-under-Edge belonging to Kingswood Abbey. Wine was needed in the monasteries for the mass, for feast days and for use by the abbeys' guests.

Monastic records also mention parks. At Tewkesbury, where the lords of the manor had their own deer park on the hill now occupied by the Tewkesbury Park golf course, the abbey's park was at Forthampton. In a field north-east of Forthampton Court is a magnificent collection of ancient and most stately pollarded oaks. The majority are now dead and skeletal, but some stags-head trees have a few living branches springing from their massive gnarled trunks (fig. 21). A bank and an adjacent hollow indicate the former park boundary. The deer park belonging to St Peter's Abbey was at Highnam, Llanthony Priory's was at Great Barrington, and Cirencester Abbey's was at Hagbourne, near Didcot, in Berkshire.

The Benedictine Rule prohibited the eating of meat on Fridays, Saturdays and some Wednesdays, and also during the periods of Lent and Advent. At these times fish was an important food item in the monasteries, particularly for the abbots and their guests. Sea fish were bought in large quantities, and salmon and other fish were obtained by trapping at weirs along the River Severn. Monasteries had fishing rights all along that river. In addition, a significant, though limited supply of freshwater fish was obtained from fish ponds. These were expensive to dig out and to maintain in a clean state, so only wealthy landowners could afford them. They became status symbols of the aristocracy and their surviving sites are frequently linked to moats, castles and parks, but also to monasteries. Chains of ponds were fed by leats through sluice gates. The larger ponds (vivaria) were for breeding and rearing the fish, and the smaller (servatoria) were for storing the fish soon required at the table. The earthworks of banks and depressions of medieval fish ponds may be found at several places with monastic connections. Hailes is a good example. Pike, bream, roach and perch were the main fish stocked; carp was a late fifteenth-century introduction. It has been estimated that an acre of pond would yield an annual output of 40lb of bream, so fish ponds cannot have contributed more than a rare luxury item to the monk's diet. Fish ponds had to be close to the monastery for adequate supervision and to prevent the theft of fish. They continued in use after the Dissolution as a valuable asset, in some places only ceasing production in the early eighteenth century.

Thus, the minor landforms from farming and fishing practice, extensive market town layouts and watermills and enormous barns, complement the houses, churches and claustral buildings of the monastic landscapes. They made a very significant contribution to the landscape of Atkyns' Gloucestershire.

6

Landscapes of Desertion, Dereliction & Disorder

In widely dispersed fields across the county, the tumbled ground of grassed-over earthworks indicates where small villages once existed. These earthworks would have been clearly visible in the eighteenth century, and probably more were to be seen at that time because some have since been destroyed by ploughing and levelling, and their former existence is known only from field names, ancient documents or the scatterings of medieval pottery. Manless Town at Brimpsfield is an example of such a lost settlement, where the evocative name is linked to some shallow earthworks in a field on the east side of the lane from Climperwell to Caudle Green (fig. 22). This is an exposed site in winter, but no more so than the parent village of Brimpsfield, which had the benefit of early protection from the Giffards' castle. Deserted village sites are most common in the north Cotswolds, with clusters in the upper valleys of the Rivers Coln and Windrush, and in the valley of the Kneebrook, a tributary of the River Stour. If Gloucestershire corresponds to adjoining counties, where more detailed surveys have been made, there are probably more than 200 such sites. Atkyns does not refer to any of them, nor do other early writers, and it is only since the 1950s that their existence has become widely recognised. Nevertheless, they are widespread and locally conspicuous landscape features.

The visible signs of deserted villages are holloways, which indicate the positions of former village streets; small raised platforms that show where houses once stood; and shallow linear ridges formed from the weathered remains of the dry stone walls or earthen banks that once marked the boundaries of the farmyard enclosures or tofts. Due to the uneven ground, the sites are now generally used for permanent pasture and are often grazed by sheep. More rarely they are wooded. Patches of nettles in the fields may reveal the higher nitrate and phosphate content of the soil, where domestic rubbish once accumulated, and rushes may grow in the damp holloways. Footpaths

Fig. 22 The site of Manless Town, a deserted village high on the Cotswolds near Brimpsfield. Notice the nettles in the uneven field in the foreground.

and tracks converge on these fields for no apparent reason, and occasionally there is evidence that a water course was once modified to provide power for a mill.

The sites of these deserted villages are not significantly different from those of the existing villages in the area. Although some are in high and rather bleak places (such as Wontley to the east of Cleeve Hill, which was deserted by 1372), or on hillsides exposed to cold north-east winds (as is the case with the shrunken village at Hawling), most sites are relatively sheltered with adequate space for crops, soils (which are now shown in mole hills to be well drained and friable) and good water supplies from nearby springs and streams.

The reasons for their abandonment are complex. Gradual changes in physical, economic and social conditions frequently combined with sudden, devastating epidemics to cause the desertions and shrinkages, which occurred mainly but not exclusively in the fourteenth and fifteenth centuries. The peasant populations

occupying the villages did not leave written records of their abandonment and the literate members of the society of the day were not particularly concerned with recording such events, so the explanations for desertion and shrinkage have been mainly inferred from secondary sources.

During the medieval period, two types of change in the physical environment resulted in significant declines in the yields of cereals. The first change was climatic. Colder and wetter winters delayed the spring sowing of barley and held back the growth of autumn-sown wheat, and cool, cloudy and wet summers checked the ripening of the grains. The resultant lower yields reduced the available food supply for the village populations, and undernourished people are more vulnerable to disease epidemics. Malnutrition is particularly serious for children, weakening their resistance to illness in later life, and it has been suggested that the failure of harvests across most of Europe in the Great Famine of 1315 and 1316 contributed to the severity of the impact of the Black Death thirty years later, although the death rate then seems to have been highest for young children and the elderly. The other changing physical factor was a decline in soil fertility. To maintain the fertility of medieval arable land, the manure of livestock, particularly of sheep, was essential. In the typical two-field system of agriculture on the Cotswolds, each field grew cereals one year and was left fallow the next, and during the fallow year the land was heavily manured by sheep. By day the flocks had grazed on the common pasture and on the stubble and weeds of the fallow field, but at night they were all folded on the fallow field. The hurdle enclosures of the folds were systematically moved across the field, ensuring an even spread of dung. As many as 1,000 sheep were folded on one acre. If, for any reason, the number of sheep declined, then so too did the fertility of the soil. Mismanagement and sheep diseases, such as scab, could quickly reduce the size of the flock, with serious consequences for future grain yields. A similar decline in soil fertility could result from allocating more of the village land to cereal growing than the supply of manure could replenish with soil nutrients. Thus we can explain some medieval depopulation by food shortages and consequent starvation, and by the migration that resulted from these falling crop yields.

Village desertion was usually attributed to the Black Death, when as much as a third of Europe's population died. This is still the local tradition and often quoted as an explanation. The fourteenth-century spread of this plague was assisted by several largely independent factors. These include the growth of crowded urban populations in the thirteenth century, the development of new trade and marketing routes along which the rats with their fleas carrying the plague bacillus could spread, the clearance of woodland that had formerly acted as a buffer to their movements and the unsanitary conditions of the settlements. But while it is recognised that the Black Death was a catastrophe of the greatest magnitude, perhaps the greatest Europe has ever faced, and

that it affected nearly every village and town, desertion is now known to have been a process that lasted for much longer than the three years of 1348–50, and many other factors beside disease were involved.

Desertion also followed changes in farm economics. During the fourteenth and fifteenth centuries the value of wool relative to grain increased significantly. A reduced population meant that less food was needed, so the demand for grain declined and consequently its price dropped, while the expansion of the Flemish cloth industry increased the overseas demand for wool. Some landowners, therefore, decided to increase the size of their flocks to capitalise on the rising wool market, and land formerly used for arable farming was converted to sheep pasture. The workforce required to care

Fig. 23 Naunton Farm, near Alderton. The uneven ground in the field on the left marks the site of the former village, and behind it faint corrugations show where the ridge and furrow of arable land once existed.

for sheep was much less than that required for harvesting cereals and some agricultural historians have suggested that as many as 200 harvest workers could be replaced by three shepherds. As an example of such a change, the court records concerning the Tracys' estate at Toddington reveal an increase in the size of their flocks in the mid-fifteenth century, overburdening the existing common pastures. Some arable land was therefore converted to pasture, and this contributed to the population decline of the two small settlements of Frampton and Naunton (fig. 23). Both settlements were more important than the neighbouring manor of Alderton in the time of *Domesday Book*, and the earthworks marking their sites may still be seen beside the two farms, which retain the settlement names. Although the fields on the lower southern slopes of Alderton Hill continue to be used for arable farming, growing wheat, barley and maize, shallow ridge and furrow on the steeper land above the farm buildings indicates where the arable land of the open fields was converted to pasture for the Tracys' sheep, and this land has remained as grassland ever since. A similar pattern of land use change from arable to pasture continued in the Vale right up to the eighteenth century, when Parliamentary Enclosure allowed all landholders relative freedom of choice in the use of their fields. Many landholders favoured pastoral farming, and the cottages of the displaced labourers were allowed to decay or in some instances were deliberately destroyed.

Migration of workers to larger rural settlements and to the growing towns, where better amenities and more employment opportunities were available, was another key factor contributing to desertion. This was more likely in remote settlements. Where the settlement was near to a market, there was a wider range of opportunities for peasants to make a living when times were difficult and a greater likelihood of settlement survival.

After the mid-fourteenth century, the power of the landowners relative to the peasantry was diminished, and they were no longer able to retain their workforce by the traditional manor court orders. The resulting greater freedom in mobility of the tenants opened the way for the depopulation of small settlements. Landholdings were simply left. The Nonarium Inquisitiones of 1340 record that at Lower Harford and Aylworth in Naunton parish, 'many tenants left their holdings and left them vacant and uncultivated', and in the next parish of Cold Aston, 'seven parishioners of Little Aston left the parish'. In this latter example the seven parishioners represented more than half of the estimated total of ten households. Such abandonment must have been a common occurrence. Tenants frequently moved house, and the turnover rate of the occupants of a particular holding was generally high, but before this time the peasant movements were normally within the manor.

The strength of a family's tie to a particular holding depended on the status of the occupants. If the holder was a free man, cultivating the land of his ancestors, he

was much more likely to stay than if he was a customary tenant. So the proportion of the population that consisted of freeholders influenced the likelihood of settlement durability: the more free men, the more stable the settlement.

From these observations we may conclude that village desertion resulted from decisions made by both landowners and their tenants in response to changes in the physical, social and economic environment. It was not a simple consequence of the Black Death. The plague's effect was accompanied by other factors, such as climatic deterioration, soil fertility decline, changing patterns of land use, the freedom of tenants to move and coercion by powerful landowners, and it was the combination of all these factors that was so telling.

Fig. 24 Lower Harford Farm, Naunton. Earthworks of the deserted village may be seen in the field beyond the farm buildings.

But there were other issues, not linked to making a living or feeding a family, that influenced the decisions of some landowners to move a complete village population. For the establishment of a Cistercian abbey in an already populated area, the requirement of solitude could only be achieved by the depopulation of the land around the abbey. This was the case with Hailes Abbey, where, as we have seen, the local population was moved to Didbrook, and possibly also with Kingswood Abbey. The Vale of Castiard, where the other Cistercian abbey was sited at Flaxley, was still secluded at the time of the abbey's foundation, but there may have been forced depopulation around its granges. At a later date, when it became fashionable for country houses to be situated with a view over picturesque scenery or over carefully landscaped grounds, the view was 'improved' by the removal of peasant dwellings. The seventeenth-century owners of Highmeadow House near Coleford, which is now just a rubble mound, had the offending houses removed for this reason. However, this latter practice generally developed after Atkyns' time.

If we take the valleys of the upper Windrush and its tributaries as a case study area of desertion, the earthworks of deserted sites close to isolated single farms are found at Lower Harford, Aylworth, Castlett, Pinnock, Roel and Taddington, and the existing villages of Guiting Power, Temple Guiting and Hawling, like so many Cotswold villages, have peripheral earthworks indicating where the settlement has shrunk. The site at Lower Harford (fig. 24) is close to the River Windrush. It is sheltered on three sides, and although the valley here is exposed to north winds, the former village lies on a gentle south-facing slope. There is sufficient space on the lower slopes of the valley sides for cultivation, and there is some evidence of shallow cultivation terracing. Higher up, the slopes are steeper and even today are used for pasture with a flock of Cotswold sheep and a herd of Longhorn cattle. At Aylworth, the field name for the former village site is Lady's Hayes, implying a hedged enclosure and possibly a chapel dedicated to Our Lady. It is on a north-facing lower slope and more exposed to cold north-easterly winds than Lower Harford, but neither site is conspicuously inferior to that of Naunton, the main surviving settlement of the parish, or of others in the area. Probably, with a general population decline, Naunton developed at the expense of the other two villages, expanding along the north side of the River Windrush, while the others were eventually reduced to single farms. At Guiting Power, the fields by the parish church, particularly on its south side, contain the earthworks of former houses and this shrinkage explains the peripheral location of the church relative to the present-day village. Earthworks near a church are common on the Cotswolds, and there are similar former village earthworks near the churches at Brimpsfield, Little Rissington, Winstone and Notgrove, and even near Atkyns' own church at Sapperton. Less than a mile to the north of Guiting Power are the earthworks of the deserted village of Castlett, again in a very favourable setting but away from the ancient road

linking Winchcombe and Stow-on-the-Wold. To the west, in a more constricted site but still relatively sheltered, was the village of Roel, important in Domesday times. In both cases single farms have replaced the villages. Similarly at Temple Guiting, there are village earthworks in the field south of the church and about a mile to the west is the deserted site of Pinnock (fig. 25), with its former village street continuing as the track linking it to the main village. There are no visible earthworks at Hyde, but at Taddington they spread over the shallow slope to the west of the source springs of the River Windrush. These deserted settlements were probably smaller and less important than the surviving villages, and perhaps their populations were more servile. They may have been founded later as daughter settlements to the original villages, and may have possessed insufficient land to support their population in times of food shortages, but

Fig. 25 The site of the deserted village of Pinnock, near Temple Guiting. Houses once lined the track on both sides.

Fig. 26 The bank on the right is part of the earthwork surrounding the large Iron Age camp of Uley Bury. The steep slopes of the Cotswold escarpment gave it a natural defence on three sides.

the qualities of their sites were not markedly inferior. Only four of the original nine settlements in this upper part of the Windrush valley have survived as villages, and three of these are shrunken villages.

At Whittington, close to the A40 road, is another deserted site. Here the holloway of the curving village street is easily followed and the house platforms are conspicuous. The site is unusual in that the medieval village extended on to the site of a Roman villa and some of the earthworks here are the untidy waste mounds from a mid-twentieth-century archaeological dig. The present village is closer to the shelter of the hillside and was also near to places of employment in the quarries and mines from which large quantities of freestone were extracted in the nineteenth century. Whittington Court, beside the small Norman church, is built within a moated site, which would have been contemporary with the deserted village.

Apart from the earthworks, the legacy of the deserted settlements sometimes continued long after the population had gone. In the case of Pinnock, although there were no inhabitants and the shepherd employed in the area was a Quaker, the woodherd an Anabaptist and the church had gone, there was still a rector in the 1670s. The Revd Henry Winde, clerk of Didbrook and Hailes, was also rector of Pinnock, and the son who succeeded him, the Revd William Winde, continued to have common grazing rights for 140 sheep at Pinnock in the early eighteenth century. Parsons says that the church was destroyed in the Civil War.

In the winter, when grass is short and the sun low in the sky, the shadows cast by these earthworks quickly attract the visitor's attention, particularly when hoar frost or snow has partially thawed. Once the tumbled ground of one deserted village has been recognised, it is easy to spot others. However, it is left to the imagination to picture the anxiety and fear, the frustration and anger, the sense of injustice and undeserved suffering, and even the violence that was associated with desertion, whether it was caused by disease, starvation or landowner decisions. The literature of the day refers to the soul-searching that went on in seeking an explanation for the atrocious weather of the early fourteenth century and the devastating spread of bubonic plague in the succeeding years, but not to the despair of some doom-laden peasants, who finally moved from the ancestral homes that had been in their families for generations.

Whatever the causes, the effects of desertion on the whole landscape were profound and led to a significant reorganisation of rural settlements. Sheep grazing began to dominate the agricultural land use and led to the prosperity of landowners in the fifteenth century, to the expansion of the towns possessing wool markets, to the splendid architecture of the Cotswold wool churches and eventually to the rise of the woollen industry in the Stroud area in the seventeenth century.

The earthworks of former villages are not the only types of earthwork in the county. Those of a more easily recognised form are found on most promontories of the Cotswold escarpment and crown other hills in the area. They consist of grass-covered, steep-sided, linear ridges, from 10 to 15ft high, which are sometimes arranged closely parallel to each other and separated by deep ditches. They enclose areas that range in size from 5 to 50 acres. Similar earthworks are found at less easily characterised sites on the gently sloping sides of Cotswold valleys and, occasionally, on wide flat surfaces. These are the Iron Age hill forts and camps and are clear evidence of the considerable organisation of labour in their construction from earth and stones. More than 2,000 years later they are still impressive features in the landscape. The earliest forts date from about 700 BC and were built for defence. Here, people, possessions and livestock could be brought together and more easily protected from hostile invaders. Later, after 300 BC, more elaborate hill forts were built as symbols of security rather than for actual

defence, expressing the demonstrable power of their owners. There is evidence in reddish stones that the earlier hill forts had been attacked and their timbers set alight, but the later ones were not designed to prevent attack and did not have complete defensive structures on all sides.

Although he was unaware of the existence of deserted villages, Atkyns knew of these massive earthworks and makes reference to them as camps. In all, he records fifteen Iron Age sites in the county, mostly identified by their entrenchments. He refers to entrenchments rather than to ramparts, and distinguishes between the single and double ditches surrounding the enclosures, rather than between the univallate and bivallate hill forts in the terminology of modern archaeology. Along the Cotswold escarpment, his parish entries include the hill forts on Meon Hill, Willersley Hill, Shenberrow, Cleeve Hill, Painswick Beacon and Uley Bury (fig. 26). He omits references to the hill forts on Nottingham Hill, Leckhampton Hill, Crickley Hill and Haresfield Beacon, and also that of Brackenbury Ditches above Wotton-under-Edge. Perhaps the omissions are because his informants failed to include them owing to the camps' remoteness from the parish settlements. A few hill forts also existed west of the Severn, such as in Lydney Park, at Welshbury and Symonds Yat. None of these are mentioned, but the hill fort at Towbury, sited on a river terrace overlooking the meadows beside the River Severn in Twyning parish, is included in what is a remarkably comprehensive coverage for a 1712 publication.

Away from the escarpment and hilltops, Atkyns records Iron Age earthworks at Trewsbury (in Coates parish), at Farmington (where Camden's measurements of 850 x 473 paces are quoted for the Norbury camp), at Colesbourne (another camp also known as Norbury), at Dowdeswell and, finally, at Windrush. More complex earthworks than these simple enclosures are found on Minchinhampton Common, and north of Bourton-on-the-Water is the important 50-acre site of Salmonsbury. At Bagendon, on two sides, the huge rampart and ditch borders an area that may have been as large as 500 acres (fig. 27). Atkyns refers to the camps at Bagendon, Bourton and Farmington as Roman camps, and subsequent investigation has shown that these were occupied up to Roman times. He was evidently very interested in these earthworks.

With the arrival of the Roman army and the establishment of Pax Romana, such defences were no longer necessary, nor were they effective against the new military technology. The rule of the emperor displaced any local tribal authority and a more centralised economy was developed. A comparison between the high-quality stonework of the remains of the Roman walls at Gloucester and Cirencester (see fig. 62 on p. 163) and the Iron Age rampart of loose stones at Crickley Hill quickly reveals the contrast in the structural engineering skills of the two cultures. The most extensive linear earthwork in Britain, built in the eighth century as a frontier with the Welsh, is Offa's Dyke and Atkyns makes a single reference to this in the entry for Newland parish.

Fig. 27 Bagendon earthworks. The ditch and 15ft-high rampart on the left mark the boundary of an important Iron Age settlement.

The earthworks of ridge and furrow have already been discussed, and in the early eighteenth century the open field system of agriculture was still operating in parts of most parishes. Its ploughing patterns would have been more evident than they are today, particularly in the Vale where, a few years later, William Marshall wrote that the corrugations were so high as to hide one plough team from another as they worked on different strips in the same huge field. The ridges would have reached their maximum height in Atkyns' time. Also on some Cotswold slopes, particularly near Wotton-under-Edge in the south and at Farmcote in the north (fig. 28), shallow terraces or lynchets were still being cultivated. These medieval ploughing landforms were much larger than those of the earlier Celtic fields.

The regularity of the earthworks on the hilltops, escarpment edge and lower slopes of the Cotswolds, and in the former open fields, indicates their man-made origin. They are to be distinguished in their linear and structural composition from other hummocks on the steeper slopes, which were formed by natural processes. In the cold conditions at the end of the last Ice Age, large blocks of rock were split by frost from the exposed geological strata and slipped down the frozen slopes to come to rest some way below the outcrop. Subsequent weathering and soil creep have given them a rounded form, although sometimes parts of the stone blocks are exposed. These are solifluxion features and are common along the Cotswold scarp face beneath the top outcrop of oolitic limestone. With the much harder rocks of the Forest of Dean, similar

Fig. 28 Lynchets at Farmcote. These terraces were produced by ploughing along the contours of the slope. After each passage of the plough, loosened soil tends to move downhill before creating these step-like features.

loosened blocks remain as unweathered boulders scattered over the slopes below the rock outcrops. Landslides have also occurred from time to time along the steepest slopes in very wet conditions. One such landslide Atkyns records in Alderton parish was known as 'The Slip'. He reports that in the 1660s a mass of land on the west side of Alderton Hill, together with its tree cover, slipped for some forty-five yards 'into Worcestershire'. Samuel Rudder comments that Atkyns was misinformed about the trees changing county! The site of this landslide is not visible in the woods on the upper hillside, but the steep slopes of the combes around the hill and its geology of Upper Lias sands and clays make it a likely occurrence, and on nearby Bredon Hill landslides have been common. Tree roots are too shallow to prevent landslides.

Fig. 29 Barton Larches. An old quarry site near Temple Guiting. Stonesfield slates for roofing were once dug here and now the waste area is an ideal habitat for Cotswold flowers. Rabbits have burrowed into one of the mounds of broken slates and cowslips flourish on the dry surfaces.

Sometimes quarry waste can be confused with earthworks. Where shallow quarrying took place, especially for the Stonesfield slates used for Cotswold roofs, low mounds of broken stones and overburden were left as spoil. Frequently, these former slate quarries are now covered with scrub woodland or small plantations and they are normally located on block-faulted outcrops within the exposures of the Great Oolite limestone. With their sheltered hollows and warm, dry and thin calcareous soils, they often provide important habitats for the more delicate Cotswold flowers, such as the rare Cotswold pennycress which is now almost entirely confined to former quarry sites (fig. 29).

In several parish entries Atkyns mentions ruined settlements. At Bourton-on-the-Water were 'the ruins of many houses which are discovered after great rains'. It is not clear what he meant by this, because silt from flooding is more likely to conceal footings than to expose them, unless the floodwater caused scouring. The site of these ruins is unknown, but it was probably between the church and Salmonsbury and has now been built over. His comment on Frocester is more easily understood, for here were houses that had burnt down near St Peter's Church and had been rebuilt in a drier place. The spire of the old church still stands alone in its churchyard. Gatcombe, on the west bank of the River Severn, was 'wholly ruined', having once been a well-used port, and Pomerton was a large town in the same area also described as 'wholly ruined'. There is no other record of Pomerton, and Rudder thought that it was actually Blakeney. The use of the small Severn ports, like Gatcombe, continued well into the nineteenth century and they only lost their importance with the opening of the Gloucester-Sharpness Canal, which was designed to enable seagoing ships to avoid the treacherous tidal stretch of the river.

Atkyns also refers to ruined houses. Llanthony Priory consisted of 'heaps of rubbage', burying the tombs of the Bohuns. Ruined country houses are recorded at Awre, Oxenhall, Siddington and Staunton, and sites of former houses are mentioned beside the churches at Oddington and Little Rissington. More examples could be given of the earthworks of former manor houses close to their parish churches. Few of the houses engraved by Kip have survived to the present day, and Atkyns' own family home at Sapperton did not last for many years after the publication of his book (see fig. 5). Houses are among the least durable components of the historic landscape and ruins are to be expected at all times. The damage to properties caused by the Civil War was also evident and this will be discussed later. The older ruins of monastic sites, destroyed and pillaged for building materials after Henry VIII's decision to dissolve all monastic houses, were also visible features in the landscape. As we have seen in the previous chapter, several country houses had been built by favoured nobles using these materials. Stone for Wightfield Manor came from Deerhurst Priory, and tiles from Hailes Abbey went to Southam Delabere.

Derelict sites have always been a feature of the landscape as buildings decay, get damaged or become obsolete and are no longer suited to the functions for which they were designed. The words of the nineteenth-century hymn 'change and decay in all around I see' have been applicable at all periods in history, but the recognition of the abandonment of whole villages is a relatively recent discovery.

7

The Buildings of Benefactors

—◦◦◦◦—

In this chapter we will consider buildings and other amenities that were privately funded but built for the common good. Prominent among them were churches. *Domesday Book* gives the names of the holders of manors in 1086, and from among them the lay lords of manors are likely to have been the persons addressed by St Wulfstan and encouraged to build churches, as we have seen in chapter 4. From time to time changes occurred in the families owning manors, and at the Dissolution all the former monastic manors were acquired by new lords. Lords of manor generally took on the responsibility of overseeing the upkeep of church buildings, although the clergy maintained the chancels. Subsequent modifications to the church fabric, such as adding towers and steeples, aisles and transepts, inserting new windows and doors, providing porches and guild chantries, were all funded by parish benefactors.

Atkyns rarely considers the dates of church building or the sources of the capital required for rebuilding, though in a few cases he gives details of the builders. He mentions Sir Giles Tame who, he says, rebuilt Rendcomb church in 1517, although the glass in a nave window contains the initials E.T., those of Sir Edmund Tame. At Lechlade, Atkyns says St Lawrence's Church was rebuilt in the 1470s by the Revd Conrade Ney. At Northleach, he refers to John Fortey, who funded the building of the clerestoried nave of the church in about 1450, and William Bicknell, who paid for the Lady Chapel in 1489. A corbel in the Lady Chapel gives this date in Arabic numerals. He also refers to John Camber, another wool merchant, whose brass, dated 1447 and now attached to the south wall of the chancel at Sevenhampton, represents him in the dress of the time. Camber built the central tower and south porch of the church and also rebuilt the two transepts (see plate 9). Didbrook church was built by William Whitchurch, Abbot of Hailes, in 1470; Woolstone's was rebuilt in 1499, and the spire of Dowdeswell church was paid for in 1577 by the lords of the manors of Lower and Upper Dowdeswell, William Rogers and John Abbington respectively. At Toddington the old church had been lately pulled down and replaced by a 'neat new

church, decently adorned' (see fig. 43 on p. 119), but the latter only lasted until the 1860s when the Tracys again rebuilt it with the present large estate church.

We know of many other church benefactors from their wills, and sometimes their personal marks are displayed in the church fabric, together with signs indicating the origin of the wealth that had paid for its construction. This is the case with most of the Cotswold wool churches, which were built with the bequests of wealthy wool merchants. At Fairford, high on the parapet of the tower, are the emblems of the town's fifteenth-century economy – scissors, shears, a hunter's horn, gloves, horseshoes, pincers, and a shell for holding the salt of a salt merchant – as well as the arms of Sir John Tame, a Cirencester wool merchant and father of Sir Edmund, who paid for the rebuilding of the church (see plate 11). At Northleach are the famous wool brasses portraying wool merchants and their wives, with their feet resting either on sheep or wool packs. Most of these merchants were benefactors to the church. St James', Chipping Campden, was also built using the bequests of wool merchants, particularly William Bradway and William Grevel. The latter's brass rather immodestly describes him as the 'flower of the wool merchants of all England'. Wool merchants and members of a weavers' guild were also involved in the building of St John the Baptist's, Cirencester, and here there are wool marks on the brasses of Reginald Spycer and Robert Pagge. At Winchcombe, the chancel of the 1460s rebuilding was funded by the abbot, William Winchcombe, and the principal benefactor for the construction of the nave was Sir Ralph Boteler of Sudeley Castle. The arms of both are displayed together on the south chancel wall. On a buttress on the magnificent south facade of St Andrew's, Chedworth, is an inscription, dated 1461, referring to Richard Scly, presumably a benefactor to the rebuilding of this wall. At Bibury, in a recess in the south aisle, at Compton Abdale, on the buttresses of the tower, and at Windrush, on the south arcade of the nave, are sculptures of sheep or sheep's heads, and at Cranham two pairs of scissors are carved into the stonework of the tower. We do not know the names of the benefactors of these latter churches but the source of wealth is very evident. At Abenhall, on the edge of the Forest of Dean, a renewed stone on the west side of the tower shows the tools of freeminers. These tools are also sculptured on the fifteenth-century font, together with several coats of arms of families associated with the church.

Although Atkyns makes few references to individual benefactors who provided the church buildings, he often includes details of other charitable gifts to the parishes. Many churches have boards displaying details of past bequests to the parish – for the poor, for the education of its children, and for the ministry of the church – and the majority were built, repaired and maintained by generations of unnamed local people, on whose munificence the churches have depended throughout the centuries.

For each parish, he gives a brief and standardised description of the visual profile of the church. References are made to 277 churches and chapels in the modern county.

Just over half their number, 143, are recorded as having a west tower, with twenty-one having central towers. The majority of towers were battlemented, and those with pinnacles Atkyns describes as 'handsome'. Low towers were much more common than high towers, and occasionally Atkyns gives details of the church roofs – whether wooden, leaded, slated or tiled. About fifty churches had spires, a fifth of the total number, and they are also frequently described as 'handsome'. Sometimes he mentions that a spire had collapsed in a recent storm or had been struck by lightning. Some of the spires he lists may have been bellcotes rather than genuine steeples, and most small churches and chapels had neither tower nor spire.

He tells us whether the church had two aisles, a single north or south aisle, or none at all. Forty-seven had both north and south aisles, thirty-six had only a south aisle and twenty-five had only a north aisle. Aisles were usually later extensions to the original building, and often indicate an increase in the population able to attend church. In some cases a former private family church was opened up for the whole population of the settlement; in others a medieval settlement adjustment increased the population living near to a particular church, as happened for example at Naunton; and in others natural population growth occurred. This increase in the size of the congregation could be more easily accommodated by a lateral expansion of the building, rather than by demolishing and replacing the chancel at the east end of the nave or the tower at its west end. Sometimes aisles reflect an increase in the wealth of the parish population or of the patronage. Here, the monuments of the lord of the manor's family could be located, small altars erected, and more elaborate ritual processions followed. Thus at St Mary's, Great Barrington, the beautifully carved marble monuments to members of the Bray family are in the north aisle. It is thought that if the church possessed two aisles, which were built at different times, the north aisle generally came before the south aisle. This sequence was less disruptive to the entry to the church through the south porch and to the early burial places outside. Aisles are now known to be significant diagnostic features of church and local history, and it is interesting that Atkyns includes these details.

In several cases he gives additional information, commenting on a church's stained-glass windows, galleries, wainscoting, bells or porch. Where its condition was poor, ruinous or, in the cases of Charlton Abbots and Sudeley, disused, he notes this too. Presumably, most of these details were collected from the questionnaires sent to the parish priests by Parsons, and then supplemented by additional information from Atkyns, and this accounts for the strong ecclesiastical interest in *The Ancient and Present State of Glostershire*. In only a few instances do the descriptions give the impression of direct observation, although Atkyns must have known several churches very well indeed.

The repetition of these basic details of church architectural forms is rather tedious to read, but it does help us in building a picture of the early eighteenth-century landscape,

because churches were generally its largest man-made structures and very conspicuous features from the principal viewpoints. In fact, there are few vistas of more than 2 or 3 miles which do not include a church tower or spire. Atkyns mentions that from Barrow Hill (see fig. 64 on p. 172), a low rise in Arlingham parish, it was possible on a 'fair day' to see thirty-six churches. It must have been a very fair day indeed, with no foliage on the trees or no trees at all! He also draws attention to churches in the most prominent positions, such as All Saints', Bisley ('a great landmark'), St Bartholomew's, Churchdown ('standing on top of a steep high hill'), St Mary's, Forthampton, and St Swithun's, Hempstead (both on the tops of rising ground), and St Edward's, Stow ('standing on a high hill and seen from all sides'). The skyline of Kip's 'Prospect of Gloucester from the west' (see fig. 58 on p. 156) shows just how eye-catching the spires and towers of the period could be, with the tower of Gloucester Cathedral rising to 225ft and visible for many miles around.

Settlements were much smaller then; towns and villages had not begun to sprawl across their surrounding countryside, and in these more compact layouts the visual impact of a tall church was more pronounced than it is today. Also, rural parish churches were less hidden among trees than they have been at later dates. The beeches, oaks and cedars in the grounds of the adjacent manor houses and old rectories had not yet been planted, for the fashion of planting trees for ornamental and status purposes, or to give shelter and seclusion to farms and country houses, generally came later in the eighteenth and early nineteenth centuries under the influence of the great landscape gardeners and their followers. The dominant effects of nearby mature trees are never shown in the Kip engravings. Sometimes an old manor house dwarfed its neighbouring church, as with Whittington Court and as seen in some of Kip's engravings, but the 'arrogant, overbearing and exhibitionist Italianate confectionary' country houses, that H.J. Massingham so castigated in his *Cotswold Country*, were yet to come.

Some details are likely to have been incorrectly reported. We know, for example, that St Bartholomew's, Aldsworth, had a north aisle from its Norman beginnings and that the church towers at Coln St Aldwyns and Lechlade had pinnacles in Atkyns' time. We also know that there were west towers at Bagendon, Compton Abdale, Duntisbourne Abbots, Duntisbourne Rous, Harnhill, Kempley, Longhope and North Cerney which he fails to record. In other cases there may have been some difficulty for the respondents in deciding whether a side extension was a chapel or an aisle, as with St Margaret's Chapel at Badgeworth, or which generalisation should be applied when describing a church which had a west tower with a very small steeple, as with St Margaret's at Corse. Some of Kip's engravings of houses give added information about the appearance of a nearby church, but the latter may not have been drawn with as much care as the house.

Of course, many more churches have been built since Atkyns' time. They include all the churches in Cheltenham, apart from the parish church of St Mary's, and those in the suburbs of Gloucester, in the interior of the Forest of Dean and in the industrial settlements around Stroud. A number of others have been rebuilt since the early eighteenth century, mostly with spires, as at Batsford, Bisley, Flaxley, Fretherne, Hatherop, Moreton-in-Marsh, Stinchcombe, Toddington and Woodchester. Rebuilding has gone on ever since the first Saxon churches were erected, sometimes following the foundation lines of the earlier church, but often the plan was entirely different, emphasising the tastes of the new patron or the fashion at the time. Solidly built and buttressed towers were durable and it was often possible to add upper stages to twelfth-century lower stages, and then for the tower to rise to elaborate fourteenth- and fifteenth-century battlements and pinnacles. This style of church building is widespread throughout the county. St Michael's, Withington, is a fine example. Here a plain Norman base to the central tower is surmounted by an elegant and decorative upper stage, built in the Perpendicular style, with battlements, pinnacles, and ogee-shaped hood moulds over the bell openings to complement the clerestory windows. The south doorway, inside the porch and within the Norman part of the building, has a typical chevron pattern and finely sculptured flowers. Many Perpendicular-style towers were intended to have spires that were never built, as with St John the Baptist's, Cirencester. Here, settlement of the tower required huge buttresses to be built to hold it in place, and plans for a greater height had to be abandoned. Those spires that were completed were often replaced or repaired in subsequent years. Several spires Atkyns mentions have fallen and not been replaced. They include those of the churches at Deerhurst (blown down in 1666) (see fig. 8), Dursley (collapsed in 1699), Littledean, Longhope, Minsterworth (destroyed by lightning in 1702), Owlpen and South Cerney. At Huntley a spire was later added to the older west tower. Although there are outstanding examples of spires in the Cotswold churches at Lechlade, Painswick and Tetbury, they are relatively uncommon here. In the Vale they are more popular and were introduced in the fourteenth century. Today, they are found most frequently in a line along the foot of the Cotswold escarpment and in an arc around the north-east of the Forest of Dean, a distribution pattern that was more pronounced in the early eighteenth century. The majority of spires are broached, where an octagonal spire rises from a square tower, as at Leckhampton and Shurdington (fig. 30). Fewer towers have the spire recessed behind a parapet, as at Newent, Painswick and Ashleworth. The tower at Ashleworth dates from the fourteenth century in its lower three stages, which have the typical diagonal buttresses. Above these is the fifteenth-century upper stage, with its battlements and gargoyles, and at the top is a recessed ribbed spire. The tower's walls are thick, but like so many buildings in the area that have been constructed with the local Lias limestone,

Fig. 30 St Paul's Church, Shurdington. The slender ribbed and broached spire was first built in the fourteenth century. Atkyns refers to its very handsome steeple.

they suffer from severe weathering. The end walls of the neighbouring tithe barn and of Ashleworth Court display the same shaling problem. A few spires are described by Atkyns as wooden. By this he means that they were covered with wooden shingles, such as may be seen on the detached tower at Westbury-on-Severn. Spires were built mainly for outward show and inside the church there are rarely signs of their existence.

Usually, the brief details of the form of the church are introduced by a reference to its size, whether large or small, and this is followed by a comment on its aisles, tower or spire. Fuller details are given for the great wool churches, such as the length and width of the nave and chancel, the height of the tower and the adornment of the exterior. St John the Baptist's, Cirencester, has a 'spacious, comely and graceful porch' facing the market place, and St Mary's, Fairford, is noted for its painted glass windows in which 'the colours are very lively, especially in the drapery, some figures so well finished that Sir Anthony Vandyke affirmed that the pencil could not exceed them'. Atkyns states that they escaped destruction during the Civil War by being inserted upside down, but this opinion has been challenged. Naturally, Gloucester Cathedral and Tewkesbury Abbey are given extended treatment.

Atkyns also mentions places where churches or chapels had once existed, but had been demolished or allowed to collapse. Some of these correspond to deserted medieval village sites such as Eastington (near Northleach), Pinnock (see fig. 25) and Roel. At Lemington, he says that the demolition occurred at the time of the Civil War, when St Mary's, Sudeley, was also damaged. Several churches were left in a ruinous condition at the end of the Civil War and a few still bear the marks of gunshot. There had been chapels at Cam, Dixton, Gorsley, Lower Norton (in Weston-sub-Edge parish), Owdeswell, Pinbury, Poulton Court, Sezincote, and at both Woodmancote and Calmsden in North Cerney parish. He tells us that the chapel at Ford had become an ale house, the one at Broad Campden a barn, and for Pinnock's, where there may have been remains in the early eighteenth century, he refers to its conversion, like that at Coscombe, to 'profane uses'.

He does not mention Nonconformist chapels. These were in existence at the time, for Quaker, Baptist and Independent congregations already had their dedicated premises in the market towns of the seventeenth century, sometimes adapted from former cottages, sometimes specially built as meeting places. These were, however, inconspicuous and usually in back lanes, where land was cheap and more readily available, and where there was less likelihood of violent interference or vandalism. Only after the Riot Act of 1715 were the Dissenting meeting places given state protection. The Old Baptist Chapel in Tewkesbury and the Friends' Meeting House in Nailsworth are typical for their discrete locations.

In addition to the details of the church form, Atkyns tells us, following Parsons, the deanery in which the church was situated, whether it was a rectory or vicarage, and its

value. In his day, rectories and vicarages referred to the cure of souls, not to the home of the rector or vicar. When the benefice was held by a lay person, such as the owner of a large country estate, as at Berkeley, Sherborne and Toddington, the incumbent was a vicar. On the other hand, a rector received all the tithes of the parish himself. Although such details were not collected for every parish, 102 parishes are recorded as rectories and sixty-eight are vicarages. Vicarages had lower values than rectories. Two-thirds of rectories were valued above £50 and ranged from £20 at Witcombe to £400 at Bishop's Cleeve, while two-thirds of vicarages were valued below £50 and ranged from £20 at Hewelsfield to £200 at Bibury and Lechlade. Each of the Cotswold woollen towns of Chipping Campden, Fairford, Lechlade, Northleach, Tetbury and Wotton-under-Edge had vicarages. Atkyns also records where new parsonages had been recently built and sometimes how much the buildings cost. They were at Adlestrop (£1,500), Eastleach Martin, Great Barrington, Great Rissington, Hempstead (£700), Naunton (fig. 31), Oddington, Quedgley, Sapperton and Weston-sub-Edge. Apart from the parsonages at Great Barrington and Weston-sub-Edge, these fine seventeenth-century houses still stand, although no longer occupied by the resident clergy and usually known today as the 'Old Rectory'.

Churchyards have existed from Saxon times, and were sometimes used as the sites for markets and fairs, as well as for burials. A few are mentioned in *The Ancient and Present State of Glostershire*, mainly for their tombs. At Alderley the monuments for Sir Matthew Hale and his family were enclosed by palings, and shown as such in the Kip engraving; at Elmore the Guises had a family vault, and at Newland was the tomb bearing the effigy of John Wyrall, Forester of Fee, wearing a fifteenth-century hunting costume. This tomb has now been moved into the church. Deerhurst is recorded as having a churchyard of two acres and Atkyns tells us that the use for burial of the churchyard at Adlestrop only dates from 1594, after the gift of land from the Leighs. He also refers to two outside sculptures. At Notgrove, on the east wall of St Bartholomew's Church, is a small Saxon stone calvary and in the churchyard at Tredington is a 'handsome cross several yards high'. There were many more fourteenth-century crosses but this is the only one he records. Benefactors gave not only money, but also land and property for the repair and maintenance of churches. At Colesbourne and Coln Rogers land was given to provide for replacement bell ropes. But churches and chapels were not the only buildings to be privately funded by benefactors.

The earliest schools were linked to abbeys and priories, such as the school in Smith Street (Longsmith Street), Gloucester, maintained by Llanthony Priory. In the developing market towns provision was usually made for grammar schools. These were invariably small establishments, educating ten boys or less, and consisted of a single schoolroom and accommodation for a master. The oldest was at Wotton-under-Edge, founded in 1384 by Katherine, Lady Berkeley. It was in School Road where its

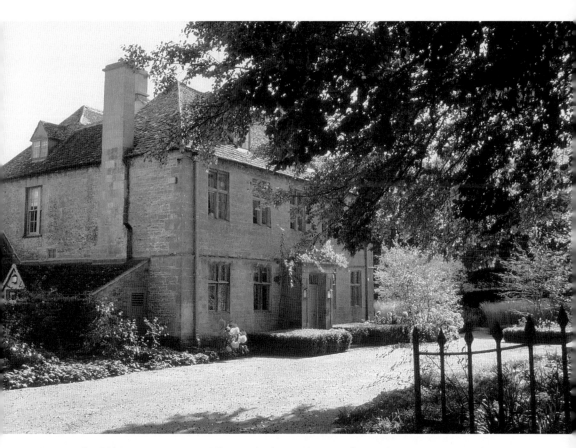

Fig. 31 The Old Rectory, Naunton. This was built in 1694, one of several new parsonages Atkyns records.

replacement building dates from 1726 and, according to Rudder, had capacity for ten boys. In the fifteenth century came John Fereby's school at Chipping Campden, where the old schoolroom lies behind a nineteenth-century frontage. The inscription over the doorway of 'Scola Grammatica 1487' is not original. The grammar school in Cirencester was founded possibly as early as 1458 by John Chedworth and further endowed by Bishop Ruthall in about 1522. It was originally housed in part of the parish church but was later moved to Park Lane, where a medieval hall and solar was converted into a school in the middle of the sixteenth century. Other schools came at about the same time. The Crypt School, Gloucester, was founded in 1539 following the 1528 bequest of John Cooke, with the schoolroom still standing beside St Mary de Crypt Church in Southgate Street and with the school badge over the nearby archway (see fig. 60 on p. 159). Hugh Westwood's Grammar School in Northleach dates from 1559

and was at the corner of Farmington Road and the High Street, now Keith Harding's World of Mechanical Music. Richard Pate, who was Recorder of Gloucester and whose memorial tablet is in the cathedral, founded the grammar school in Cheltenham. The first stone was laid in 1571, near to where the shop Wilkinsons now stands in the High Street. Sir William Romney's School, Tetbury, was probably established in 1610, certainly by 1623, and St Edward's Grammar School, Stow, was rebuilt in 1594 according to the weathered inscription on the building by the church gate. The recently restored Jacobean House in Winchcombe (fig. 32) was the King's Grammar School, built in 1618, and one of several schools in the town. It was originally endowed by Dame Joan Huddleston in 1521, but became known as the King's School because Henry VIII allowed it to continue after he had confiscated the monastic property in Winchcombe – it had been incorrectly assumed that the school was included in the

Fig. 32 Jacobean House, Winchcombe. This was built as the King's Grammar School in 1618. The master lived on the first floor.

abbey's possessions. On the west side of the churchyard at Newland was Edward Bell's Grammar School of 1576. The building still bears his coat of arms with the date 1639, but there had been a grammar school here since about 1445. William Ferrer's bequest to Tewkesbury Grammar School came in 1626, to a school founded in 1609 and then occupying the north transept of the abbey.

Grammar schools taught Latin and Greek, and their masters were carefully vetted before appointment, but the many charity and dames' schools, which were set up soon afterwards, were concerned with the basic teaching of reading and writing. There is little evidence today of these small dames' schoolrooms, but on the side of the detached church tower at Westbury-on-Severn may be seen the marks of a former adjoining schoolroom, which is also shown in the Kip engraving of Westbury Court. The gallery in Buckland church, which had been given by James Thynn, a generous local benefactor, was for a free school and there was a schoolroom above the porch of Mickleton church.

Just as Katherine, Lady Berkeley's School at Wotton-under-Edge was modelled on Winchester College, so in Gloucester Sir Thomas Rich's Blue Coat Hospital was modelled on Christ's Hospital. This school was exceptionally well endowed with £6,000, a bequest which was left to the mayor and burgesses in 1667 to establish the school for twenty poor boys (see plate 12). Atkyns reports that the money was used to buy farmland at Awre and Blakeney, so that the running of the school could be funded from the farm rentals. The site of the school, originally Rich's old house in Eastgate Street, became used for the Guildhall in 1892. Each year at the school's speech day the 'Tommy Psalm' is sung, and after celebrating the bounty of many in the city comes the following verse:

> And in this rank of pious men
> Our founder though the last
> In time, yet in munificence
> By none has been surpassed;
> Sixteen thousand pounds of what God gave
> He did lend back again;
> Though having issue of his blood
> Did not poor heirs disdain.

Although the sum of money referred to in the eighteenth-century verse refers to the total charitable bequest, of which the school formed only a part, the sentiment is genuine and other schools have a similar traditional regard for their founders.

Another common component of most market towns, and again based on the gifts of benefactors, was the hospital or almshouse, which provided care and accommodation for poor men and women. Some of these buildings remain today. In Cirencester, the arcade

of the infirmary of the twelfth-century St John's Hospital may be found in Spitalgate Lane, and in Thomas Street the Weavers' Hall was formerly St Thomas' Hospital for four poor weavers. In Wotton-under-Edge, surrounding the lawns and chapel of their peaceful quadrangle, are Hugh Perry's Almshouses of 1638 and the Dawes and General Hospitals which were added in 1723. At Newland, beside the large churchyard, are the William Jones Almshouses dated 1615 and built to accommodate sixteen poor people. Beside a raised pavement opposite the ruins of his Chipping Campden mansion and close to St John's Church are Sir Baptist Hicks' Almshouses (fig. 33). Hicks acquired the manor of Chipping Campden between 1606 and 1609, and in 1612 built the almshouses at a cost of £1,000. These twelve houses for six poor men and six poor women have shared doorways and the plan is in the form of a capital I, signifying James I, and indicating Hicks' royalist allegiance. His coat of arms is displayed in the centre of the terrace. In Northleach, at East End, are the Dutton Almshouses of 1616, with

Fig. 33 Almshouses in Chipping Campden given by Sir Baptist Hicks in 1612. They provided accommodation for six poor men and six poor women.

Thomas Dutton's initials in the sculptured spandrel over the central door. Slightly earlier are the 1573 Chandos Almshouses in Winchcombe, which were rebuilt in the nineteenth century. Both the latter two almshouses were for women. In Gloucester there were several hospitals, the largest being the twelfth-century St Bartholomew's Hospital near Westgate Bridge, which could accommodate more than fifty people. There were also almshouses in Cam, Cheltenham, Dursley, Lydney, Minchinhampton, Newent, Stow-on-the-Wold and Tetbury. Several benefactors, including Richard Pate at Cheltenham, Sir William Romney at Tetbury, and Hugh Westwood at Bibury and Northleach, made bequests for both schools and almshouses. In his general comments and recommendations to his fellow countrymen and neighbours, Atkyns expressed the wish that more hospitals for the poor could be provided in the larger settlements.

All these buildings and their subsequent maintenance were funded by gifts, sometimes from a few very generous and wealthy donors. For example, John Fortey's gift of £300 for rebuilding the nave of Northleach church was equivalent to ninety-one sacks of wool or the fleeces of nearly 19,000 sheep. But often the gifts came from a large number of ordinary people. Atkyns gives quite detailed records of their generosity to their communities.

It will have been noticed that gifts for hospitals and almshouses and for most grammar schools occur after the mid-sixteenth century, and that before this time bequests were almost entirely for the Church. The delicate tracery of the Perpendicular style of church architecture, the finely carved pinnacles and battlements of the highest stage of church towers, and the interior formation of chantries both for wealthy families and merchant guilds, were largely funded by gifts made to the Church during the late fourteenth and fifteenth centuries. This was a period in which there was great concern over alleviating the pains of Purgatory. The memory of the terrors of the Black Death and the preaching of the Dominican friars had aroused a widespread anxiety over the eternal fate of the soul. Intercessory masses were said for the dead and some bequests were made to fund these. The wealthier paid for private chantries where these could be said, and gifts to the Church were, at least partly, designed to give relief after death. However, with the Reformation this all changed. In 1545 and 1547 there were acts for the suppression of chantries, and most were quickly removed, the concept of Purgatory was challenged, and intercessory masses for the dead ceased. Consequently, new outlets for public giving had to be sought. Schools and almshouses provided the occasion for named bequests and complemented the many churches in the list of benefactors' buildings.

Bequests also provided other visible amenities and in several towns the water supply was a significant benefit. Scriven's conduit in Southgate Street, Gloucester, drew water from Robinswood Hill; Perry's conduit in Wotton-under-Edge brought water from Edbrooke field north of the town to the market cross; and Sir Baptist Hick's conduit at

Chipping Campden brought water from Conduit Hill to his own mansion and to the nearby almshouses. These conduits were each laid in the early seventeenth century.

A little later came an amenity for travellers – the signpost. Nathaniel Izod's finger post, which gave directions and mileages for travellers journeying on the Oxford to Worcester road near Chipping Campden, was the earliest. Edmund Attwood's at Teddington Hands came a little later (see plate 1).

Some gifts were probably to emulate or exceed what was happening in a neighbouring parish, others were to provide for the needs of the population of the town or manor that was largely dependent on the benefactor. Many of the bequests we have considered were also designated 'for the glory of God'. Atkyns appreciated the legacy of many fine benefactors' buildings in the early eighteenth-century landscape, and 300 years later we may do the same.

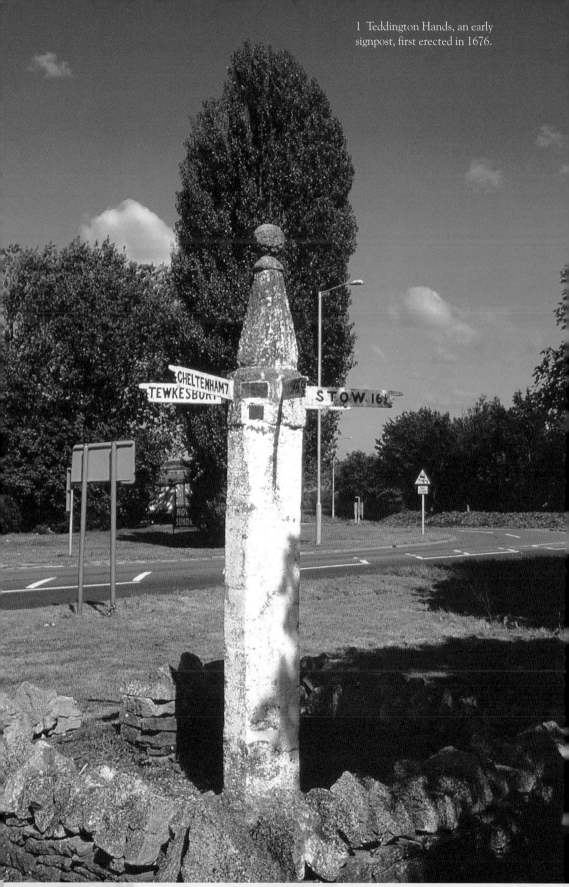

1 Teddington Hands, an early
signpost, first erected in 1676.

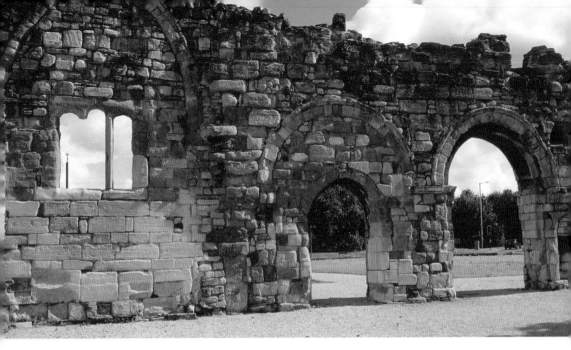

2 The ruins of St Oswald's Priory, Gloucester. Some of the large stone blocks in the wall came from the Roman ruins in Glevum and were used in the original minster founded in c. AD 900.

3 Holy Rood Church, Daglingworth. Saxon 'longs and shorts' are found at the corners of the nave, a Saxon sundial is inside the south porch and there are four Saxon sculptures displayed on the interior walls. The porch doorway has re-used Saxon stones. The tower dates from the fifteenth century, as is common for Cotswold churches.

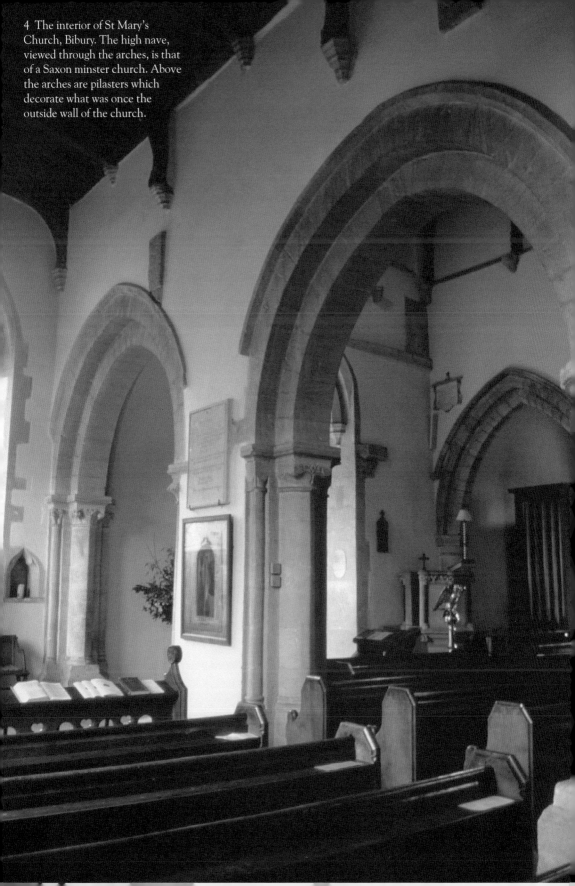

4 The interior of St Mary's Church, Bibury. The high nave, viewed through the arches, is that of a Saxon minster church. Above the arches are pilasters which decorate what was once the outside wall of the church.

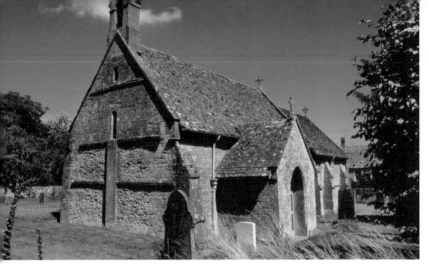

5 St Nicholas' Church, Condicote, a typical small Norman church with nave and chancel. The bellcote is a later addition, but the decorative string courses and the buttresses on the west wall are Norman.

6 Gloucester Cathedral from the south showing the decorated south aisle, the Perpendicular style of the south transept and the fifteenth-century tower. A 'stately magnificent building' is Atkyns' description.

7 The gatehouse of Kingswood Abbey. The window above the central arch has a beautifully carved mullion in the form of a lily, an important Cistercian motif.

8 Ruins of the nave and north aisle of the Greyfriars, Gloucester. Most of the Franciscan buildings here were severely damaged in the Civil War.

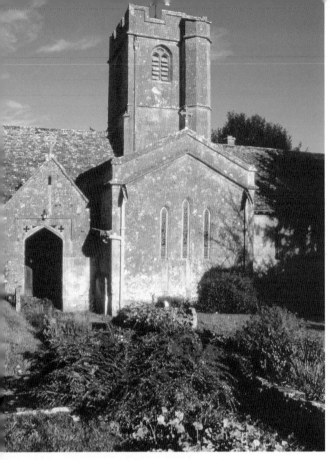

9 St Andrew's Church, Sevenhampton. The tower, porch and south transept were funded by John Camber, whose brass is now on a chancel wall.

10 The gatehouse of Standish Court. This was built in the fourteenth century. The Court was a country residence of the Abbots of Gloucester.

11 The parapet of St Mary's Church, Fairford, shows the arms of Sir John Tame and symbols of the town's trade in the fifteenth century.

12 The classroom of the Blue Coat Hospital, Gloucester, a school endowed by Sir Thomas Rich in 1667. The painting is by John Kemp.

13 The rear of the Town Hall, Wotton-under-Edge. The stone pillars supporting the first-floor Market House, which dates from about 1700, once surrounded an open market space and were embedded in the walls when rebuilding occurred in 1870.

14 Jettied houses in Tewkesbury. The terrace of Abbey Cottages dates from the late fifteenth century and included shops on the ground floor. The window shutters could be lowered to make a counter to display the goods on sale.

15 The Market Place, Cirencester. Stalls for the Friday market fill the centre of the Market Place. There is a fifteenth-century Market Cross just beyond St John's Church and an impression of the appearance of the market area in Atkyns' day may be gained from the Kip engraving (see plate 23).

16 The Market House, Newent. The apse at the front is a later addition to a building which dates from 1668. The timber framework shows close studding and the upper room is approached by outside stairs. It is more like the market houses of Herefordshire and Shropshire than those of Gloucestershire.

17 Stow Fair. Gypsy caravans and piebald
horses are on sale at this famous fair,
together with other equestrian products and
a wide range of cheap goods. The latter are
displayed on the temporary stalls erected in
a field just outside the town.

18 Seventeenth-century cottages at
Bibury. Notice the gables, oak lintels and
cross-passage design.

19 Preston Court, a magnificent timber-framed and jettied mansion, home of William Pauncefoote in 1712. The Pauncefootes had been significant landowners in the west of the county from 1200.

20 A painting of the Redstreak apple, the most popular cider apple.

21 Typical scowles in the Forest of Dean. These deep clefts in the Crease Limestone were formed when iron miners extracted the ore which once filled the solution widened joints in the rock.

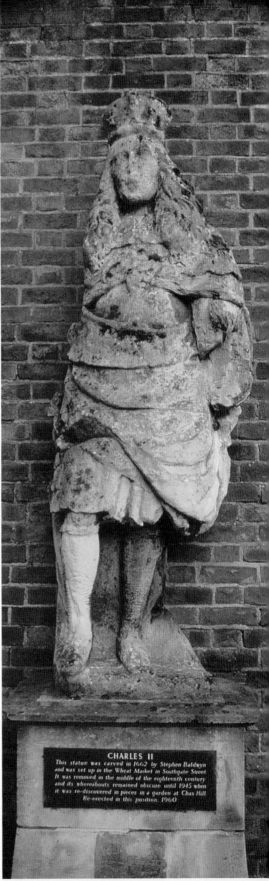

CHARLES II

This statue was carved in 1662 by Stephen Baldwyn and was set up in the Wheat Market in Southgate Street. It was removed in the middle of the eighteenth century and its whereabouts remained obscure until 1945 when it was re-discovered in pieces in a garden at Chax Hill. Re-erected in this position. 1960

22 The life-size statue of Charles II, now in St Mary's Square, Gloucester, but formerly positioned on the north side of the Wheat Market in Southgate Street.

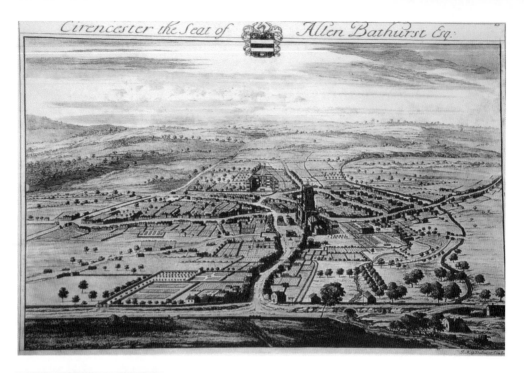

23 Kip's engraving of Cirencester. The Fosse Way crosses the foreground.

24 The entrance to the former George Inn, Winchcombe.

Left: 25 Jetties and alleys are still conspicuous features in Tewkesbury.

Above: 26 Pentacrinus fossils from the Lias clay. The best-known site for Pentacrinus fossils is Hock Cliff at Fretherne, but Atkyns mentions pentagonal stones at Awre on the other side of the River Severn.

Below: 27 The last uncovering in the 1970s of the famous Woodchester Roman pavement.

28 Lower Slaughter Manor, built in 1656 by Valentine Strong at an initial cost of £210. The house has been extended to the right, but the original building had five windows on the first floor and its early symmetry may be easily appreciated.

29 The quay at Lechlade. This was the head of navigation on the River Thames and from here salt, cheese, corn, cloth and other produce from Gloucestershire was sent to London.

30 Berkeley Castle – Defoe described it as 'noble and ancient'.

31 A single woad plant growing by the roadside near Tewkesbury. Woad was grown commercially on the Mythe, north of Tewkesbury, and was used for dyeing cloth in the woollen industry of the Stroud valley.

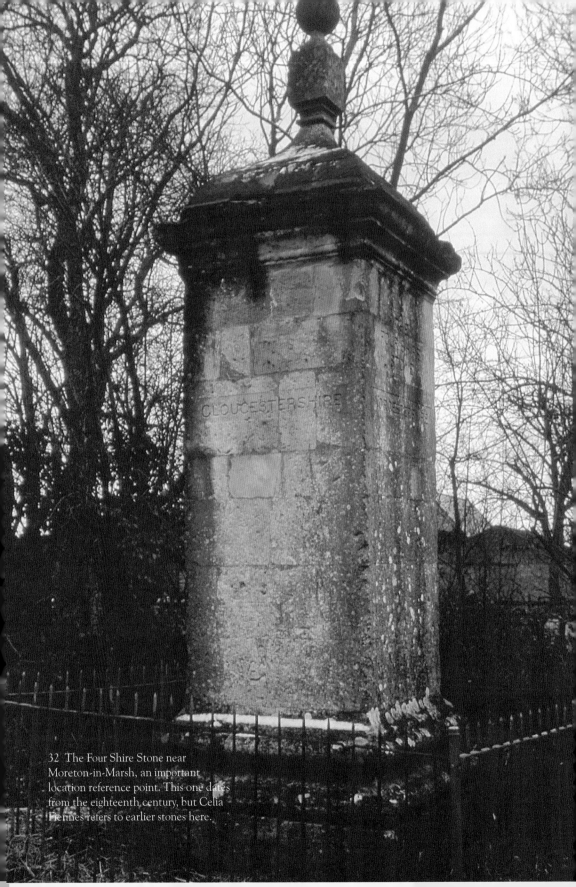

GLOUCESTERSIRE

32 The Four Shire Stone near
Moreton-in-Marsh, an important
location reference point. This one dates
from the eighteenth century, but Celia
Fiennes refers to earlier stones here.

8

Markets & Fairs

————⁂————

I n the early eighteenth century the buying and selling of farm produce, which
included food, livestock and raw materials for small-scale local industry, and of the
goods of local craftsmen, mainly took place in the weekly markets and the annual
fairs across the county. Atkyns includes many details of these markets and fairs, often
giving the name of the monarch and the year of the reign in which the market charter
was first granted. Thus for Minchinhampton, the grant of the right to hold a market
and fair was purchased from the Crown by the Abbess of Caen, who held the manor
in 1269, the fifty-third year of the reign of Henry III. During his long reign Henry
granted most of the county's market charters. Atkyns records twenty-four markets in
existence in 1712, although there were probably a few more than this, and by now some
of the less favourably located markets had closed. He mentions that at some time in
the past there had been markets at Alvington, Beverstone, Brimpsfield, Leckhampton,
Longborough and Prestbury, but all of these were 'long disused'. Early market charters
had also been granted for Alkerton, Deerhurst, Dymock, Guiting Power and St
Briavels. Generally, those markets that had been in more isolated places, away from the
main thoroughfares, in settlements with smaller populations, and also too close to more
prosperous markets, were the markets that had closed, and the eleven listed above had
one or more of these disadvantages. Yet the county was still well provided with markets
and only four counties, each larger than Gloucestershire, had a greater number. Their
wide distribution in the eighteenth century served all areas of the county.

Markets were held somewhere on every day of the working week. On Mondays
there were markets at Cirencester and Mitcheldean, on Tuesdays at Berkeley,
Minchinhampton, Lechlade and Painswick, on Wednesdays at Chipping Campden,
Gloucester, Northleach, Tetbury and Tewkesbury, on Thursdays at Bisley, Cheltenham,
Dursley, Fairford and Stow-on-the-Wold, on Fridays at Cirencester, Newent, Newland,
Newnham, Stroud and Wotton-under-Edge, and on Saturdays at Gloucester,
Leonard Stanley, Tewkesbury and Winchcombe. There was also a Saturday market at

Horsley, which Atkyns does not mention. It will have been noticed from this list that Cirencester, Gloucester and Tewkesbury had two market days each week, and that Moreton-in-Marsh, although it possesses an important Tuesday market today and its market charter was granted to the Abbot of Westminster in 1226, had no market at the time. It had ceased, temporarily, some time before Atkyns' survey. He does, however, comment on its favourable location for a market at the junction of the Fosse Way and the London to Worcester road.

Markets were often linked together in circuits of four, so that pedlars and craftsmen could travel from one to another to sell their wares on successive days of the week. A sixteenth-century court book from Northleach gives the licence fee for traders in the market at two shillings for townsmen and three shillings for strangers, and traders are recorded as coming to Northleach from Bourton-on-the-Water, Burford, Guiting, Naunton, Rissington, Sherborne, Stow-on-the-Wold and Winchcombe. Some of these traders would have visited other markets on other days of the week.

Three of the markets Atkyns mentions, those at Bisley, Newland (i.e. Coleford) and Stroud, did not have early charters. They were established after the medieval period and developed as a result of their increased population and prosperity associated with the industries working with wool on the Cotswolds and iron in the Forest of Dean. Most market towns had a population of above 1,000 people in 1712. There were, however, several growing woollen centres which had reached this population figure but were without a market. Kingswood and Nibley exceeded it, and Cam and Uley were only just below it. Westbury-on-Severn was the other parish with a large population of 1,200 but without a market. Fairford, Lechlade, Mitcheldean and Newnham, all market towns, had much smaller populations than these but had other commercial advantages, such as very productive agricultural hinterlands, bridge points on rivers, busy roads and nearby industrial growth.

We have already seen in chapter 2 that some markets arose beside Saxon minsters, and these market locations may be explained by the economic potential of sites chosen for religious reasons. In *Domesday Book* these markets are recorded at Berkeley, Cirencester, Gloucester, Tewkesbury and Winchcombe. Bisley, Blockley, Cheltenham, Deerhurst, Stow and Tetbury were also minster settlements that had markets at a later date. Other market towns developed from small settlements, where the lord of the manor had successfully applied to the Crown for the grant of a market charter, frequently following some special service to the king. In other cases, a completely new settlement was formed by very influential landowners, such as abbots and nobles, and laid out purposely to facilitate market activities. In the early eighteenth century these orderly layouts would have been very evident.

It is of interest that Kingswood, although not possessing a market, was described by Atkyns as having very compact houses 'like a market town'. Dense housing was not

always an advantage, however, and epidemics such as the plague spread more quickly in crowded conditions. The market at Painswick moved temporarily to Wick Street as a result of the plague and never fully recovered. Fire was another hazard when buildings were close together. Prestbury's market did not recover from a serious fire, nor did that of Leonard Stanley.

Today, the morphology of a planned medieval market town may be easily recognised. Northleach, founded by the Abbot of Gloucester in the 1220s, with a charter dating from 1227, has already been discussed in chapter 5. Stow-on-the-Wold and Wotton-under-Edge are also good examples of planned market towns and these will be considered in more detail.

The Abbot of Evesham held several manors around Stow-on-the-Wold, and was granted a market charter for Stow in 1107. Stow's breezy, hilltop site was at the junction of a number of old roads and tracks, which included the important north–south Fosse Way, an ancient east–west Cotswold ridgeway and a salt way. There was space for a large market area in this corner of Maugersbury parish, and it had been a meeting place as far back as prehistoric times in association with an Iron Age camp. An area of 33 acres was allocated for the market town, with a rectangular space for the market within the triangle of roads. The market area was bordered on the north, east and south sides by burgage plots, and mainly by the church on the west side. Buildings subsequently encroached on to the market place, as also happened in many other market towns. When a large market was held at Stow, the activities spread from the Market Square into Sheep Street, and a similar expansion into neighbouring streets was a common feature of most successful markets.

Although it has needed repair on several occasions, the fifteenth-century Market Cross still stands in one corner of the Market Square, symbolising the interest and protection of the Church (fig. 34). Early markets and fairs were often held in churchyards, and the Church frequently supplied the market crosses in order to identify the new market places and to demonstrate its continued concern for the welfare of both buyers and sellers, and sometimes also for the tolls collected at the cross! The shop at the corner of Church Street and the Market Square marks the site of the old Court House. This building, which was demolished in 1901, was constructed in the thirteenth or fourteenth century and here the pie powder court was held. This was a court where market misdemeanours could be dealt with rapidly before the pedlars or 'ambulatory merchants' left the town. The name 'pie powder' is a corruption of pied poudre, or dusty foot, a term applied to pedlars. Court leets or half-yearly courts were also established in market towns to ensure safe and fair trading. A bell was rung at the opening and closing of the market, and transactions were restricted to the designated market area. These regulations were designed to prevent unfair advantage and to facilitate the collection of tolls. There had been early legislation against 'regrators',

who bought food at one market to resell at higher prices at a nearby market; against 'engrossers', who bought up produce before the market opened in order to control the supply of goods and hence their prices; and against 'forestallers', who traded before the market was opened. Rudder tells us that the general decline of markets later in the eighteenth century was caused by forestalling. Weights and measures were also strictly controlled at the market, and there was always a weigh beam somewhere in the market area. At Stow there was another building associated with the market. This was Cross House, near to the Market Cross, and here the hurdles for sheep pens, sometimes known as cubs, and other market equipment were kept.

Over time some markets developed reputations for particular types of produce, and Stow's reputation was for sheep. Atkyns mentions 20,000 sheep being sold here at one sheep fair, a figure that was repeated at other times in the eighteenth century. It is thought that the very narrow passages leading from the Market Square, known as 'tures', may have been designed to ease the counting of sheep and to control their movements. Before corn exchanges and provincial banks were formed in the mid-eighteenth century, business transactions often took place in inns around the market area. Inns had always been important places for informal trading, and at Stow there were many, both in the Market Square and in Sheep Street. Some, like the Talbot and the Unicorn, were built at a later date but are on the sites of earlier inns, and several houses in the upper part of Sheep Street were former inns. A local tradition has it that every house facing the Market Square, as well as the inns, sold drink at the time of markets and fairs. There were fifteen ale houses in Stow in 1635 and twenty-four in 1755. Sometimes deals were finalised in church porches, places where trust and honesty might be expected, and market squares are often adjacent to churches where services were held on market days, as was the case at Stow. The right to hold an annual fair at Stow was granted in 1330, and from 1476 there were two fairs, both lasting five days around 1 May and 13 October.

The manor of Wotton was held by the Berkeleys of Berkeley Castle. After the destruction of much of the town by fire in the thirteenth century, it was rebuilt as a planned market town, with burgage plots each a third of an acre in size. This followed the grant of a market charter to Joan, Lady Berkeley, in 1252. Its main street and clothier interests were commented upon by Leland in 1537. He reported 'a praty

Opposite: Fig. 34 The Market Cross at Stow-on-the-Wold. The shaft and base date from the fifteenth century, while the head depicting St Edward, a calvary, the Civil War and the wool trade is modern. At the Market Cross tolls were collected, friars preached, petty criminals were publicly displayed and banns were read. The large Market Square at Stow was originally rectangular with burgage plots on three sides. The two-gabled frontage of the seventeenth-century King's Arms, behind the cross, stretches over one of these burgage plots.

market Towne, welle occupyed with Clothiars, havyinge one faire longe Strete, and welle buyldyd in it'. The site is sheltered, protected from the north by wooded hills, and overlooks a combe to the north-east and the village of Kingswood and fertile grazing land to the south-west. Water power for woollen mills was readily available in the valley below. Atkyns says it was an ancient place for clothiers, and Rudder adds that there were still seven or eight master clothiers in 1779, but the industry was less prosperous than formerly. Beside the former market place, known locally as the 'Stony Chipping', was the Green Chipping, a field where the fairs were held. It is now the Chipping car park. The name 'chipping', which is found in several place names and often refers to a particular area of a market town, means a market place where 'cheapning' or haggling over prices took place.

There are still a Tolsey and a Town Hall in Wotton, and both buildings rest on foundations laid when the market flourished. The warm brick walls of the Tolsey hide a jettied sixteenth-century building, which was the market court house given by Lady Anne, Countess of Warwick, another member of the Berkeley family. Its cupola and dragon weather vane, which makes an interesting contribution to the varied roof profile of the High Street, replaced an earlier one of 1707. The Town Hall in Market Street was the market hall of c.1700, and the fifteen stone pillars that originally supported the first-floor room and enclosed an open space beneath have been incorporated into the front and rear walls of the present-day building. They are best seen at the back of the Town Hall (see plate 13). Behind the frontages of many shops in the High Street and Long Street, and also in some side streets, are houses that were standing in Atkyns' day, and in a few instances, such as 13 Market Street, their original forms are still visible. But the clearest evidence that Wotton was a planned market town is in the grid pattern of its narrow streets and their occasional widening. The three-day fair at Wotton was held in September and was noted for cheese and cattle. Atkyns gives its date as 14 September, which became 25 September after the 1752 calendar change.

Markets dealt with a wide range of products, which were brought to the stalls by wagons, packhorses, hand carts and baskets, or in the case of cattle and sheep, driven along the surrounding roads to the market pens. In the small markets there was no clear segregation of wares, but in the larger markets different areas dealt with particular goods, with meat being sold in a specialist area, usually called the Butchery or Shambles. At Tewkesbury, sheep were sold in Church Street, cattle in the upper High Street, corn between the White Hart and the Quart Pot Inns in the lower High Street, and hatters and coopers sold their wares in Barton Street. Gloucester also had special areas for particular types of produce, for which there is clear documentary evidence from the fifteenth century.

Markets with specialisms had catchment areas that were more extensive than the usual 6- or 7-mile radius. The latter spacing had been advised by the thirteenth-century

lawyer Henry de Bracton, who had reasoned that a person travelling to market could walk 20 miles in the day. So if the day was divided into three, with a third of the time spent in journeying to market, a third buying and selling at the market, and a third returning home, the maximum range of a market was a third of 20 miles, or in Bracton's words 'six miles and a half and a third part of a half'. Farmers within a radius of 3 or 4 miles of a market town took their farm produce to that local market, but farmers further away may have considered using several markets, their choice being determined by seasonal advantages, dates when many buyers were known to come, or by reputations for a particular product. The catchment areas for specialist markets could extend to as much as 70 miles.

The markets at Chipping Campden, Dursley, Tetbury and Wotton-under-Edge were noted for cheese, and Atkyns writes that the price of cheese was set for the whole area on 17 September at Barton Fair in Gloucester. Wool and yarn were sold at Cirencester, Minchinhampton and Tetbury; Cheltenham and Cirencester specialised in corn; Gloucester and Tewkesbury in fruit and hops; and Winchcombe in horses. Because of the high levels of productivity in the local area, Tewkesbury market sold the cheapest provisions. As livestock could be driven long distances, the markets specialising in cattle, sheep and horses were more widely spaced than those dealing in corn. The latter was a bulky product and had to be transported by wagons along poor road surfaces. The success of the markets at Gloucester and Tewkesbury owed much to their river crossings and riverside quays.

Shops already existed in medieval towns and villages. Interesting examples from the late fifteenth century survive in Abbey Cottages, Tewkesbury, where the wooden window shutters could be lowered to make counters (see plate 14). Here, the front room was the shop and living accommodation was at the rear and upstairs. One of these properties is often open for inspection. Robert Cole's rental of the properties in Gloucester in 1455 records forty-six shops, eleven inns, five bakeries and five forges. In addition to shops, temporary stalls were set up in the main streets of market towns. Often these streets were wider than others in the town, as with Westgate Street in Gloucester and the High Streets of Chipping Campden and Tewkesbury. In some other towns distinct market squares or market places were formed. These occur in Cirencester (see plate 15), Fairford, Lechlade, Minchinhampton and Winchcombe, as well as at Northleach, Stow-on-the-Wold and Wotton-under-Edge. The Market Square at Minchinhampton was once larger and more regular in plan than today, with buildings in the middle of both the High Street and Butt Street, as the Kip engraving shows (fig. 35). There were three adjacent inns, the Crown, the former Ram and the former White Lion, and the Shambles were south of the churchyard. The manor house, home of Philip Sheppard, who gave the Market House, was to the west of the church, where the school stands today. The Market House still carries a board giving various

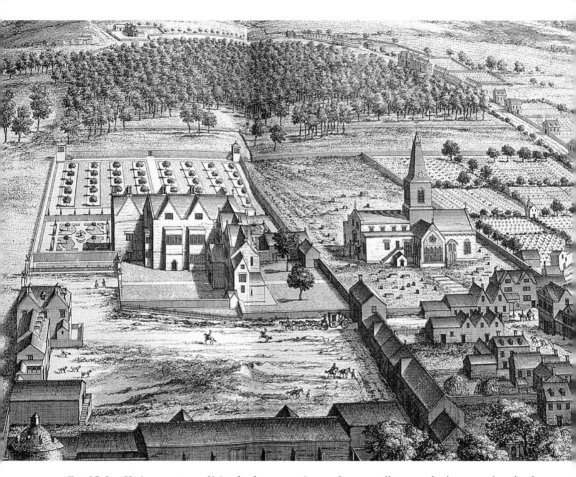

Fig. 35 Jan Kip's engraving of Minchinhampton. It was drawn to illustrate the house and park of Philip Sheppard, lord of the manor in 1712, but it also shows the Market Square on the lower right-hand side.

charges, including the 1/- rental for a stall of 8ft x 4ft. (1/- had been the normal yearly rent paid to the lord of the manor for a burgage plot.)

Market houses for the sale of valuable or perishable goods were built at Chipping Campden in 1627 (fig. 36), at Tetbury in 1655, at Newent in 1668 (see plate 16), at Minchinhampton in 1698 and at Wotton-under-Edge in 1700. They not only gave protection for the goods to be sold, but were also places of trading, and sometimes the market court was held in the room on the first floor supported by the pillars. These buildings still give visual charm to town centres, as does the market house in Dursley which was built in 1738. Usually the main thoroughfare passed on one side of the market house and a narrower street on the other. There were market buildings in other

towns, including Bisley, Cheltenham, Littledean, Painswick and Stroud, but these have all been demolished. The market house at Coleford was destroyed in 1643 during the Civil War, but a replacement was erected in 1679 and this remained until 1968. At Northleach, the market house has been hidden in further building developments. There was a Boot Hall, a Market House and a High Cross there, all probably in the area now known as the Green. The property at present called the Market House, beside the Red Lion Inn, was not the official market house but has been formed from two old cottages. Some market towns have street names referring to a particular day of the week, and these may indicate the day of the market, but in the case of both

Fig. 36 The Market Hall, Chipping Campden. This was erected in 1627 for Sir Baptist Hicks at a cost of about £90. His coat of arms is displayed on the north side of the building. Butter, cheese and poultry were originally sold here. The Market Hall is now maintained by the National Trust.

Minchinhampton and Painswick, which have Friday Streets, the market was held on a Tuesday.

The fairs of the market towns often lasted for several days, and one was normally held on and around the feast day of the patron saint of the church. It seems likely that the selection of some patron saints was influenced by a need for the day to be at a time when there was less work on the land. By far the most popular church dedications, making more than twenty per cent of all dedications in the county, were to St Mary, but there were relatively few fairs held on her feast days, which occurred in busy farming periods. Atkyns notes that on the feast days there were large concourses of people, ideal for buying and selling. He also quotes a statute of Henry VIII requiring all church dedications to be on the first Sunday in October. The associated fairs would then be held when harvest was over and people had more leisure time, but he adds that this statute was not observed in the eighteenth century. Earlier statutes had prohibited fairs on particular religious festival days, but these laws were also 'ill observed'. He gives the dates of the various fairs and, in some cases, the principal speciality. Cirencester and Tewkesbury had five fairs in the year; Chipping Campden, Gloucester and Newent four; most market towns had two, although the frequency changed with shifting prosperity. Fairs usually included the sale of cattle, horses and sheep, with Cotswold fairs being particularly important for sheep and Vale fairs for cattle and cheeses. Some autumn fairs involved the hiring of farm labourers for the next year's work, a development which arose as farming became more specialised and significant numbers of extra workers were required at peak periods in the farming year. These were mop fairs, when the person seeking employment carried an insignia of his or her craft, such as a shovel for a labourer, a bill for a woodman and a wool comb for a cloth worker.

Although fairs were held in every month of the year except January, most occurred in four particular months of the year: April, May, July and November. These were months which corresponded to the slacker periods in the farming calendar when ploughing, spring sowing, hay making and harvesting were usually over. Some dates were movable when linked to Easter and Whitsun, and some were on specific days of the week, such as a Wednesday or a Saturday after a saint's day. It should also be noted that the dates of fairs, as well as the days of the week when markets were held, had often changed between the grant of the first charters and the time when Atkyns wrote.

The catchment areas of fairs were much larger than those for specialist markets and some, such as Barton Fair in Gloucester and the great sheep fairs at Stow-on-the-Wold, were of national or even international importance. At Barton Fair, traders came from the continent bringing spices, cloth and silks, and others came from far away in England, with products of tin from Cornwall and of lead from Derbyshire. Each trader was allocated a special place in the layout of these fairs. Fairs were important local time pieces. One emigrant farm labourer thought that even in Australia people would

know the date of Stow fair! The October fair at Stow, which today is a gypsy horse fair (see plate 17) with a range of cheap stalls, was then noted for its cheese and hops. Fairs required more space than markets for their tents and booths, and so were often held on land outside the town, such as the Green Chipping at Wotton-under-Edge, Castle Field at Dursley and the meadow by St John's Bridge at Lechlade. Fairs sometimes had special names and Atkyns records the 'Frying Pan Fair', held on 3 February on the green at Frampton-on-Severn.

While markets were essential parts of the working week, where news and other items of information were shared and where vital goods required for the running of home and farm were bought and farm produce sold, fairs were also great social events. Entertainments and sports took place at the fairs and, as they were held after periods of heavy labour, there was more time for relaxation and leisure. Jugglers and conjurers, singers and dancers, boxers and wrestlers came to the fairs, as well as pickpockets and petty thieves. There were races and puppet shows and jesters performing. No longer were buying and selling, bargains and losses, economic successes and failures the only issues on the minds of those who travelled to the fairs – although for some these were of huge significance and involved large sums of money.

Fig. 37 The restored King's Board in Hillfield Gardens, Gloucester. This was erected in Westgate Street in the late fourteenth century and used as a pulpit by friars. It became the butter market in the sixteenth century and was eventually removed from the middle of the street in 1750 [see p. 158].

As we have hinted in other chapters, in viewing the layout of the market places, noting the variety of old inns, admiring the sturdy structures of the market houses and resting on the steps of the market crosses, we easily forget the social interaction and the bustle around the market stalls and pens that once took place here on market days, and the calm that settled over the fields when the fair was over and the last traders had left.

We have noted in chapter 7 that market towns had other functions beside the buying and selling of produce. They frequently had a grammar school and a row of almshouses. As the scale of marketing farm produce increased, with private transactions becoming more important, it was essential that those involved in these activities should understand accounting and written agreements. Grammar schools provided these skills and at least eleven of the county's twenty-four market towns had grammar schools. Ten of them also had almshouses, often provided by prosperous merchants, who had benefited from their local upbringing and from their marketing successes. Atkyns thought that market towns could be further improved by street lighting, 'set up as in London', and in the more populous towns he advised that 'a piece of ground should be set out with delightful walks and planted with rows of trees for public use'. This would therefore provide for 'health and pleasure, and better discourse of affairs' – an attractive idea, far in advance of anything in Gloucestershire at the time, but perhaps inspired by the earliest spa towns, such as Bath, Epsom and Tunbridge Wells.

9

Good Houses & Handsome Seats

———✦———

For almost every parish of the county, Sir Robert Atkyns records its total number of houses. Sometimes these houses were clustered in a single settlement, in other parishes they were shared among several scattered hamlets. Thus Harnhill, on the Cotswolds, had twenty houses grouped together in the nucleated village, while the next parish in alphabetical order, Hartpury, situated in the Vale of Gloucester, had its sixty houses dispersed in six hamlets, mostly named -End, such as Moor End. The majority of houses at the time were small, of two or three rooms, and Atkyns thought that they were occupied on average by no more than four people in the rural settlements and by five in the compact market towns. In rural areas some of these seventeenth- and early eighteenth-century cottages and former farmhouses still remain today, particularly if they were well built in stone and where money was not so readily available for later rebuilding. Most were tied properties, occupied by labourers and farmers working on the manor estate as tenants of the lord of the manor, and they were generally maintained by the estate. On the Cotswolds they were often built by the farm labourers themselves, who usually had dry-stone walling skills but needed some help from an experienced stonemason for the key structural elements of chimneys and corners. The houses were constructed from building materials invariably drawn from within the estate or parish. There is, therefore, a local conformity to them, which was imposed by the building materials and by the skills of the craftsmen, and as a result the Cotswold vernacular style differs from that of the Vale and also from that around the periphery of the Forest of Dean. The houses were functional for their occupants, suitable for the daily round and common task, and expressed little concern for the whims of changing architectural fashions or the desire for competitive display. Some did not last long and were replaced on the same site, but those that remain have undergone repairs from time to time and are now in their best ever condition, having been modernised, extended and adapted for retirement or commuter living.

A notable village, extremely popular with today's tourists, which well illustrates the architectural characteristics of an early eighteenth-century Cotswold village, is Bibury. Appropriately, J. Arthur Gibbs gave the title A *Cotswold Village* to his classic study of Bibury, while earlier in the nineteenth century William Morris had expressed the opinion that Bibury was the most beautiful village in England, and as far back as 1726 Alexander Pope had referred to its 'pleasing prospect'. The focus of Bibury was then the small green, now known as the Square, and Arlington, its adjoining neighbour, was similarly focused on a small green. Beside both greens are clusters of seventeenth- and eighteenth-century cottages. They are mostly built of rubble or undressed stone. Some have stone-mullioned windows but the majority have oak lintels and window frames. Most have steeply pitched roofs, which include dormer and gable windows, and they are frequently planned with a cross passage. The latter feature can be easily recognised from a front door being positioned just to the right or left of a line drawn vertically down from the central chimney and good examples may be seen in the row of cottages to the south-west of the Square (see plate 18). Most of the cottages beside the road bordering the River Coln are of this same period.

There are several houses of particular interest in the village. The Pigeon House on Packhorse Lane, the lane along which wool was once carried to Osney Abbey's wool store at Arlington Row, is a much earlier house than those we have mentioned, but is built in the same style. Arlington Row, probably the most frequently photographed group of cottages on the Cotswolds, was converted from the wool store into weavers' cottages by the seventeenth century. The outdoor privies and cottagers' pigsties can be seen from the rear. Cloth was woven in these cottages and then taken to the fulling mill at Arlington on the other side of Rack Island, the former cloth drying ground. The road down Awkward Hill, which passes in front of the cottages and across the narrow stone bridge, is an early routeway, but the other crossing of the River Coln for the old Cirencester to Oxford road, first recorded in 1619 as the 'Burford Way', was originally behind Arlington Mill. The road then followed a course, still visible, to the rear of the Swan Hotel, then to a dog leg section of Packhorse Lane and joined the present Burford Road towards the top of the hill at the north of the village. There was then only a path beside the left bank of the Coln towards the stone footbridge. Bibury Mill, where the mill house also dates from the seventeenth century, is downriver beyond Bibury Court. As was common at the time, there was one much larger house in the village, and Atkyns writes of Bibury Court: 'Henry Sackville has a handsome large house near the church and a great estate.' There had been an older house here owned by the Westwood family, former lords of the manor, which now forms the north wing of the E-shaped frontage. In 1633 Thomas Sackville extended the property to its present plan, and had the Sackville coat of arms displayed above the central porch (fig. 38).

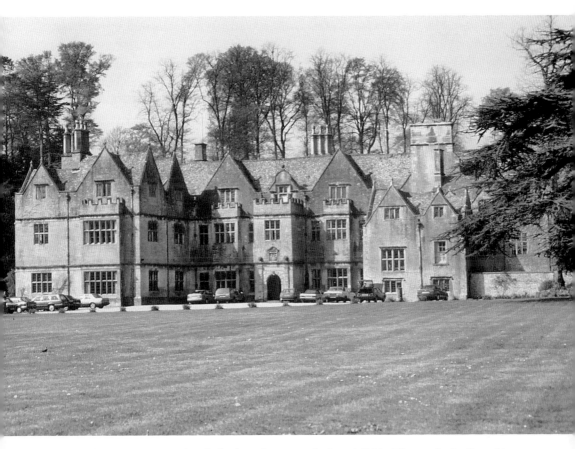

Fig. 38 Bibury Court. Now a hotel, this large house was built in 1633 by Thomas Sackville and it incorporated as a wing on the right side the manor house of the Westwood family, early benefactors to Bibury and Northleach.

The house, with a frontage which at first glance appears to be symmetrical, has a fine view down the Coln valley. In winter, however, with the low sun, it lies in the shadow of the wooded and steeply sloping hillside on the right bank of the river. But shade was not seen as a problem for house location in the seventeenth century, and dining rooms were normally positioned to avoid the glare of evening sunlight.

Apart from its through traffic, congested car parking and considerable visitor activity, Bibury retains a recognisable early eighteenth-century ambience, best appreciated on a warm summer evening, after the last tourist coach has left and the village quietly settles. A fine enclosure award map for Bibury has been preserved at the County Records Office, and this shows the village layout in 1768, when it had scarcely changed from Atkyns' time.

A rare collection of yeoman farmhouses, sensitively restored and improved in the early twentieth century by Sir Philip Stott, who bought the village estate in 1906, is at Stanton in the north of the county. Cotswold stone houses of a deeper, rustier colour than at Bibury, with gables, finials and mullioned and transomed windows, are grouped together along the village streets (fig. 39). Some have their dates and owners' initials cut into the stonework above the doors, for example 'TW 1577' referring to Thomas Warren. The manor of Stanton belonged to Winchcombe Abbey until the Dissolution, and then passed through the hands of several middlemen before being 'parcelled', Atkyns says, 'amongst divers freeholders'. This explains why there are so many substantial houses here, in addition to the old manor house, and also why it has become another modern tourist village. The architecture reveals a different social structure in early seventeenth-century Stanton from that of most other villages, a

Fig. 39 The two main streets at Stanton are lined with large, well-built yeomens' farmhouses. Some have their dates and the initials of their first owners above the door frame.

distinction that is more clearly visible today than it was in Atkyns' time when properties were not as well preserved.

Near the county border, across the River Severn from Tewkesbury, lies the village of Forthampton, with its loosely scattered houses. Here, the seventeenth-century properties are timber-framed, now with brick infill, but originally of wattle and daub. The larger houses have close timber studding, and thatch is still a common roofing material. There are also later estate houses of brick, built when the whole parish had come into the possession of the Yorke family, and the latter's resources have enabled the survival of so many earlier cottages and farmhouses. Oak trees are common in the area and they provided the main local building material, but mature elm trees, which often provided floor boards, have disappeared from the landscape following the ravages of Dutch Elm Disease. Occasionally, local Lias limestone has been used in the older buildings. Atkyns refers to two houses in this parish: Southfield House, the home of the Hayward family, which was rebuilt in brick in the early eighteenth century but possesses a collection of brick outbuildings, some of which are older; and the 'very good seat and estate' of Charles Dowdeswell. The latter was Forthampton Court, referred to earlier as the medieval country residence of the Abbots of Tewkesbury, and which had been bought by the Dowdeswells of nearby Bushley in 1677. A large and impressive property, it has been remodelled many times, but on the south-west side of the courtyard is the original medieval hall. The oak timber-framed cottages of Forthampton are typical of many along the low-lying clay Vale, but in the wetter areas, near springs and streams, the curved branches of black poplar trees provided the chief structural timbers for cruck-framed cottages.

The houses in these three villages give a fair impression of the variety of properties to be seen in the rural settlements of Atkyns' Gloucestershire. His parish statistics also allow an assessment to be made of the spatial variations in the county's housing density. He provides both the number of houses and a linear distance for nearly all the parishes in his survey. The linear distance is probably the circumference of the parish but, as we have seen, his mileages do not correspond to present-day statute miles. If we take the number of houses and divide this by the mileage figure, we may obtain a crude index of parish housing density. These indices show major variations across the county. The lowest densities are found in the high Cotswolds, where there was a relatively low-yielding system of agriculture, but even here there may be sharp contrasts between adjacent villages. In the Vale, densities are higher and increase towards the south, especially near the River Severn. Within the Forest of Dean, Atkyns says, only the original six keepers' lodges were to be found, following a recent large-scale hovel clearance, but the villages around it were large and accommodated the mining population as well as those engaged in local agriculture. Houses were always tightly packed in the market towns throughout the county, but by far the densest housing was

in the expanding woollen towns, especially Stroud and Dursley, and to a lesser degree Wotton-under-Edge and Bisley. Only Tewkesbury and parts of Gloucester approached these textile centres in density of housing. Further comments on population density, as distinct from housing density, are made in chapter 11.

But Atkyns' main interest was neither in cottages and farms, nor in housing density, but in the larger properties. In three-quarters of parishes there was a 'good house and good estate', and some parishes had two or more of these. About 300 such houses and estates are recorded. The principal houses were often to be found 'near the church' and they were frequently referred to as manor houses. The sites of the manor houses were much older than the actual buildings that existed in the early eighteenth century, and the remains of moats around some of them suggest thirteenth-century origins. Whittington Court and the site of the old manor house at Weston-sub-Edge have well-preserved, though dry, moats. He records moated houses at Boddington, Hardwick, Prestbury, Siddington and Twyning. Occasionally, the principal houses are described as having a large prospect over the surrounding countryside, which we consider further in chapter 13, but many occupied sheltered positions, enclosed by hills and woods. There is possibly a distinction to be made between 'good houses' and 'handsome seats' in Atkyns' terminology, but this is not entirely clear from the text or from the surviving properties. He usually gives the name of the person owning the house at the time but, if the house is not named, it is not always possible to identify the building from the limited information he provides. He also records that some properties were newly built, that others were ancient seats of the landed families, and in a few cases he refers to their size and their building materials of stone or brick.

There had been a significant increase in the number of gentry families in Gloucestershire in the sixteenth century, and when former monastic land became available at the Dissolution, these families were in a position to express their rise in status by newly built houses. Most of these were constructed after the 1580s. Building ceased during the Civil War, but it resumed soon after, despite Parliament's sequestration of large sums of money from Royalist families. In his references to the country seats of the gentry, Atkyns is supported by the Kip engravings. Jan Kip came from Amsterdam as an engraver and drew many Gloucestershire houses for an earlier publication. A few more were added to these for *The Ancient and Present State of Glostershire*, and forty-two of the sixty engravings are of properties in the present county. Kip's drawings are oblique aerial views, usually of the front of the houses and often from the right-hand side, and invariably from viewpoints he could not possibly have reached in order to make his observations. The engravings are remarkably detailed for the main buildings and often include other features of interest in the gardens and the surroundings. Careful inspection of the engravings reveals the fashionable projections and recessions in the frontages of the houses, larger windows which indicate where the hall or parlour was positioned and

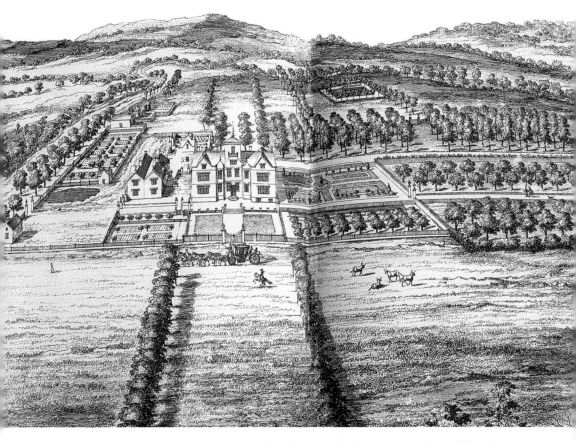

Fig. 40 Jan Kip's engraving of the Greenway, Shurdington. The house was built in 1620 and its frontage has not been greatly altered. The garden had a symbolic meaning, which is explained in the text.

large chimney stacks which indicate the location of the kitchen. Seventeenth-century houses became increasingly symmetrical in the appearance of their frontages, and classical features such as pilasters had been introduced to the newest properties. Most of the houses that Kip illustrated have been demolished or destroyed by fire; some have been completely replaced by buildings of different architectural styles. Some have been so modified that there is little visible external trace of their early eighteenth-century forms, and a few have frontages almost unchanged from the Kip portraits. Three of the houses or 'seats' Kip engraved are considered here because of their variety of interesting surviving features and their relatively good accessibility – the Greenway at Shurdington, Coberley Court and Stanway House.

The Greenway was home to several generations of the Lawrence family, and the front of the house, built in about 1620, with three large gables and two smaller ones between

them, is still much as Kip has drawn it (fig. 40). Each gable has a finial, the wings of the house project while the entrance recedes, and the mullioned and transomed windows have continuous drip moulds above them, as Kip has shown. The only differences today are that the base is all that remains of the central octagonal cupola, which Kip drew as a small square room, and bay windows and a modified porch have been introduced. The walls are now rough cast with ashlar details but the whole general appearance is typical of an early seventeenth-century small country house of Cotswold stone. The garden Kip has drawn had symbolic significance. It consisted of a succession of enclosed compartments, which increase in size from left to right in the engraving, and were designed by William Lawrence in 1692 to be representative of the successive stages of life. The larger garden to the right of the house symbolises maturity. There are many urn-capped piers on which Lawrence inscribed letters and dates referring to various members of his family. The gateways between the gardens represented the sequence of obstacles faced in the different stages of life. In front of the garden symbolising maturity is a plantation of fruit trees representing heaven. He chose to plant the border between these two compartments with cypress trees because of their association with death, and laurels were also used in the plantings because of the early spelling of the family name of Laurence. The original intention was for four avenues of oaks to form a cross to be centred on the house. The whole design was for a memorial garden, which Kip, with his use of standardised ways of representing vegetable plots, orchards, topiary and avenues, may not have appreciated. A few ancient oaks and yews are all that remain of Lawrence's planting, most details having been lost in later landscaping. The fish pond in the background of the engraving, to the right beyond the house, is now a damp hollow, and the busy A46 road follows the foreground margin, with Greenway Lane represented by the winding, rutted track to the left.

In one of his published letters, Lawrence describes the view from the top of the hill above the Greenway. The description was made before he had inherited the estate from his uncle, and is dated 1675. He wrote that from here, 'I see the three divisions of the county, the Cotswold Hills, the Vale and the Forest; the first eminent for pleasure, the second for profit, and the third for strength'. The first division of the county was famous, he noted, for its rich fleeces and country diversions; the second for its meadows, cornfields, enclosed pastures, for Tewkesbury and the pleasant city of Gloucester; and the third for its oak ship timbers and the cast-iron guns from its iron industry – a neat and concise summary of the county's late seventeenth-century landscape and economy.

'Jonathan Castleman has a large house near the church with handsome gardens and ponds and a great estate.' This statement is included in Atkyns' entry for Coberley. The estate originally belonged to a branch of the Berkeley family, and there are monuments to several of its members in the church. The house was demolished in 1790 and the chancel and nave of the church were rebuilt in about 1870, but many features of the

Kip engraving survive in today's landscape. The courtyard of the house had a high crenulated wall, and parts remain with their arched and pedimented doorways. The long barn in the foreground of the engraving also remains, and it has been pointed out that the positions of the carriage and postern entrances to the house have been reversed by Kip. Beyond the site of the house, now marked by uneven stony ground, a pond with a small island represents what appears to be the canal of a Dutch water garden in the engraving, and the two avenues in the distance, as well as the track beside the buildings, are now public footpaths (fig. 41). There is no evidence on the ground today that these avenues ever existed or that the pond extended to the right of the bridge, but a curving ditch and bank across the nearby field may be the boundary of a medieval deer park. It is easy to envisage an early eighteenth-century landscape at Coberley.

Fig. 41 The 1712 engraving of Coberley Court. The house was demolished in 1790, but many features in the engraving may still be identified in the landscape.

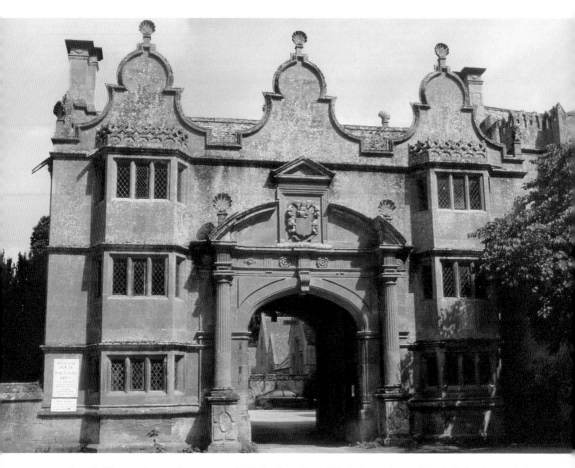

Fig. 42 The gatehouse, Stanway, probably built in the 1630s. Notice the scallop shell finials, symbols of the Tracys.

The same is true for Stanway, although here, with its fourteenth-century tithe barn, there are traces of its earlier links with the Abbots of Tewkesbury. The estate was purchased after the Dissolution by the Tracy family and is still in the possession of its descendants. The west front of the house was built between 1580 and 1590. It has four widely spaced and high gables, and a huge oriel window for the hall, containing a remarkable total of 1,036 panes of glass. The south front, which is shown in the Kip engraving, dates from 1620 and has a low symmetry with strapwork over the bays. The contemporary gatehouse, in a richer coloured stone than the west front of the house, has curved gables and above them are stone scallop shells, the emblem of the Tracys (fig. 42). Other gateways are similarly decorated. Kip's view shows the road passing in front of the house, whereas now it skirts around the church and tithe barn. This cluster

of honey-coloured buildings is little changed from Atkyns' time, when he refers to John Tracy's 'large, handsome house near the church'. The house and grounds are open to the public in summer months.

Nearby Toddington was the main seat of the Tracys. Kip shows a magnificent courtyard house, again built in 1620, with impressive gardens containing statues, trees planted in tubs, and a large fountain. The house was built on three sides of the courtyard and the fourth was closed by a screen wall and gatehouse (fig. 43). The ruins of this gatehouse remain from the time when the site was abandoned for a new mansion on higher and drier ground in 1819 (fig. 44). Another former courtyard house of smaller scale, which Kip also engraved, is Upper Dowdeswell Manor. This was built in about 1590 for John Abbington and has a north front of three central bays and slightly protruding gabled wings. Lionel Rich owned the house at the beginning of the

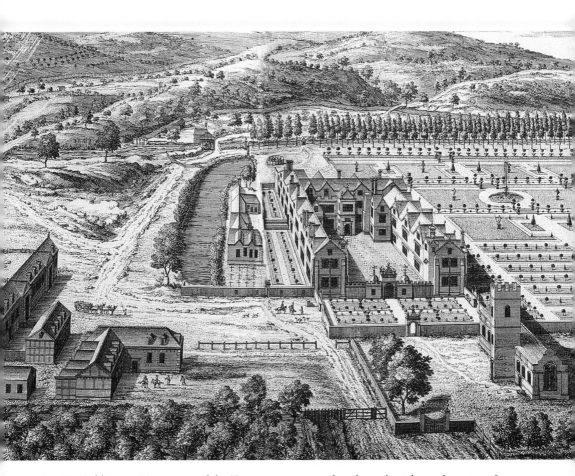

Fig. 43 Toddington Manor, seat of the Tracys, as it appeared in the early eighteenth century. Its impressive size may be assessed by the surviving ruined gatehouse [see fig. 44].

eighteenth century, and he was responsible for several additions, including the stone piers and elaborate urns forming the gateposts at the entrance to the front court. His arms are over the door. The outbuildings shown in the engraving also remain, although the whole of the south range was demolished when the property was downgraded to a farmhouse.

Other important houses Atkyns mentions which retain the same frontages today include Barnsley Park, Newark Park and Owlpen Manor. At the north end of Barnsley village, near to where the road turns to go round the park, is the beginning of a footpath which passes beside a ha-ha on the west side of Barnsley Park House, from which is a clear view of the building. The west side is of nine bays, with impressive Corinthian pilasters, a large three-bay pediment in the centre and balustrade around the top. It is

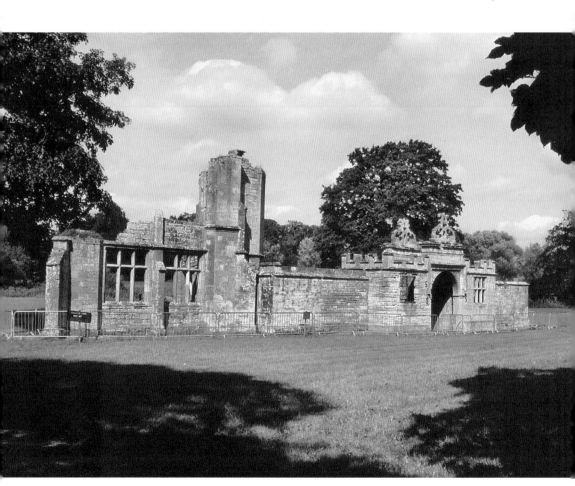

Fig. 44 Only the ruined gatehouse and parts of the screen wall remain from Toddington Manor [see fig. 43].

in a grand Baroque style, unique to the county, and most writers on Gloucestershire's architecture believe it was built after Atkyns' publication. But in his entry for Barnsley he writes, 'Brereton Bourchier has a large new house with a pleasant grove, walks of trees, large park and great estate'. Bourchier died in 1713.

The east front of Newark Park is largely unchanged from the 1550s when Sir Nicholas Poyntz, a courtier of Henry VIII, had the hunting lodge built with stone obtained from Kingswood Abbey. This symmetrical front is of three bays, four-storeys high, and with mullioned and transomed windows. The entrance is on the first floor and reached by a simple flight of steps. The south side, with its superb view over the Ozleworth valley, has been rebuilt, but the flat roof remained as a viewing platform from which the hunt could be observed. Atkyns refers to it as a 'handsome seat which stands high and has a great prospect' (see fig. 66 on p. 174). It is now in the possession of the National Trust.

Owlpen Manor, east of Uley, in an embayment of the Cotswold escarpment, was 'Thomas Daunt's ancient seat near the church'. The building of the house, which lay derelict in the nineteenth century, began in the fifteenth century. The south front, which has a great variety of window sizes, dates from 1616 on the left, from the sixteenth century in the centre and from the fifteenth century, with 1719 remodelling, on the right (fig. 45). Yet despite the many alterations there is a unity in its composition. It is in a secluded setting, facing a steep hill, and is probably on the site of an earlier property. The terraced garden at Owlpen, with its now massive yew trees, was laid out in the early 1720s, and the account book giving details of expenditure on this layout and planting has also been preserved in the County Records Office.

At Sherborne, Atkyns records Sir Ralph Dutton's 'large stately house by the church' and his 'pleasant paddock course and beautiful lodge house'. The former has been rebuilt, possibly on the lines of the earlier property drawn by Kip. The latter is Lodge Park, built in elegant classical style in the early 1630s for the entertainment of the Duttons' guests and as a viewing platform for deer coursing. Both the balcony of the first-floor banqueting room and the flat roof gave good viewing opportunities over the 1-mile course passing in front of the lodge. This also is a National Trust property.

Two other large houses, not this time built of stone, are of interest. 'Edward Cooke has a large beautiful seat, great gardens and plantations, large ponds and a pleasant prospect on the city of Gloucester and Vale.' Highnam Court, to which this entry refers, was built in 1658 following damage to an earlier property in the Civil War. The site is in a park, which originally belonged to the Abbots of Gloucester. The very large brick house, with a frontage of nine bays, an ornate doorcase and eaves cornice, has been very well preserved, and its present setting is as attractive as the one Atkyns describes – although the scenic 'prospect' towards Gloucester has changed.

A short distance north-west of Dymock is Preston Court, 'William Pauncefoot's handsome house by the church'. This fine timber-framed mansion was built on land

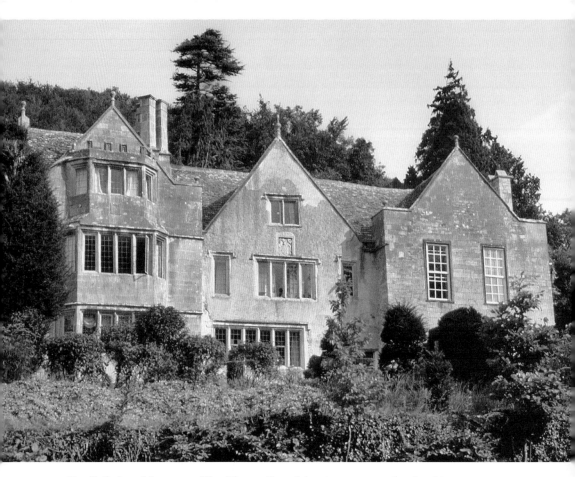

Fig. 45 Owlpen Manor, near Uley, Thomas Daunt's 'ancient seat near the church'.

that also belonged at one time to the Abbots of Gloucester. The central part of the west front is close-studded and dates from 1590, while the extensions at the side have square timber-framing and are from 1610. Above the jettied second floor are six gables and the lower floors are typically asymmetrical (see plate 19). It is now the only large timber-framed country house in the county, although there are several others across the border in Herefordshire.

Thus, by the early eighteenth century, there was considerable variety in the architectural styles of the 'handsome seats', a variety reflecting differences in building materials, dates of construction and fashions. There was also a large range in building costs. Sir Baptist Hicks' Campden House (see fig. 68 on p. 177) is reputed to have cost £29,000 in 1620, while the contract for Lower Slaughter Manor (see plate 28),

'a neat handsome seat', built in 1656 for Richard Whitmore, was for £200. Although Lower Slaughter Manor has been extended, the original frontage with five windows on the first floor can be easily envisaged. Its builder, Valentine Strong, was an important Cotswold master mason from Taynton near Burford who also worked on the great houses of Sherborne and Fairford. It was at Fairford that he died and his bale top tomb is in the churchyard there.

Eighteen of the houses Atkyns records are given additional comments on their gardens, usually described simply as 'pleasant', 'beautiful', 'adorned' or 'delightful'. For some houses there are also references to groves and ponds, and the Kip engravings convey additional information on their appearance. Gardens were formal, orderly, with strong linear features, and evidently very labour intensive. Kip tends to exaggerate their sizes and has his own coding for orchards and vegetable plots, which were often more spacious and evidently more important than the flower gardens. Clipped trees and topiary, parterres with repeated patterns, fountains and statues, pillars, urns and stone steps are all features to be seen in most engravings, so too were 'pleasant long walks of trees', as at Fairford and Sapperton (see fig. 4). Many gardens also had canals, which reflected in their water the newly acquired exotic flowers and the shearing skills of the gardeners as they worked on yew, holly and box. As we have noted before, the engravings were drawn to flatter the owners of the houses and we may not be sure of their complete accuracy, but they give a good general impression of the layout of gardens at the time. This style of design was soon to be swept away with changes in garden fashion, briefly replaced in the 1740s with the rococo style, which we may observe restored at Painswick House, and then by the traditional English landscaped garden. A few skeletal remains, such as banks, water courses and long-lived trees, may still be found where the house was downgraded to a tenant farmhouse or where the property was no longer the principal seat of the family, but elsewhere all traces have gone. The finer details of an early eighteenth-century garden design are best experienced and appreciated in the restored garden of Westbury Court, now also a property of the National Trust, to which Atkyns makes reference as 'Maynard Colchester's large house and seat'. Maynard Colchester designed the garden, and his surviving account book, giving details of the plants purchased and other costs, together with the Kip engraving, have given authenticity to the restoration.

In looking at these grand old houses and their settings, we must remember that they are not just features of historic interest, but have been home to many generations of their resident families. Changes over time in the social and economic status of the occupants have been reflected in the changing state of the fabric of the buildings, and today's residents may have quite different positions in local society to those for whom the houses were originally built.

There were other homes which Atkyns completely overlooks and which have left no trace in the present-day landscape. These were hovels of fragile construction and low durability, especially common in the industrial areas but also found in other places where there was a seasonal demand for labour. Early documents record their existence as when, in 1656, Cromwell ordered the suppression of 400 'cabins of beggarly people' in the Forest of Dean. By 1700 there were many landless and migrant labourers who had been displaced by the enclosure of common land or by changes in agricultural practice and were now rootless. Their former homes had been demolished by the landowners and they now lived in temporary shelters. They were largely ignored and may not even have been included in the population totals we will consider in chapter 11.

10

Rural Land Use

———◇◦◦◦◇———

The predominant land use in each parish is another significant item of information Atkyns records. He uses four categories of land use – arable, pasture, meadow and wood, and records them either singly or in various combinations. As one might expect, almost every parish had areas of arable land and many parishes had pasture as well, but meadow and woodland were more restricted. The distinction between pasture and meadow was an important one at the time. Pasture was for grazing sheep and cattle, while meadows were primarily for hay, but were also grazed by livestock after the hay crop had been cut and carried. There were strict manorial rules about the numbers and types of grazing animals that were allowed to use the common pasture, and also about the dates by which haymaking was to be completed and grazing animals could be introduced to the meadows. The plant species growing in the pastures and meadows also differed, not only because of contrasts in soil type, but also because of different management regimes. Sheep nibble close to the ground and so plants which have their growth tips more than an inch or two above the ground are gradually eliminated from sheep pastures. These plants may survive cattle grazing, however. Cattle feed by pulling the vegetation into their mouths with their tongues and so do not graze as closely. Also, in fields where grass is cut for hay, plant growth is left unchecked until May or June, and the taller species that are allowed to flourish until haymaking tend to smother the shorter species.

Although Atkyns' method of recording land use was very general, it is the earliest survey of its kind, and we have to wait for nearly another hundred years for the first acreage returns for specific crops. From the information he provides, it is clear that at the beginning of the eighteenth century there were well-marked land use differences between the Cotswolds, the Vale, including the north-west of the county around Dymock, and the parishes bordering the Forest of Dean. Farming had become more specialised by now and local subsistence was no longer the only concern of farmers. Freedom of choice of land use, following early enclosure by agreement, had encouraged

diversity, and so too had the growth of urban markets, where surplus farm produce could be sold.

The Cotswolds, although 'not so very fertile', were sheep and corn land, being well suited to both types of farming. Sheep farming had expanded here during the fourteenth and fifteenth centuries, as many landholders began to move away from subsistence farming. The combination of climatic deterioration, high population mortality levels caused by sudden epidemics, the consequent reorganisation of settlement patterns, and the increase in the market value of wool, which we have discussed earlier with regard to village desertion, explains this trend. Atkyns gives many references to grants of sheep lands for church repairs, and even in parishes where arable is the only land use he records, there is clear evidence of pasture as well. For example, Upper Swell, which

Fig. 46 Cotswold sheep. These animals are from the last commercial flock at Aldsworth and show the distinct features of the breed. Hurdles were used not only to control the grazing area but also to ensure an even spread of dung at night.

was recorded as an arable parish, had 240 sheep pastures and thirteen beast pastures in the glebe. Large flocks of sheep were kept for their wool and their dung made a vital contribution to maintaining the fertility of the thin and brashy Cotswold soils. Sheep also provided mutton, for which there was a growing demand in the eighteenth century.

Fifty-four Cotswold parishes (45 per cent) had some pasture, and sheep pastures are specifically mentioned in the entries for Coln St Dennis, Eastleach Turville and Snowshill. Sheep houses, for the winter protection of the animals and to encourage finer wool production, are also recorded at Ampney Crucis and Upper Slaughter. Atkyns quotes Camden in referring to these large flocks of sheep, 'grazing on the short grass of the hills, the animals having long necks and square bodies and producing the whitest wool' (fig. 46). This description of the appearance of the sheep corresponds to the features of the animals portrayed on the locally made fifteenth-century wool merchants' brasses in Northleach church. The wool from the Cotswold breed was coarser and longer than that of the Ryeland breed from the north-west of the county, and Camden's reference to the whitest wool was by now dated. Grazing rights on the common pasture often allowed a farmer to put out sixty sheep for each yardland or 30 acres of arable land he possessed, and some farm labourers were also permitted to graze a few sheep on the commons. In his calculations, Atkyns reckoned on a grazing density of one sheep for every 2 acres, much lower than would be acceptable in today's farming when there may be three or four ewes per forage acre. On Isaac Taylor's map of the county (1777), large areas of the Cotswolds are marked as downs, presumably for sheep, although near Guiting Power the land is labelled as cow pastures.

Despite his many references to sheep farming, Atkyns records arable or mainly arable as the predominant land use of the Cotswolds. Fifty-eight of the 119 parishes (49 per cent) are described as having arable as the single land use, and only six small and peripheral parishes have no mention of crop land. Possibly by now the sales of barley, and to a lesser extent of wheat, were more important sources of income to the farmer than wool. This was certainly the opinion of Daniel Defoe, whose observations will be considered in chapter 14. Also, much wool for the Stroud woollen industry was now brought from the Midlands or imported from Spain, and this imported wool was considered to be more suitable than the local wool for the finest cloth.

The arable fields were the vast open fields developed by medieval and earlier farming practice, with widely dispersed strips of land held by each farmer and where cropping one year alternated with fallow the next. This two-field system of agriculture was normally followed on the Cotswolds, and from time to time in his discussion of bequests to church, school and hospital, or 'for the poor', Atkyns refers to grants of land in a north or south field. He does this for the parishes of Boxwell, Eastleach Turville, Edgeworth, Preston and Sherborne. Most parishes had two fields and they were often distinguished as north and south fields, but occasionally as east and west fields, as at

Cherrington, or upper and lower fields, as at Hawling. Sometimes a bequest was for a certain number of ridges, as with William Higford's gift of forty-eight ridges for church repairs at Alderton, and seven ridges were given by another benefactor for the same purpose at Saintbury.

Barley is the traditional Cotswold cereal. It was mainly sold for brewing, but was also used as the normal bread cereal by the poorer people. Unless spoilt, barley was not fed to livestock in the early eighteenth century. It probably had a larger acreage than wheat, and Atkyns notes that Oddington was renowned for seed barley. Barley was sown in March and wheat in September. Sainfoin, clover and turnips had been introduced to the Cotswolds in the early seventeenth century, but the full impact of these new crops was not felt until the Parliamentary Enclosure awards, which were generally made for Cotswold parishes between 1730 and 1830. After enclosure, individual farmers could

Fig. 47 Ridge and furrow in fields south of Broadway. Notice the way the ridges curve at their ends. This indicates ploughing by oxen, where the plough team was turned on the headland at the end of each strip.

follow their own choice of cropping system on their consolidated holdings and did not have to conform to the decisions of manor courts. The seven-year crop rotation of turnips, followed by barley, two years of grass (the first for hay and then for grazing), then wheat, oats and finally peas, beans or vetch, came later in the eighteenth century. This particular rotation was very important in raising productivity on the Cotswolds for it enabled produce and labour to be diversified, fertility to be improved, weeds, pests and diseases to be more effectively controlled, and all land was productive every year. There was no need for a fallow period when the land rested. But pre-eighteenth-century dispersed farmhouses and the richer shrub species list of some farm boundary hedges indicate that some land had been enclosed by the end of the seventeenth century and no doubt independent yeomen farmers were already experimenting with different crop rotations. Atkyns writes that most of Batsford parish had been enclosed about a hundred years previously, and that the farm land of Lemington parish consisted entirely of enclosed pasture. 'Inclosures' are also mentioned at Saintbury and Winstone, and small enclosures had existed for a long time around the farmsteads in the villages.

Ploughing was mainly with oxen, as is indicated by the aratral curve at the end of the ridges (fig. 47). Early ploughs cut a single furrow, and when they were pulled by a team of six or eight oxen, they were lengthy affairs. To prevent trampling on the strips of adjacent plots, the plough was turned before the end of the strip was reached and then plough reversal could take place on the headland. Ridge and furrow was produced by heaping the soil along the middle of the strip where the first two layers of soil turned over by the plough were superimposed, and then by turning soil inwards towards the centre of the strip with each successive cutting of furrows, until the ploughing of the strip was completed. The feature is more prominent in the Vale than on the Cotswolds, but the same ploughing methods applied to all areas. Seeds were sown broadcast and then harrowed or ploughed in, so the neat rows of crops, where seed drills have been used, were not seen in the early eighteenth century. Hoeing, mowing and harvesting were all by hand, and large teams of farm labourers were employed. Before the availability of herbicides to 'clean' arable fields, annual weeds would have flourished among the growing crops. The dazzling yellow of oil seed rape in flower in May, which is such a common feature of today's Cotswold farms, would have been unknown then, and the bright pink of sainfoin would not have given a uniform colour because it would have been mixed with the whites, yellows and blues of the flowers of annual weeds.

The twenty-three parishes (19 per cent) that possessed meadowland were those through which the principal Cotswold rivers flow. Some of these meadows were managed as water meadows, where controlled shallow flooding in the winter enabled early grass growth and where the fertility of the soil was maintained by the silt brought in by the river water. Water meadows were highly valued for their 'early bight'. Soil temperatures were kept above freezing point beneath the floodwater, which covered

the meadows from time to time between November and March, and there was adequate moisture to enable earlier grass growth than on the higher ground. These meadows also produced heavy crops of hay, followed by rich grazing for dairy cattle. Manor records show that there was often controversy over water supply between farmers managing water meadows and the corn millers further downriver.

Many of the higher, western Cotswold parishes also had areas of woodland. Only for Avening parish has Atkyns mentioned that it was beech wood, although beech is likely to have been the dominant tree in all these woods. In the entry for Cold Aston parish, he includes a lengthy and exaggerated tribute to the medicinal virtues of ash trees. Ash trees were normally planted along field boundaries to provide shelter for livestock, wood for fuel and timber for farm use. Their reputed benefit to people suffering from ague, fever, blisters or snake bite poisoning, although commonly believed, is less convincing.

Fig. 48 Furze still grows on the Cotswolds but it was formerly much more widespread. It provided fuel for poor people and has been described as 'the signature of the commons'.

At Chedworth, the St John's Ashes made a notable local landmark. Box grew at Boxwell, and this was the source of much of the box hedging used in the parterres of late seventeenth-century ornamental gardens. Several woods are named, and the list includes Oakley wood, which later became part of the Cirencester Park estate, Bushcombe, Queen's, Chedworth, Buckholt, Hailes, Pinnock, Puckham and Weston Park woods. These were all medieval woods, and some still have the diagnostic sinuous boundary bank. Unless they have been gutted and replanted, these medieval woods still have a greater variety of trees and a richer ground flora than other woods, and some of their shrub and flower species are indicators of old woodland. Sunken trackways show where timber has been extracted over the centuries. Woodland was typically located near to the boundaries of the parish because it was not necessary for woods to be as accessible to the village population as farmland. In two parishes, Charlton Abbots and Dowdeswell, the woods are described as coppiced, and this was the normal way of managing woods. The fox coverts and small regularly shaped plantations that have become so conspicuous in today's landscape had not yet been planted. In many parishes there were also patches of furze (fig. 48). Furze has been described as 'the signature of the commons', and as late as 1806 a field in Temple Guiting parish was known as 'Poors' Furze'. Furze was cut for fuel by the villagers. It gave a fierce oven heat, well suited to baking bread, and poor people were allowed to cut as much furze as could be carried on their backs. When land was enclosed, these furze patches usually disappeared to the detriment of many in the local population.

Thirty-two parishes spanned the Cotswold edge like scrolls. On the lower ground was rich arable land, usually growing wheat; the steep slopes were used as woodland or grassland; and common pasture was found on the top. Atkyns records the land use of most of these parishes as shared between arable and pasture; a fifth had pasture, arable and wood, and another fifth were all pasture. Steep gradients, hummocky surfaces and frequent springs restricted cultivation, but the ridge and furrow left by medieval ploughing often climbs towards the top of the escarpment, and indicates the great importance of arable farming to these spring line settlements (fig. 49).

The Vale was considered to be less windy and less cold than the Cotswolds. Atkyns makes what is probably the first published reference to the exposure of Stow-on-the-Wold to winds from all directions. However, his generalisation of eight months' summer with warm weather for the rest of the year in the Vale, in contrast to eight months' winter with cold all the year round on the Cotswolds, was exaggerated in both cases. But there is a difference in climate between the two areas, which has always impacted their agriculture. The land use of three-quarters of Vale parishes was a combination of arable and pasture. Almost invariably, both are described as rich or good. Soils are deeper here than on the Cotswolds, inherently more fertile, but they often required improved drainage and were more difficult to plough. The furrows of ridge and

furrow helped the drainage of the ridges, but rushes were apt to spread in them. In the parishes where common and open field farming had continued, two or three annual crops were grown in the rotation before the fallow year. There were, therefore, three or four common fields in each of these parishes. In the north of the Vale, above Gloucester, the succession was barley, beans, wheat and fallow. Beans, as a legume, replenished the nitrates in the soil, and the fallow year, with the dung of livestock grazing the stubble from the previous year's wheat crop, restored general fertility. South of Gloucester, the rotation was wheat, beans and fallow. With two or three years of continuous cropping, the fields naturally tended to become weedy, and with this agricultural system, weeding was only possible in the fallow year. There were later complaints of huge flocks of pigeons feeding on the grain and beans. Dovecotes are still to be seen in many places in the Vale, from which the lord of the manor benefited from the meat supply of squabs at the expense of the grain of many of his poorer tenants.

Fig. 49 The Cotswold escarpment at Barrow Wake, near Birdlip. The traces of ridge and furrow show how arable farming once extended far up the steep slope.

Several parishes beside the River Severn experienced frequent flooding. Deerhurst, Slimbridge and Westbury are mentioned in this respect, and Atkyns notes that the rich pastures of these parishes resulted from the deposits of river silt. For Tewkesbury, he writes that the town was 'annoyed by floods but the resulting fertility of the soil made sufficient amends'. He is probably referring here to Tewkesbury Ham, where grazing rights were held by many townspeople. The very rich meadows of the New Grounds at Slimbridge also resulted from alluvial deposits from the Severn, and here by the Dumbles, at the edge of the river, Atkyns says 'right samphire' was growing. Samphire is a wild vegetable which was cut as a salad. The occurrence of damage and loss from flooding was generally located south of Arlingham, and here parishes beside the Severn were charged for maintaining the river bank in proportion to their number of acres of floodable land.

The grazing of dairy cattle was of major importance in the Vale, and cheese the principal product. The cheese dairies of Berkeley are singled out for comment. Many farmhouses had special airy chambers or louvred cheese lofts in which cheeses were stored. There was a Double Gloucester cheese and also a Double Berkeley cheese, and the markets for both types of cheese extended throughout the country, some produce even going overseas. Enclosure by agreement between the landholders came earlier in the Vale than on the Cotswolds, and small-hedged fields made it easier to control the grazing and breeding of the dairy cattle in the Berkeley area. Milk yields were very low and the specialist high-yielding dairy breeds came later than Atkyns' time. The Gloucester breed, developed from crossing Longhorns with the red Severn-side cattle, and the Double Gloucester cheese became the hallmarks of farming in the Vale. Most milk was produced in the summer months when grass was more abundant, and because of its poor keeping quality the milk was immediately used for cheese making. Very little liquid milk was drunk in the early eighteenth century. Sheep were also over-wintered in the Vale and then moved on to the Cotswolds for the summer. There is a fourteenth-century reference to 5,745 sheep from the Berkeley estate being sheared at Beverstone, but without root crops, particularly turnips, the Cotswolds were unable to provide adequate winter food for such high numbers of sheep.

A famous painting, now in the Cheltenham Museum, shows farm labourers working in Mickle Mead, a large field near Dixton Manor. The painting is a view from Dixton Hill and is dated c.1715. Twenty-three men in a row are scything grass, another twelve men and women are coming to rake up the grass, six people are forming stooks, several are involved in carrying the hay on a wagon drawn by four horses, and the work is overseen by a man on horseback, perhaps the lord of the manor or his bailiff, accompanied by two mounted women. Several groups of workers are being led by musicians, probably fiddlers or hurdy-gurdy players, and there is also a group of Morris dancers. Women are preparing refreshments at the side of the field, and there are other people in adjacent

fields. The scene is obviously contrived, but there are 116 men and women involved in one day's work in one field in late June. The background includes many smaller-hedged fields, some with cattle. The painting reminds us of the communal nature of traditional farming and also of a highly populated working countryside. The total population of Alderton parish, within which the hamlet of Dixton is situated, was estimated to be 200 in 1712, so it is likely that seasonal workers had been recruited from other places.

Among the crops grown on a small but significant scale around Tewkesbury were mustard and woad. Mustard was grown for a cottage industry and will be considered further in chapter 12. Woad is a very exhaustive crop and was grown on the Mythe, north of Tewkesbury, to supply dyes for the Stroud woollen mills (see plate 31). It was cultivated on recently ploughed-up old pasture or on deep, well-drained alluvial soils, and provided employment for large numbers of poor people, often attracting them from considerable distances. It has been recorded that on one 40-acre field, 250 workers found employment. Near Winchcombe, flax was grown, again with several hundred men employed. Celia Fiennes comments on both crops on her visit to Toddington in 1694. Another crop, which was grown in the triangle between Winchcombe, Cheltenham and Tewkesbury, and which had caused some political controversy, was tobacco. Atkyns says that this was the first place in England where tobacco had been planted, and the controversy arose because it deprived the British colony of Virginia of its monopoly of a very lucrative trade. Eventually, the army was summoned in an attempt to stamp out tobacco growing at Winchcombe.

Five parishes – Ashleworth, Dumbleton, Dymock, Kempley and Longney – are recorded as having orchards. These were primarily cider orchards, and in the case of Dymock, Atkyns says thousands of hogsheads of cider were produced each year. (Parsons noted that 1,000 hogsheads were produced each year at Kempley.) Hogsheads were barrels with a capacity to hold 100–120 gallons of cider. Their destination was partly for export to other areas of the country, via Severn-side ports, but large quantities of cider were drunk in the county's inns and by local farm labourers. The truck for farm labourers included a daily allowance of a gallon of cider, an allowance that was increased to two gallons at harvest time. Different types of soil favoured different varieties of apple tree, and consequently gave variations in the types and strengths of cider produced. Most varieties were of local provenance and were often spread by scions. These were cut from 'greenings' found in the hedgerows, and were grafted on to crab apple stocks. Dymock Red, Hagloe Crab (Hagloe is in Awre parish), Longney Russet, and the White Styre from the Forest of Dean, were all important for cider making, but the most favoured cider apple was the Redstreak (see plate 20), introduced from France in c.1640. Perry was also produced, with Blakeney Red, Taynton Squash and Hartpury Green being the most popular varieties of pear tree. Some eating apples were also grown. Ashmead's Kernel was a local variety, originating in a garden in Clarence

Street, Gloucester, in c.1700, which eventually had a countrywide distribution. Apples and pears for dessert were exported by boat, via Tewkesbury, Gloucester, Newnham and Berkeley, and transported to the south-west of England and to South and West Wales. Fruit trees were planted on low ridges, which often remain today, sometimes long after the trees have gone. For cider and perry making, apples and pears were crushed by a stone wheel, running in a circular stone trough. Because of the acidity of the juices, quartz conglomerate was the favoured stone used for both runners and troughs. The rock was quarried at Staunton, taken down the River Wye by barge, and then carried by Severn trows from Brockweir to the port nearest to where it was needed. The cider presses were made from elm wood, and elm trees were formerly abundant in the Vale.

Atkyns mistakenly decided that the references to vineyards in old documents must have been to apple orchards because no vineyards existed in his day. He quotes a fourteenth-century document which refers to a William Mansfield, who, in 1320, held land which included a vineyard, 6 acres of arable and 3 acres of wood in Bisley parish. He comments that 'it is improbable that any other vineyard than that for apples could grow in that cold barren place. One might as soon gather grapes from thistles'. In fact, the Vale had many vineyards in early medieval times, and as we have seen in chapter 5, it was primarily the frosts and cold weather of the late sixteenth and seventeenth centuries, as well as more profitable alternative land uses, that eliminated the vine and encouraged the expansion of apple orchards. The loss of the monastic market and increased imports of French wine were additional factors. The shallow terraces of former vineyards may still be seen in many parts of the county, including the Cotswolds. The sunny slopes on the south side of Minchinhampton, where the terraces are clearly visible, provide a good example.

Although there was much common land, only a few commons are specifically mentioned in Atkyns' survey. On the Cotswolds they were at Minchinhampton, Amberley and King's Stanley, and by the River Severn were the commons of Deerhurst, Leigh, Minsterworth, Walmore, Frampton and the New Grounds at Slimbridge. In the extreme north-west of the county, on the commons of the sandy soils around Pauntley and Newent, flocks of the small Ryeland sheep were kept.

There had once been an extensive forest at Kingswood and another smaller one at Corse, but wood is only recorded for three parishes in the Vale. On the other hand, parishes bordering the Forest of Dean had plenty of woods. Eighty per cent of these latter parishes also had both arable and pasture. On the smallholdings, a few pigs and sheep were kept, together with a cow for home butter and cheese supplies. Enough corn was grown for local use, but not much more. The rioting associated with the theft of corn from farmers' wagons on the way to market and from grain boats on the River Severn, in order to feed a starving mining population, came later. Apple orchards were also quite common in these parishes, and the cider produced from the Styre apples

had a reputation of being some of the best in the country. A document of 1313, which Atkyns quotes, refers to a vineyard at Noxon. Several experiments with alternative crops had also been made in and around the Forest of Dean. One example is the growing of oil seed rape, which was first recorded here in 1620, when 550 acres were allocated to produce the oil needed to treat the woollen cloth manufactured in the Stroud valleys. Such experiments were usually made on poorer soils, where the yields of traditional crops were lower. Many people living on the edge of the Forest in the early eighteenth century were squatters, poor people who had moved into the area to find employment in mining coal and iron ore, whose animals grazed in the woods and whose women folk grew vegetables in their narrow garden plots taken in from the waste.

The wet clay soil in the interior of the Forest of Dean was ideal for growing oak trees for ship timber, and on the outskirts of the Forest, Littledean is mentioned for its great store of oaks. Atkyns was aware of the large-scale destruction of potential ship timber at the time of the 'great rebellion', i.e. the Civil War, and of the unfortunate use of mature oaks for fuel and for charcoal burning in the seventeenth century. However, the legislation for replanting that followed this destruction had not yet produced mature trees. The Surveyor-General to the Royal Forests reported that, in 1705, Dean was very full of young trees, in which beech was dominant, 'overtopping the oaks to their injury'. Oak trees mature after about a hundred years but, if they are planted close to beech trees, they are liable to be outgrown by the beech in their early stages. The oak trees planted in 1668, following the Dean Forest (Reafforestation) Act, were pedunculate oaks. With their spreading form, it was thought that they would produce the whole range of shapes and sizes of timber needed for ship building. These trees have become known as King Charles II oaks, and a few are still alive in the Churchill Inclosure near Parkend, while the decaying trunks of others lie on the ground (fig. 50). Although oak was by far the most important tree, oak and beech were not the only species growing in the Forest. Alder, birch and holly were also abundant, and Spanish chestnuts were noted at Flaxley. Conifers had not yet been introduced – the first were Weymouth pines in 1781. Commoners grazed their sheep in the glades and on the roadside pastures (they still do!), but in the eighteenth century there were other types of livestock, including pigs, goats and geese, all feeding in the woods.

Owners of land beside the rivers had fishing rights, and entries for a few parishes contain references to fishing. Fishermen are shown on the banks of the River Severn in Kip's engraving of Gloucester (see fig. 58 on p. 156) and the Severn is described as being 'well furnished with salmon and famous for lamprey'. Lamprey were always fairly scarce and were highly valued. Fishing for lamprey is recorded at Westbury, and general fishing at Rodley and Eastington. A trout river is also mentioned at Awre. On the far west of the county, the River Wye was 'well stocked with salmon'. On the Cotswolds, the 'brook' at Naunton, presumably the River Windrush, 'bred very large trout', but

Fig. 50 One of the King Charles II oaks still growing in the Forest of Dean. This tree was planted in 1668.

there is no mention of fly fishing on the Rivers Coln or Windrush, although it took place in the seventeenth century, nor is there reference to fishing for elvers in the Severn. Atkyns quotes several documents mentioning fisheries at Great Barrington, Westcote, Arlingham, Framilode, Minsterworth, Newnham and Tewkesbury.

He also mentions two sports, which would have made a small local impact on the landscape. At Sherborne, he refers to the 'pleasant paddock course' for deer coursing, and Stinchcombe Hill was 'remarkable for the robust game of stoball'. Stoolball is still a popular game in Sussex. Many of the Kip engravings of country houses show bowls being played on the lawns.

The farming and woodland landscapes we have considered in this chapter were working landscapes. To quote the eminent landscape historian Alan Everitt, 'no one

has written his signature more plainly across the English countryside than the Tudor and Stuart farm worker'. There was great variety in the general work of farm labourers at the time, and it involved many skills. Hedging and ditching, ploughing and sowing, harvesting and carting, building walls and felling trees, caring for sheep, cattle and horses, and the variety of work in orchards, were all tasks labourers were expected to perform. The standard farm labourer's wage was about a shilling a day, but specialist work, such as thatching, earned more. Loyalty to a particular estate had often extended over many generations of farm workers, but conditions were changing. Throughout the seventeenth century the number of landless people was growing, and this corresponded to an increase in the seasonal labour requirements on the more specialised farms. The number of migratory workers was further increased in the eighteenth century by Parliamentary Enclosure and by now the attraction of employment in the growing industrial areas had become impossible for many poor people to ignore. To the early phases in this industrial development we turn in the next chapter.

11

Industry & Population Distribution

T he iron industry in the Forest of Dean had flourished during the first half of the seventeenth century. There had been a demand for guns and cannon balls for export to the continent for the Thirty Years' War (1618–48), as well as a growing domestic market for iron goods. At that time, the Forest began to surpass the Weald in having the largest concentration of furnaces and forges in the country, and it produced good quality iron. Charcoal was used for smelting the iron ore and for heating the pig iron at the forges, and the streams were harnessed for water power to work the furnace bellows and the forge hammers. Plumes of dense smoke, flames rising far above the furnaces, and the thud of massive hammers characterised the industrial valleys of the Forest, such as those of Lydbrook, Redbrook, Soudley and Flaxley. The Vale of Castiard, in which Flaxley is situated, had two blast furnaces and possibly as many as five forges within a distance of not much more than a mile.

During the 1640s, while the Civil War was being fought, both Royalists and Parliamentarians were keen to control this strategic industry, and furnaces and forges changed hands as the war proceeded. But in the uncertain times immediately after the war, the ironworks within the Forest boundary were destroyed, partly for political reasons but also to help with the conservation of ship timber. Some ironworks had been destroyed in 1644 during the Civil War, others in 1650 by orders of the 'Preservators' of the Forest, and yet more under Crown instructions in 1674.

By Atkyns' time, however, furnaces and forges had been rebuilt, and the industry was again employing many workers. All the iron ore used in these ironworks came from within the Forest and some ore was exported. In his entry for Littledean parish, Atkyns reports that iron ore was dug in several places. These mines were on Edge Hills, north-east of the site of the later town of Cinderford, where the ore bearing Crease Limestone outcrops. Deposits of iron ore, mainly hydrated oxides of iron, were found lining joints and wider spaces in the limestone. The spaces had been caused by earlier solution, affected by the downward flow of acidic water from strata laid above the Crease Limestone. The limestone rock was itself made more porous by a chemical

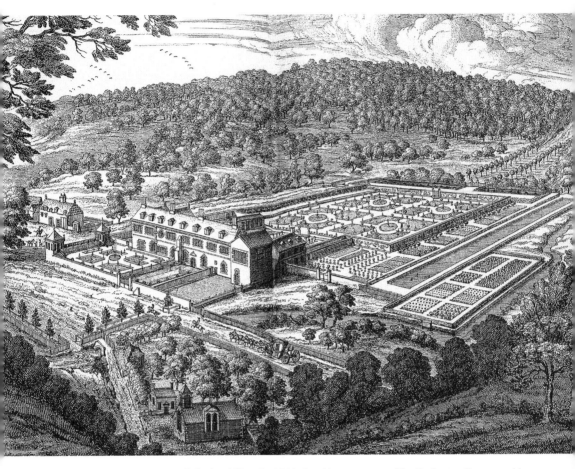

Fig. 51 Kip's engraving of Flaxley Abbey. In 1712 the abbey was owned by Catherine Boevy, and her blast furnace and forge may be seen midway down the right side of the engraving.

change in which there had been some mineral replacement, and strata adjacent to the Crease Limestone also contained calcareous bands, similarly vulnerable to solution. In these, too, ores were found. Miners gave their own names to the different ores. 'Brush ore' looked like a collection of small light-brown brushwood sticks, 'colour' or yellow ochre was used as a pigment, and haematite was known as 'smith' ore. At the surface the widened crevices, from which the iron stone had been extracted, became known as 'scowles' (see plate 21), beneath which 'leads' went down to caverns, formerly ore-filled and known as 'churns'. In Newland parish, on the western side of the Forest, Atkyns refers to 'large hollow places underground and to vast mine pits, sixty to seventy feet deep'. He quotes Camden's comment on the hollows being as large as 'a considerable

church'. Churns were later known as 'old men's workings', when they were rediscovered by nineteenth-century miners both at Edge Hills and near Clearwell, south-east of Newland, and were found to go as deep as 500 or 600ft beneath the surface. Iron mines were also reported in Staunton parish, on the north-west of the Forest. The geology of the Forest of Dean is synclinal, and so the outcrops of Crease Limestone are to be found all around its north, east and west edges. Iron ore generally colours the spring water and the streams flowing from them, which Atkyns also notes.

The blast furnaces used cinders in addition to iron ore, and these were said to ease the process of smelting. Cinders were the finely broken pieces of slag from much earlier iron smelting, when the lower temperatures of the more primitive bloomery process only allowed a small portion of the iron in the ore to be extracted. In his entry for Mitcheldean parish, Atkyns mentions 'cinders of iron not well tried formerly and sold at a good price to the furnaces'. Catherine Boevy, the owner of Flaxley Abbey, bought cinders from the Wemyss family at Mitcheldean for her furnace, which was just downstream from the abbey. The furnace is illustrated in the Kip engraving of the abbey, with clouds of smoke rising above it, and the forge, with its large water wheel, is shown just below the furnace (fig. 51).

Furnaces are recorded at Guns Mill (Abenhall), Blakeney, Flaxley, Lydney, Redbrook (Newland) and Elmbridge (Oxenhall), and Atkyns tells us that the first two and the last were operated by Paul Foley, an iron master from Stoke Edith near Hereford. In 1674 the Foleys had bought, initially for demolition, what remained of the 1612 King's ironworks at Cannop, Lydbrook, Parkend and Soudley, together with rights to raw materials. They also acquired the furnaces at Bishopswood, Flaxley, Redbrook and Longhope, so that five years after Atkyns' book was published, the Foleys and their associates held 70 per cent of all the Forest iron-producing capacity. A survey of the industry in 1717 placed the Forest of Dean as the leading iron-producing area in the country, with nearly twice the output of the Weald. The Flaxley furnace was the highest producer with an average annual output of 700 tons, Blakeney and Redbrook furnaces came second equal with 600 tons, and then Lydney's furnace with 250 tons and Guns Mill's with 200 tons. These furnaces were stone built, about 30ft high, rising from a 24ft square base, and slightly larger than the King's ironworks of 1612, which were 22ft square at the base and 22ft high. The structure of the furnace above the hearth was usually strengthened with cast-iron sows. At Guns Mill is the only surviving charcoal blast furnace in the country and at the time of writing is awaiting restoration. This furnace was converted to a paper mill in 1743, but the cast-iron sows reinforcing its original structure, and bearing their date of casting, may be clearly seen (fig. 52). Furnaces were charged from a ramp leading to the top, and the standard input or charge was of equal volumes of charcoal, cinders and iron ore, introduced as a succession of layers in that order. Molten iron drawn from the furnaces

Fig. 52 Part of Guns Mill furnace. The original blast furnace was built here in 1629 to produce guns for export. It was replaced in 1683 by the present structure, which is awaiting restoration by English Heritage. The cast-iron bars in the furnace wall are marked with the date 1683.

was cast in sand-lined trenches or moulds. Such furnaces were capable of casting 20 tons of pig iron a week and they worked for as long as the water power was available. The creation of furnace and forge ponds, by damming the streams in the valley floors, was to control and conserve the water supply and so extend this working period. Large ponds remain at Soudley and Cannop, but these were generally formed at a later date than Atkyns' book.

Nearly half the pig iron produced in the Forest of Dean was exported to Bewdley, Bridgnorth or to South Wales, the rest was processed at the local forges and then the merchant bar iron was sold to smiths working in Gloucester, Tewkesbury and

other nearby centres. The small Severn ports of Ashleworth, Newnham and Gatcombe handled these exports, while Lydney and Cone Pill near Woolaston on the River Severn and Brockweir on the River Wye handled exports of iron ore. The ore went mainly to Ireland but also to local furnaces just outside the Forest boundary. Gatcombe, in particular, was described as 'a port of considerable trade', but the transport of ore and iron goods along the deeply rutted roads to these river ports was very difficult.

The woodland of the Forest, particularly in the Lydney area, had suffered extensive damage through the excessive felling of trees for the ironworks of Sir John Winter. This had led to the Dean Forest (Reafforestation) Act of 1667, and the subsequent planting and enclosure of large areas of young oak trees. As we have noted, a few of these, now venerable, trees are still alive (see fig. 50). After the mid-seventeenth century, more care was taken of the woods, and charcoal was then made from old and decomposed trees, coppice stems and underwood, rather than from the high quality and mature trees, which were grown for ship timber. A Commissioners' report of 1788 stated that the condition of the woodland in the Forest had been at its best in 1712.

In addition to the iron industry and its associated employment, coal mining continued. This was originally on a much smaller scale than iron mining, but the number of pits was rapidly increasing. Atkyns describes them as coal pits rather than mines, a term restricted in his book to the Bristol coalfield, and he writes of many coal pits, particularly in Newland parish, and also of coal abounding in Littledean parish. He was aware of the rights of free miners and the Revd H.G. Nicholls, in his classic work *The Forest of Dean, an historical and descriptive account*, published in 1858, judged that Atkyns knew the Forest well. Most coal mines were shallow drift mines, again located around the periphery of the Forest and just inside the outcrops of the iron ore-bearing rocks. Some drift mines were cut into the hillsides, rising gently to the coal seams, and in this way there was natural drainage and it was easier to bring coal to the surface. Where shallow pits were dug the coal was raised to the surface in buckets or baskets using hand windlasses or horse gins. The shallow depressions of former pits may still be seen in the Delves near Brierley. Flooding was always a major problem for coal mining in the Forest of Dean and the early pits were normally abandoned after this occurred. Forest coal was not used in iron smelting in the early eighteenth century, for although Abraham Darby had begun using coal for his blast furnace at Ironbridge in 1709, similar attempts in the Forest of Dean had failed. It was, however, sometimes used in the forges for reheating the pig iron. Coal was sold for domestic use as 'fire coal', to blacksmiths as 'smith coal' and 'lime coal' went to lime kilns for burning agricultural lime – the price of coal declining in that order. The science of geology was then in its infancy and Atkyns hazarded the opinion that coal was to be found within a degree of

a line joining the mouth of the Severn with Newcastle and 'continuing round the globe with scarcely any elsewhere'.

In Newland parish there were 'two great copper works'. These were at Redbrook and were established in 1690. Copper ore was brought by boat up the River Wye from Cornwall and smelted here. Water power and charcoal were the main location factors. But the industry was short-lived, and by the end of the eighteenth century the sites were being used for tin plating.

Mining and metal smelting employed many men. Most lived in the villages around the Forest and walked in to work, but from time to time settlers encroached on to the Crown land of the Forest. Atkyns mentions that recently many cottages had been pulled down and only the six seventeenth-century keepers' lodges remained. These lodges had been built in 1675, being funded from the sale of the King's ironworks and they sometimes incorporated materials from the demolished works. They were provided so that the woods in each of the forest divisions or 'walks' could be more effectively supervised and the timber protected. The Speech House or the King's Lodge was one of them; the others, named after the most eminent political figures of the time, were the Danby, Herbert, Latimer, Worcester and York Lodges. An anti-authority riotous mob had, in 1688, pulled down the Worcester and York Lodges and damaged the Speech House, but these were soon rebuilt. The 'cottages' Atkyns refers to were really the 'cabins' or hovels of squatters, who had come seeking work in the Forest of Dean and had built their poor homes on what was apparently wasteland. There was a long history of 'cabin' removal, but as the demand for labour in the mines and ironworks increased, so a blind eye was turned on later illegal settlements.

The other very important industry in Gloucestershire in 1712 was located on the other side of the county on the Cotswolds. It was so significant that Atkyns wrote 'the clothing trade is so eminent in this county that no other manufacture deserves a mention', and he comments on the large number of wagon loads of cloth going to London and Bristol. No longer was the wool from Cotswold sheep sold to other parts of Europe for manufacture into cloth, as had happened in the fifteenth century. It was now treated, spun and woven in the woollen industry of the Stroud area. Stroud was described as 'famous for the trade of clothing and for dyeing scarlet'; Wotton-under-Edge was 'an ancient place for clothing'; King's Stanley 'a considerable place for clothing', and Kingswood 'a very considerable place for clothing'. Horsley 'depends mainly on the clothing trade' and Bisley's 'chief trade is clothing'. No reference was made to the clothing industry at Dursley, Minchinhampton, Painswick, Tetbury or Uley, although these are known to have been important woollen centres in the early eighteenth century, and in two of these towns, Minchinhampton and Tetbury, the market houses were built specifically for the sale of wool and yarn. Cirencester had the 'greatest wool

market in England', but apart from references to a hospital for 'decayed weavers' and its cloth fairs, the industry is not recorded here either.

Initially, wool was supplied to the clothiers from local flocks. This was later supplemented by wool from the Ryeland breed, coming from further west in the county, and the Leicester breed from the Midlands. Large supplies of wool also came from Spain, imported through Bristol. After it had been washed and sorted at the mill, the wool was distributed to domestic spinners, working in cottages in the many squatter settlements on the steep slopes at the edges of the commons. After spinning, the wool was redistributed to weavers, who often had handlooms in the attics of these same cottages. The woven cloth was then returned to the mills for scouring, fulling and dyeing. Water power was required to move the large wooden hammers or stocks at the fulling mills, where the cloth was beaten to make a felt. This is the prime reason for the mills being situated along the rivers, such as the Frome and its tributaries, although a good supply of water was also needed for washing and dyeing. The early mills were long and low, as distinct from the later four- or five-storey buildings in which the whole clothing industry was under one roof. Close to the mills were the clothiers' houses and other buildings, such as the warehouses, where cloth and wool were stored, and dye houses. Locally grown woad and madder, and imported cochineal and indigo, were used as dyes to produce the famous Stroud scarlets and Uley blues. Atkyns says that the quality of the scarlet dyeing was imputed to the clearness of the water, but it is thought that this was a local myth, popularised to deter competitors. The combination of excellent dyes, assessed by tasting, and water kept cool by being shaded by trees is the most likely explanation for the high-quality product. In fields on the hillsides above the mills tenter racks were erected, on which the dyed cloth could dry.

Atkyns reports that the first clothing mill was in Todgemore Bottom, an early name for the Toadsmoor valley near Bisley, and he identifies Chalford Bottom as having 'a great number of cloth makers producing a great quantity of cloth'. He says that in Bisley parish, which included both of these 'Bottoms', were great wastes and an abundance of poor cottages. As with the Forest of Dean iron industry, the possibility of employment attracted many poor people to the Stroud area. The levels of poor relief, which Atkyns records, were therefore much higher in these places. The highest rate in the whole county was at Randwick, with six shillings in the pound. For King's Stanley, it was four shillings in the pound, and at Bisley, two shillings and six pence in the pound. Typically, throughout the county, it was about one shilling in the pound, as is quoted for Bibury, Coln St Aldwyns, Fairford, Meysey Hampton and Norton, or one shilling and six pence in the pound, as at Mitcheldean and Lechlade. Atkyns points out that the higher rates in the clothing parishes were partly offset by the high income

Fig. 53 Wick Street House. The initials and the cloth marks of clothiers were often engraved in the stonework above the doorways of their houses, as in this example. It was built in 1633, and has the date, initials and wool mark of George Fletcher above the front door.

received from the rents of the larger number of houses there and by the lower wages paid to day labourers.

Another tax that also varied from place to place was the poll tax. This had been introduced in 1377, at four pence a head, but was later modified to include graduations according to rank, wealth and wages. It was always an unpopular tax and difficult to collect, but the assessments of tax levels are good indicators of parish prosperity. Atkyns gives population figures and poll tax totals for each parish, so it is possible to plot one against the other in order to see their general relationships and to identify those parishes that deviate significantly from the mean, by being either extremely wealthy or

very poor. The most conspicuous feature of this graph is that the cloth-making towns had much lower poll taxes per head than other towns, indicating the severe poverty sometimes experienced in these places. Weavers were generally independent workers, not tied to any one clothier, and when the industry was in decline they suffered greatly. They often worked from 5 a.m. to 7 p.m. in winter and from 4 a.m. to 9 p.m. in summer for a subsistence income. Freezing conditions in winter and drought in summer, both of which reduced the water power of the mills and thereby checked the fulling of cloth,

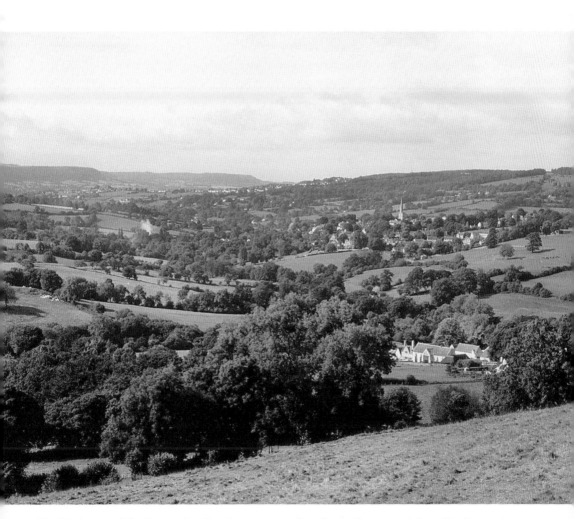

Fig. 54 A view of the Painswick valley. A succession of woollen mills occupied the valley floor and spinning and weaving was undertaken in cottages in the settlements further up the valley sides. The buildings in the centre are of Painswick Lodge, originally a hunting lodge, but from the sixteenth century the home of the lord of the manor.

had very serious consequences for the earnings of weavers, although in the earlier years many of them had taken in sufficient land to grow food for their families.

A traveller, writing in 1681, reports that 'at Painswick, on the way to Stroud you begin to enter the land of the clothiers, who in these bourns building fair houses because of the conveniency of water, so useful for their trade, do extend their country some miles'. One-third of the men listed in Painswick parish in John Smith's *Men and Armour* of 1608 were employed in the clothing industry, and it was still the chief source of income when Atkyns was writing. Although the first mills that were built along the Painswick stream have been demolished, rebuilt or modified by being converted to other uses, the clothiers' houses often remain, some with their dates, clothiers' initials and wool marks over the doorways (fig. 53). Damsell's, Loveday's, Brookhouse, Cap, Painswick, King's, Small's and Rock mills were all at one time fulling mills along the Painswick stream, although they were not all known by these names in 1712. They were owned in the early eighteenth century by the leading clothier families of Webbs, Fletchers, Packers, Lovedays and Pallings, and some of the beautifully carved tombs in Painswick churchyard are memorials to these clothiers. The Lovedays, many of whom were Quakers, also had a burial ground at Dell Farm. Spinning and weaving was undertaken in the cottages in Vicarage Street and Tibbiwell Street, and also in some of the small clusters of houses scattered along the sides of the valley. When steam was introduced to power the looms in the late eighteenth century, Painswick was less favourably located for the woollen industry than other centres. It was at a distance from the Stroudwater and Thames-Severn Canals, which were opened in 1779 and 1789 respectively, along which the coal for steam making was carried. Thus the industry declined in the Painswick valley while it expanded elsewhere, and so today this valley gives a clearer impression of the early eighteenth-century landscape (fig. 54) than the lower Frome valley and the valleys further south along the Cotswold escarpment. In these latter valleys, traces of the early woollen industry have been masked by more recent industrial buildings.

A third industry, briefly mentioned in *The Ancient and Present State of Glostershire*, is stone quarrying. 'Quarrs' are noted at Leckhampton and Sevenhampton, and at Barnsley there was a very large quarry of good freestone. However, the main area for quarrying Atkyns records was along the River Windrush from Sherborne, through Windrush and the Barringtons, and across the county boundary to Taynton and Burford. Here, where the Taynton Limestone of the Greater Oolite series outcrops, was found the finest freestone. Atkyns says that the quarries at Barrington (fig. 55) provided 'durable stone for the repairs of Westminster Abbey and an important building at Woodstock'. The reference is most likely to St Paul's Cathedral and to Blenheim Palace, for the latter was under construction when Atkyns was writing and Cotswold stonemasons were employed in rebuilding St Paul's Cathedral. Surprisingly, he does

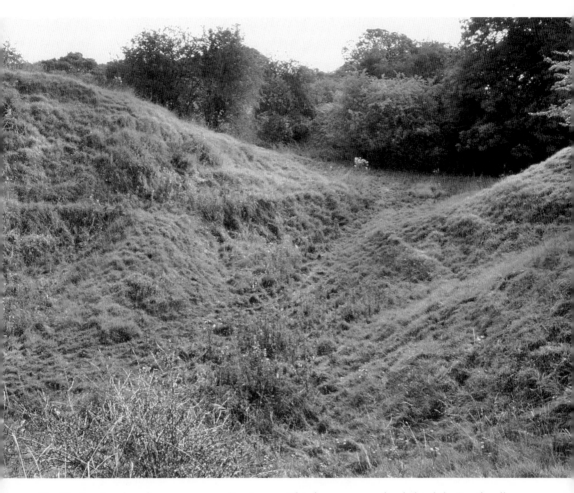

Fig. 55 An abandoned stone quarry at Barrington. This famous quarry lies behind the Inn for all Seasons and high-quality freestone was both quarried and mined here.

not mention Oxford colleges, which relied heavily on the high-quality stone from the Windrush valley, and he ignores other significant Cotswold quarries such as those at Painswick.

Quarrying also occurred in the Forest of Dean at this time, particularly at Staunton and in the north of the area near Ruardean. As with the oolitic limestone of the Cotswolds, the older limestones and sandstones of the Forest were used as building materials. Stone was heavy and costly to transport, unless it was by boat along the navigable waterways of the Rivers Wye, Severn and Thames and their larger tributaries. At a distance of 12 miles from a quarry, the cost of overland transport began to exceed

the cost of quarrying the stone, so most parishes had their own quarries wherever building stone was available. At Dursley, a manor formerly belonging to the Berkeleys, Atkyns says a 'puffstone' was quarried. This was described as soft but very durable and had been used in building Berkeley Castle where 'it had not shown signs of decay after six hundred years'. He probably means tufa, and his comment on its durability is accurate. Tufa was used at Berkeley Castle for the arches over doors and windows, and although its porous nature makes it look rough, it has withstood weathering much better than the local red sandstone (fig. 56). Tufa was also used in building the parish church at Dursley and the tufa quarry was at the lower end of Long Street.

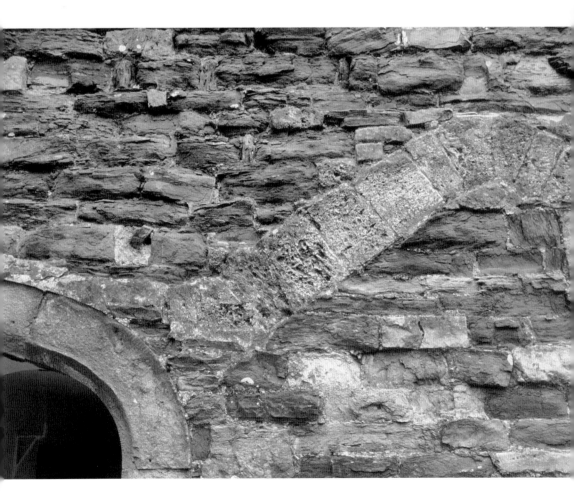

Fig. 56 Tufa in the stonework of Berkeley Castle. Atkyns said it showed no signs of weathering, even after 600 years. The red sandstone beside the tufa blocks has suffered much more decay. The tufa came from a quarry at Dursley, a manor once belonging to the Berkeleys.

Occasionally he refers to smaller-scale industries in the market towns. At Mitcheldean, he says, pin making had succeeded clothing as the town's leading employment, and at Tewkesbury the chief trades were knitting stockings and working with cotton and wool. Malt making was also a great trade here, and the town produced balls of the best mustard. Cheltenham and Lechlade also traded in malt. Gloucester had the widest range of industries with weavers and tanners, smiths and 'hammer men', shoe makers and glovers, and there was 'very considerable pin making', the city's main industry at the time.

From the Saxon period onwards, watermills had been used to grind corn and they became widespread across the county. Wherever corn was grown and streams could be harnessed for power, mills were built. In many cases, the successors of the early corn mills were still working at the beginning of the twentieth century, and in six parishes Atkyns' informants included information about them. He records a number of mills at Charlton Kings and Cirencester, and there were four in the Cranham parish. There must have been several hundred in the county at the time.

Because industrial location was the main cause of higher population densities, seen particularly in the Stroud textile areas but to a lesser degree associated with mining and iron working in the Forest of Dean, it is appropriate to consider the county's population distribution here. Although population density does vary from one agricultural area to another, the differences are by no means as great as between agricultural and industrial areas.

The earliest national population census was taken in 1801 when accurate details of parish populations first become available. But demographers for Gloucestershire are fortunate in that *The Ancient and Present State of Glostershire* contains population totals for the majority of parishes for a hundred years earlier, and Atkyns' clear intention was to give these details for every parish. Some figures convey the impression of a very accurate census, for example Temple Guiting's population is given as 191. But it is likely that the figures are mainly estimates, and for the adjoining parish, Guiting Power, the population total is given as 300. Many other parish totals are similarly given in hundreds.

When we examine the spatial pattern of population densities, based on Atkyns' figures, we notice several conspicuous features. The lowest densities are generally on the Cotswolds and in some of the spring line parishes at the foot of the Cotswold escarpment. The highest densities are in the cloth-making settlements around Stroud. Stroud ranks second to Gloucester in population density, and the county rankings of other leading woollen centres are Dursley, equal third, Bisley and Wotton-under-Edge, both equal sixth, King's Stanley, ninth, and Horsley, Kingswood and Minchinhampton, all equal tenth. This is a very clear concentration of denser population, which extends into the neighbouring parishes such as Cam, Leonard Stanley, Nibley, Randwick,

Rodborough, Uley and Woodchester. Such densities probably result not only from migration to these places for employment, but also because the migrants are younger people with higher fertility and lower mortality rates than the norm.

The old established market towns of Cirencester, Tewkesbury and Winchcombe also have high densities as might be expected. Parishes beside the River Severn from Twyning through Deerhurst, Ashleworth, Westbury, Awre and Frampton to Lydney also form a distinct group of more densely populated rural parishes, and around the periphery of the Forest of Dean the parishes of Longhope, Mitcheldean, Littledean, St Briavels and Newland match the densities of the scattered Cotswold market towns of Chipping Campden, Fairford, Lechlade, Moreton-in-Marsh, Northleach, Stow-on-the-Wold and Tetbury.

For the majority of parishes, Atkyns gives the numbers of births and deaths in the year. In seventy-three parishes with the smaller population totals, these figures exactly balance each other. In 101 parishes the number of births exceeds that of deaths by one, and in about fifty parishes the excess is of two or three (thirty-seven and fourteen parishes respectively). In only three parishes are there large differences. Bisley had twenty-four more births than deaths and Cirencester sixteen more, while Rodborough had eight fewer births than deaths. The figures for Cirencester of 103 births and 87 deaths in a population of 4,000 seem reasonable, but we note that in 1578, 495 children and adults had been buried in the town in the single year as a result of a devastating outbreak of the plague.

One would have expected greater differences between fertility and mortality in the growing woollen towns than these figures suggest. There is no evidence in Atkyns' figures that the industrial areas, to which young workers were attracted, had a higher birth rate than the more stable populations of the predominantly agricultural parishes. Nor do epidemics and industrial accidents seem to have influenced the number of deaths in particular places. The plague had ceased to cause deaths after the 1665–7 outbreak, but small pox inoculation had not yet been developed by Edward Jenner at Berkeley and this only affected mortality rates after 1721. A detailed analysis of parish registers would be necessary in order to check the accuracy of Atkyns' figures, but as the industrial areas of the Forest of Dean and the Cotswolds were areas with a less influential Anglican church, and where Nonconformity was beginning to expand, it may be that parish registers here do not include so many of the births and deaths as they do elsewhere in the county. Registrations of births and deaths were not compulsory until the Parliamentary Act of 1838. Also, the congested living conditions of the towns may have been less healthy than those of rural parishes, so a higher birth rate here may have been balanced by a higher mortality rate. Atkyns' figures do not give any support to this suggestion, however. Nor can they be used to substantiate the national picture in which it is thought that the country's population increased by 26 per cent between

Fig. 57 Path through the Forest of Dean. Other than Scots pines there were no conifers here in Atkyns' time. (Courtesy of Martin Latham)

1600 and 1700, with Gloucestershire having one of the highest increases of 45 per cent. All Atkyns tells us is that there was a small county-wide increase at the time of his survey.

There are a few hints in *The Ancient and Present State of Glostershire* of the social composition of the more industrial parishes. Where migration for employment has occurred, there is likely to have been the development of a single class society, which is different from the hierarchical society in the more traditional agricultural areas. In the latter, the lord of the manor or the squire presided over a dependent population and farmers employed labourers. In contrast to the agricultural areas, Atkyns mentions the abundance of poor cottages in Bisley parish, where the clothing industry was so important. Such communities were of rootless people, often independent in outlook, concerned for their 'rights', and sometimes antagonistic to their industrial employers. He also comments on the reputation of the Forest of Dean as a 'notorious harbour of robbers'. The notes of Dr Parsons, which he used, contained this assessment of the Forest population: 'the inhabitants are, some of them, a sort of robustic wild people,

that must be civilized by good discipline and government'. Dr Parsons, an Oxford graduate from New College and Chancellor of the Diocese, held the comfortable living of the Cotswold parish of Driffield, far distant from the poverty and squalor of the Forest cabins.

Of several notable persons mentioned in his book, Atkyns refers to a Thomas Bright of Longhope, who was then aged 130, and still retained his eyesight and the ability to walk. But he does not comment on the general healthiness of different places in the county, as did Samuel Rudder some sixty years later.

12

Historic Towns

In this chapter we consider the four historic towns of the county as they were in the early eighteenth century. Their rank order in terms of population and economic activity had changed several times during their long histories. Corinium (Cirencester) succeeded Glevum (Gloucester) as the principal Roman town, then Gloucester and Winchcombe became the leading Saxon towns, and later in the sixteenth century Tewkesbury rose to become second in importance to Gloucester. By Atkyns' time, Cirencester was the second town.

Gloucester

In 1712 Gloucester was the largest and most important town in the county, with an estimated population of 4,400, although this figure would have been considerably higher if the adjoining settlements, referred to as the North and South Hamlets, had been included. It was given city status by Henry VIII in 1541, at the same time as the diocese was formed, and was thought to be a very beautiful city in the seventeenth and eighteenth centuries. Earlier, in the sixteenth century, it had been in decay, and Henry VIII had ordered that the houses in the main streets should be rebuilt – an order which was to be applied first to the residents, then to the owners of the properties and finally to the corporation.

Our appreciation of its early eighteenth-century appearance is helped by the two engravings of the city by Kip. One is the west prospect of Gloucester from an imaginary hill near Over, a view looking across 'the rich and beautiful isle of Alney', Over Causeway and Westgate Bridge into the city (fig. 58). Church spires and towers, especially the majestic profile of the cathedral, dominate the city's skyline. Atkyns wrote of the cathedral, 'the whole is a stately magnificent building but the beauty of the tower and choir is not to be exceeded in any other church whatsoever' (see plate 6).

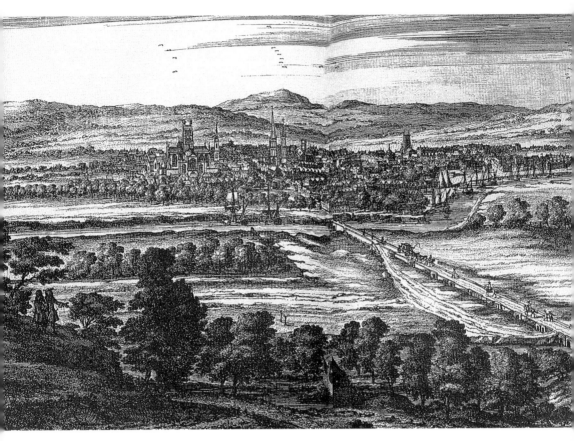

Fig. 58 'Prospect of Gloucester from the west', 1712.

Severn trows are shown in the engraving spaced along the quay, their bows facing the river bank upstream, and two are in the river channel above Westgate Bridge. The hinged masts of the trows allowed them to pass beneath its low arches. There is no indication of their cargo, but Atkyns mentions that the best supply of coal came down the River Severn from Shropshire and Worcestershire and that Bristol had captured most overseas trade, so it is likely to have been mainly coal and other cargo of local sourcing. In the city charter of 1672, the corporation was granted the rights of tolls on wine, timber and grain passing beneath Westgate Bridge.

The cupola on Ladybellegate House and the forbidding form of the castle on the southern margin of the city are also conspicuous features. The alignment of Westgate Street, which linked the spire of St Nicholas' Church, the slender ornate tower and spire of Holy Trinity Church and the more substantial tower of St Michael's Church,

is not shown as such in the engraving. In the right foreground, the half-mile long, stone-built Over Causeway has many arches, which allowed the meadows on the north side to drain into the Severn. Two tall, bottle-shaped kilns stand near the quay; one was used in glass making, the other for lime burning, and both were supplied by river-borne materials. Many trees are growing within and along the north-western edge of the city. Some are the fruit trees of orchards. A number of pedestrians and horse riders move in and out of the city, a carriage and six leaves Westgate Bridge and a pair of pack horses are walking along the Ledbury road. Fishermen are stationed on the right bank of the River Severn and two gentlemen, in the left foreground of the engraving, are pointing out details of this splendid view.

The other Kip engraving is a sketch of the city from the south-west, presented as a combined map and view (fig. 59). At the intersection of the four main streets stands

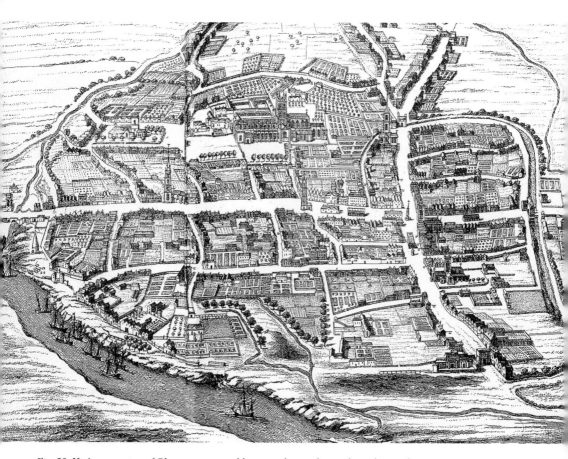

Fig. 59 Kip's engraving of Gloucester – an oblique angle aerial view from the south.

the Cross. At just over 34ft it is higher than many of the houses, and in the niches on each side of its octagonal column are the life-size statues of kings and queens who had granted significant privileges to the city.

The main streets are wider than today's as new house frontages were later built out into them, and several buildings occupy central positions in the streets. In Westgate Street, the longest, widest and most important market street, are two blocks of buildings – a covered market and the tower of the former Holy Trinity Church, with a small attached structure which housed the city's first fire engine. The King's Board, first a preaching pulpit and then a butter and cheese market, was also here. It now stands in Hillfield Gardens (see fig. 37 on p. 107). Kip shows it as a rectangular building rather than in its present rounded form, and recent excavations have confirmed this shape. Rudder says it was demolished in 1691. As the engraving was perhaps made after this date, its earlier form may have been guessed at. There had been another church, St Mary de Grace, in Westgate Street near the junction with St John's Lane, but this, too, had been demolished and in its place was a herb market. The Tolsey, containing the court room for the corporation, is the large building by the Cross. In Eastgate Street is the covered Barley Market, built close to the site of its predecessor in 1655, where beans, barley and oats were sold. In Southgate Street is the covered Wheat Market of 1660, which replaced an earlier market that had been damaged in the Civil War. It had the statue of King Charles II, now in St Mary's Square, in a niche on its north wall (see plate 22). Next to it is Scriven's Conduit. This had been erected in 1636 and supplied part of the city with water brought along wooden pipes from Robinswood Hill. The conduit has also been moved to Hillfield Gardens and some of its old wooden water pipes are displayed in the Folk Museum. It was not the only conduit into the city. There was another at the Cross, and some water was also raised 'by engine' from the Severn. The middle of street structures in Westgate Street were removed in 1751 to ease the flow of carriages. Most of the other streets are narrower than these four, particularly where they join the main streets. Here the privileged frontages of the main streets were extended as far as possible into the side streets. Inn signs are shown in the north–south orientated streets, eight in Northgate/Southgate Streets, three in Castle Lane, and one in each of St John's Lane, Three Cocks Lane, Lower Quay Street and Berkeley Street, but there were many more inns in other streets.

Although the perspective of this second engraving prevents such old buildings as the New Inn and the house in Southgate Street that became Robert Raikes' home from being identified, several south-facing houses are recognisable. Ladybellegate House (fig. 60) had been recently built, Bearland House was soon to be remodelled but is seen facing away from the south end of Berkeley Street, and further west along Longsmith Street is Marybone House, soon to have its famous rococo garden and pagoda. There is also another large, newly built house just outside the East Gate. As was typical of

Fig. 60 Ladybellegate House in Longsmith Street. It was built in c.1704 and is shown as one of the largest houses in the Kip engraving of the city. The cupola no longer exists.

the time, most houses had their gable ends facing the street. The older properties were timber-framed and some of their jettied frontages still exist behind their modern facades, but the newer ones were brick-built. This was a structural advance, for the timber-framed houses of the city had been destroyed by fire on several occasions in the past, and Atkyns mentions the fires of 1088, 1122, 1214 and 1223. The Barley Market in Eastgate Street was adjacent to the former family home of Sir Thomas Rich, which since 1668 had been used by the boys of the Blue Coat Hospital.

All four city gates are shown. The South Gate had been rebuilt after the severe damage caused by Royalist bombardment during the siege of Gloucester, and the deep and wide ditch outside the former line of the city walls is clearly evident on the east

side. The walls had been demolished on Charles II's orders in 1660. The other gates shown in the engraving are the outer North Gate, the Blind Gate at the north end of St Mary's Lane, King Edward's Gate and St Mary's Gate, both of which gave access to the cathedral precincts, and Lady Bell's Gate, near the former Blackfriars premises. Each of the churches is carefully drawn. The old St John's is shown with its spire, the tip of which is now in St Lucy's Garden, and both St Mary de Lode and St Mary de Crypt are shown to have walled churchyards. St Michael's, at the Cross, is a large building with two aisles, but only the tower remains today. Beside the South Gate are the St Kyneburgh's Almshouses built by Sir Thomas Bell, whose house and workshop for cap making had taken over much of the Blackfriars site after the Dissolution. Towards the south-west corner of the city, the strongly buttressed castle keep, then used as a prison, stands close to the Barbican, the earthen mound of the earlier Norman motte.

Outside the walled city are several hospitals to accommodate poor people. On the west is St Bartholomew's, with room for twenty-six men and thirty women; on the north is St Margaret's, the former leper hospital with accommodation for eight men, and St Mary Magdalen's, for nineteen poor persons. Atkyns also refers to churches that he says were demolished in the Civil War. These were All Saints (its site near the Cross was used for the Tolsey), St Aldate's, St Catherine's, St Mary de Grace, Holy Trinity and St Owen's. In fact, only St Owen's, just outside the South Gate, was destroyed in the Civil War, the others went as a result of a 1648 order of Parliament uniting several parishes. Materials from St Mary de Grace and St Aldate's were used to repair St Michael's and St Catherine's and to rebuild the Barley Market. Both the Abbot of Gloucester and the Prior of Llanthony had originally possessed retirement houses outside the city, with fine views over the city, the Severn and its riverside meadows. Newark House at Hempstead was the house for the prior and the Vineyard at Over was the house for the abbot. The latter, a moated house, was also destroyed in the Civil War.

One of the most striking features of the city, clearly portrayed by Kip, is the large amount of space allocated to gardens and orchards. Most properties had a rear garden, and one or two gardens near Southgate Street have distinctly ornamental designs. The northern border of the engraving is formed by the River Twyver, which flows into an old channel of the River Severn. This channel passes close to the west of St Mary de Lode Church, beneath Westgate Street at Foreign Bridge and into the main east

Opposite: Fig. 61 The arms of Henry VIII, the Tudor arms of the city and the badge of the Crypt School are all displayed over this archway near St Mary de Crypt Church, Gloucester.

channel of the river, north of the quay. South of the quay is a small island in the Severn known as the Naight. It formed the ground on which the West Quay warehouses of the nineteenth-century docks were built, and the lock entrance to the dock basin follows the route of the water course on the east side of this island. Beyond the north-west side of the city are large rectangular meadows, the various Hams, bounded by hedges and used for hay crops and cattle grazing. To the south, the open space was formerly occupied by houses, but these had been demolished in 1643 at the time of the siege. A document copied by Atkyns and requesting parliamentary aid for the city stated that 241 houses had been burnt or destroyed to ease its defence. Atkyns gives a total of 899 houses in the seven parishes of the city in 1712, which indicates just how severe the impact of the war had been on the city fabric. One might assume that the destroyed properties outside the walls were likely to have been smaller and less valuable than those within, but Rudder informs us that many were large houses. By 1712 Gloucester had not returned to its former size and grandeur, although it was still described as a fine city.

Atkyns also gives details of the city's economy, which the engravings cannot convey. There were twelve companies of tradesmen – mercers, weavers, tanners, butchers, bakers, smiths and hammer men, coopers and joiners, shoe makers, metal men, tailors, barbers and glovers. Since medieval times most of these tradesmen had tended to concentrate in particular streets. The rental prepared by Robert Cole of Llanthony Priory in 1455 enables us to locate these areas, although Atkyns seems not to have used this particular reference. Longsmith Street and Broadsmith Street (now Berkeley Street) were the iron-working streets. Several mayors had been ironmongers, and the design of the Tudor coat of arms of the city, now preserved above the gateway beside the old Crypt School, includes horseshoes and nails (fig. 61). Low-grade iron ore had been extracted from Robinswood Hill in Matson parish, where ironstone nodules may still be seen in the Middle Lias exposure. Later, iron bars were brought from the Forest of Dean to supply this important industry. Iron goods were not only sold locally, but shipped away along the Severn. Another important occupation was weaving and the manufacture of clothing. Again, some mayors had been clothiers and drapers. Brook Street, beside the Fullbrook, was the centre for fulling cloth, and on the opposite side of the city was Fullers' Lane, later known as Lower Quay Street. Hare Lane was occupied by tanners; cordwainers (shoemakers and leatherworkers) were near the Cross in Northgate Street; and mercers and butchers were north and south respectively of the central buildings in Westgate Street. Although these were recognised craft areas, the fifteenth-century rental shows that most trades were also dispersed throughout the town. By the early eighteenth century, however, the traditional industries had declined and pin making had been introduced, more particularly to provide working opportunities for the unemployed poor. Gloucester was still a busy, important and proud city.

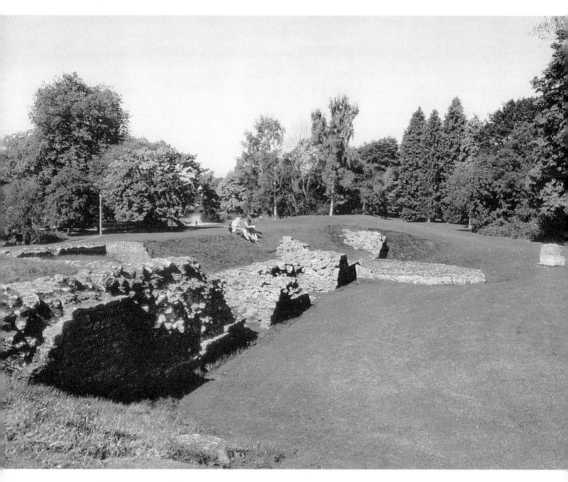

Fig. 62 Part of the Roman wall in Cirencester.

Cirencester

On the east side of the Cotswolds, Cirencester had become the second town to Gloucester in the early eighteenth century, both in population figures and in economic importance, and having been MP for Cirencester between 1678 and 1685, Atkyns knew the town well.

In Roman times it had been much more important than Gloucester and occupied the second largest urban area in the whole country. Situated at the junction of Ermin Street, the Fosse Way and Akeman Street, it was in a very favoured location. The remains of its Roman walls could still be seen on the east (fig. 62), south-east and south-west sides

of the town, and stonework littered the meadows surrounding the eighteenth-century built-up area, which did not completely fill the space within these walls. In some places the walls reached a height of 14 or 15ft and about ten years after Atkyns' publication an antiquary reported that he could trace the walls all the way round the town. They were said to extend for 2 miles. The remains of Roman buildings were generally 4 to 6ft beneath the ground surface, but tesserae from mosaic pavements had been dug up in several places and hoards of coins were found. Atkyns thought that one site had been the Roman baths. Sculptured stonework had been reused in later buildings, as archaeological sites were pillaged for building materials, and some may still be seen in Cirencester's more prestigious old buildings. The impressive Roman amphitheatre, now the Bull Ring, was a major landscape feature beyond the south-western limits of the town.

Upon the foundations of the Saxon minster, a great Augustinian abbey had been built from about 1117. The abbey ultimately came to own nearly all the land of the parish and became extremely wealthy. But at the Dissolution the main monastic buildings were quickly demolished and only the twelfth-century Spital Gate into the abbey precincts remains at its north-east corner. The ornamental lake in the Abbey Grounds occupies the place of its fishponds.

As at the present day, St John's Church dominated the town. Its tower of 'great height and beauty', 134ft high, could be seen from a distance of several miles. A room in its highly decorated three-storey porch was then used as the Town Hall. Of its five chapels, St Catherine's was noted for its roof, 'very well arched with stone' – a typically prosaic reference to its delicate fan-vaulted ceiling. The church's 'excellent ring of bells' rang out on 29 May 1660, at the restoration of Charles II, and has continued to do so since.

St John's was not the only church in Cirencester. The street names Cecily Hill and St Lawrence Street (today's Gloucester Street) preserve the memory of St Cecilia's and St Lawrence's churches, the former having been converted to housing and the latter to a hospital for two poor women. Of the numerous monuments in the parish church to leading citizens, Atkyns mentions the marble tomb of George Monox, a merchant who died in 1638, and the painted freestone tomb of Humphry Brydges, who died in 1598. Both men were benefactors to the town. There was also the marble tablet to the loyalist Sir William Master, who died in 1662, and the 1680 alabaster effigy of Thomas Master, who is represented by a reclining figure holding a book, rather like Sir Robert Atkyns' own effigy at Sapperton. The Master family had a 'very pleasant large house, beautiful gardens and a large enclosure of rich pasture'. Their house was built on the site of the cloisters of the abbey and was engraved by Kip. Its gardens were the former abbey grounds. The other 'very large house' in the town, probably on the site of the Norman castle, had been built by Henry Danvers, who had recently established the Botanic Garden at Oxford. This house was now occupied by Allen Bathurst, soon to

commence his major landscaping of Cirencester Park, with its tree-lined avenues and follies. Bathurst later rebuilt the house, but this work had not started when Atkyns wrote his book. Park Lane, the road that skirts the town-side of Cirencester Park, was once known as Law Ditch, and it has been suggested that this was part of the ditch that once surrounded the Norman motte. The other ancient ruin Atkyns records was Grismond's Tower, named after Gurmond, leader of the Danes, who was reputed to have set the town on fire in 879 with the aid of sparrows. In 1712 it was a low mound, about 20ft high, on the site where the ice house was later installed in Cirencester Park.

Cirencester was a very important market town, with market activities spreading from the Market Place, then partly occupied by houses, into Dyer Street, formerly known as Chepingstrete. The Kip engraving of the town shows that the market area extended

Fig. 63 A view of the east end of Coxwell Street, Cirencester. Little has changed since Atkyns' day.

along the south side of the church. There were two weekly markets, on Mondays for corn, cattle and general provisions, and on Fridays for wool, meat and poultry. Atkyns says the Friday market was the greatest wool market in England. There were three general fairs, on Easter Monday and on the feast days of Thomas Becket (7 July) and St Simon and St Jude (28 October), and two cloth fairs, on the week before Palm Sunday and on the week before St Bartholomew's day (13 August). The medieval Market Cross, now positioned on the north-west side of the church, having been previously removed to the grounds of Cirencester Park, was originally in the Market Place. The three mills recorded in Domesday had been reduced to two, namely St Mary's Mill at the beginning of Dollar Street, and Barton Mill. Both mills were supplied with water by leats from the River Churn. These were fulling mills for the clothing industry, but were also used at other times for corn grinding.

With its nodal position, Cirencester was a post town, with stagecoach routes to London, the West Country and the Midlands. Farm wagons and heavy carriages also passed along its dark, narrow and winding medieval streets, so different from the earlier spacious Roman grid layout. Kip's engraving is possibly less effective than that for Gloucester in giving a visual impression of the layout (see plate 23). Fingers of roads, lined with houses, radiate from the central Market Place beside St John's Church. Three blocks of buildings, separated by passages and including the Shambles, with the Market Cross behind, had been erected in the Market Place and they remained there until an 1830 clearance. The large house of the Bathursts is shown in some detail, as well as the church, but most houses are stylised. The Fosse Way runs across the foreground with Dyer Street leading from it, and both Coxwell Street and Thomas Street are clearly shown, as are the winding branches of the River Churn. Atkyns estimated that there were 800 houses in Cirencester with a population of 4,000 in 1712. Today, there are seventeenth-century gabled cottages in Coxwell Street, Dollar Street and Gloucester Street, and a scattering of other distinguished properties that were there in the early eighteenth century, such as the Weavers Hall, Woolgatherers, St John's Hospital and the Old Grammar School, buildings to which we have made earlier reference. David Verey has suggested that the appearance of the eastern end of Coxwell Street has hardly changed for 300 years (fig. 63), and the street retains several impressive and dated doorways. Number 10 Coxwell Street is dated 1640, with the initials I.P. for John Plot, a lawyer whose house was ransacked in the Civil War. At the other end of the street are cottages formerly occupied by weavers when Cirencester had been a cloth-weaving town.

Although the Georgian properties of Cirencester may have exceeded these earlier ones in their scale and finesse, they have not eliminated the visual impact of the earlier town, and it is still possible to imagine Sir Robert travelling here to deal with political matters.

Winchcombe

The third town, in terms of population totals, was not one of the other historic towns as might have been expected, or the rapidly growing Stroud, but Wotton-under-Edge. This town had been rebuilt after fire as a thirteenth-century planned market town and has been considered in more detail in chapter 8. Atkyns recorded it as having 840 houses in 1712 and a population of 3,500, compared to Winchcombe's population of 2,715 and Tewkesbury's population of 2,500. However, it is likely that Atkyns significantly overestimated Wotton's population, so we will next consider in more detail early eighteenth-century Winchcombe.

The name Winchcombe means a valley with a bend in it, the valley being that of the River Isbourne. The town had been a Saxon royal borough within its own small county, but Atkyns notes that, like Tewkesbury, its chief source of fame had been its abbey. This had been founded in 798 on the site of a former nunnery, but re-dedicated to St Mary and St Kenelm as a Benedictine monastery in 969. It was the burial place of St Kenelm and his shrine was an important focus of pilgrimage throughout the medieval period. The large and impressive abbey church overshadowed the town up to the Dissolution. As with Cirencester, the abbey buildings were then rapidly demolished so that scarcely a trace was left by the 1550s, and the town had then not only lost its principal architectural treasure, it had become economically impoverished as well. Pilgrims had brought wealth to Winchcombe and Atkyns says that the relics of St Kenelm brought 'infinite riches to the monastery'. The George Inn (see plate 24) was built to accommodate those visitors that the abbey had not the capacity to entertain, just as the New Inn in Gloucester had been built for the same reason. The spandrels of the doorway of the redeveloped property that was once the George Inn still contain the initials R.K. carved into the woodwork, referring to Richard Kidderminster, the penultimate abbot. The scholarship of the abbey under Abbot Richard had also contributed to its fame and consequently to the number of visitors.

Atkyns mentions that the abbey had been struck by lightning. This occurred in 1091 when the tower and steeple of the abbey church had been set on fire. It was not the only time that the abbey had been damaged by fire, for thatched and timber-framed houses, built close to its walls, were always a fire hazard. Because the town already possessed its own parish church in St Peter's, there was no strong incentive to keep the great abbey church at the Dissolution, in contrast to the situation in Tewkesbury.

St Peter's Church is a large, handsome wool church, 'adorned with battlements and pinnacles', which was built close to the west side of the abbey and its tower still rises high above the other buildings of the town. The 1636 monument to Thomas Williams of Corndean remains in the chancel of the church, with an unfilled space left for the effigy of his wife. But significantly, no great houses are recorded in the parish. Nearby

Sudeley Castle had been slighted after the Civil War, only ruined parts remaining, and its church 'was out of repair' so there was no economic support for the town coming from the castle. By 1712 it had become a poor reflection of its earlier prosperous state.

There were three small free schools, the King's School of 1618 (see fig. 32), opposite the parish church and probably on the site of a former castle, Lady Chandos' School of 1621 in St Nicholas Street, and George Townsend's School of 1682. The Chandos almshouses date from 1573 and were built for twelve poor people. (Several generations of the Chandos family had owned Sudeley Castle.)

Despite continued government opposition, tobacco had been grown in and around Winchcombe for more than sixty years and this, together with flax growing, gave employment opportunities to many poor labourers in the seventeenth century. But inaccessibility in a bay of the north Cotswolds and lack of support from absentee lords of the manor were handicaps that restricted the town's economic development, although the River Isbourne had provided water power for several mills.

Tewkesbury

This had been the second town to Gloucester in the sixteenth and seventeenth centuries, when many of its fine timber-framed houses were built. Atkyns describes it as 'large, populous and with three handsome high built streets and many lanes', and says that it was dominated by the 'vast and stately' tower of the abbey (see fig. 15). It is sited on a low river terrace, a little higher than the flood plain of the River Severn, where the Rivers Avon, Swilgate and Carrant also converge, like the 'four rivers of Eden'. Frequent flooding of the town's immediate surroundings restricted its expansion, so to accommodate a growing population, houses were extended upwards with second and third floors, hence Atkyns' reference to 'high built streets'. The rear gardens of the houses facing the main streets contained stores and workshops, and these gardens became housing areas for the increasing number of poor labourers that were attracted to the town. Their small, tightly packed cottages were reached by the numerous alleys, which began to appear in the late seventeenth-century town (see plate 25). These alleys are Atkyns' lanes. As most properties fronting the streets had side entrances, this development of the built-up area did not cause serious difficulties for access. Both Gloucester and Cirencester had alleys off the main streets but not so many as Tewkesbury, where the number had reached over a hundred by the nineteenth century.

Tewkesbury was also a bridging point for the River Avon. King John's Bridge was the later name for a bridge first built in about 1205, when the king allocated tolls from the town's markets and fairs for its maintenance. Until the Mythe Bridge was opened in

1826, the much wider River Severn was crossed by the ferry at Lower Lode. Tewkesbury quay was the head of navigation for larger boats on the Avon, although smaller boats could reach Stratford and trows plied up and down the Severn between Bristol and Ironbridge, with smaller boats reaching Shrewsbury.

As we have noted earlier, Abbey Cottages in Church Street form a unique survival of fifteenth-century shops. There were originally twenty-three cottages in this row, extending close to the Bell Inn on the other side of the road. Each cottage had a single room shop at the front, a chamber above, and a hall and stairway open to the roof behind. The brick chimneys and an extra room at the rear for a workshop were later additions, for bricks only became commonly available for housing construction after the middle of the seventeenth century.

Most of the seventeenth-century houses along the three streets had overhangs or jetties and many were close-studded, indicating a good level of prosperity. Subsequent rebuilding has often hidden the timber framework of these frontages, but side elevations may still disclose the earlier forms. About a hundred timber-framed houses remain in Tewkesbury, all built before Atkyns' book was published.

There had been an important clothing industry in the town, mainly concerned with finishing work, but this was now being replaced by a major employment in stocking knitting. Woollen stockings first became fashionable in Britain in Elizabethan times and by the seventeenth century, unlike the situation with the independently owned weavers' looms on the Cotswolds, stocking frames had been placed in workers' houses by the merchants who managed the industry. Atkyns records both wool and cotton as hosiery materials. He also mentions malting. Numerous small malthouses used locally grown barley and then exported their produce by boat to Bristol and beyond. The other notable product of the town he lists is mustard. Making mustard balls was a cottage industry, where mustard seeds were ground and the flour so produced was mixed with horseradish to give the distinctively hot mustard balls. These became well known throughout the country after the publication of Camden's *Britannia* in 1586. By Rudder's time, however, production had ceased long 'before living memory'.

Most of Atkyns' entry for Tewkesbury relates to the abbey, with its 'diverse curious chapels', and to the succession of manor holders. These were various members of the families of Fitz-hamons, de Clares and Despencers, who had left their mark on the abbey's design and architecture, and whose elaborate memorials remain within its walls. The de Clares' Tewkesbury residence, built by Gilbert de Clare in c.1200, was Holm Castle, sited on rising ground south-west of the abbey. Atkyns' reference to a 'high hill adjoining the town' hardly gives an accurate impression of this site, which is on land barely above the winter floodwaters of the River Swilgate, but it is slightly more appropriate for the Mythe, where a Norman motte once existed.

These four towns, Gloucester, Cirencester, Winchcombe and Tewkesbury, were the most influential in the county. The flourishing woollen industry in the Stroud valleys was attracting migrant workers and both Stroud and the other towns here were rapidly expanding. Stroud's population was estimated at 3,000 in 1712, but its history was less significant than those of the four above. The chief features of the other market towns of Gloucestershire have been considered in chapter 8.

13

Curiosities

'There are few natural curiosities in one county, but the like are in most other counties, medicinal springs, minerals, subterranean vaults, quantities of fish shells, and the summets of hills and such like, are found in most counties.'
This statement in the introductory section of Atkyns' book seems to dismiss any special interest in 'natural curiosities', in viewpoints or in archaeological sites, features that in later years would become tourist attractions. Yet from time to time in his parish surveys he does refer to them.

Although he wrote before William Gilpin made his famous journey down the River Wye, searching for the grand views that were later described in his publications to illustrate the concept of the picturesque, and before the paintings of the English school of landscape artists exemplified by the works of Constable and Gainsborough, Atkyns was conscious of views, or 'prospects' as he calls them. The breadth and distance of the field of vision, as well as particular items of scenery such as woods, rivers and the city of Gloucester, are referred to in his comments on the prospects from country houses and hilltops.

Along the Cotswold escarpment he mentions Haresfield Beacon, with its view extending from Worcester in the north to Bristol in the south, and westward into Wales; Painswick Beacon, 'a very steep hill with a large prospect'; and Stinchcombe Hill, with the largest prospect in the county and a full view of the River Severn from Gloucester to Bristol. Coaley Peak, 'a high picked hill', has another large prospect over the Vale. All four sites are still popular viewpoints, with their topographs and car parks not too far away. Atkyns does not comment on Crickley Hill, Dover's Hill or Nibley Hill, which are other well-known viewpoints along the escarpment.

Four viewpoints are recorded in the Vale. The most remarkable is Barrow Hill in Arlingham parish (fig. 64), to which we have already made reference regarding the number of churches visible from its hilltop. A small wood on the east side restricts the view in this direction, otherwise there is a panorama over the whole horseshoe bend

Fig. 64 A view from Barrow Hill in Arlingham parish, looking over the River Severn towards Westbury. Atkyns says it was possible to see thirty-six churches from this viewpoint; Parsons thought there were thirty churches in view, which he later altered to thirty-two.

of the River Severn and the backing hills, an expanse which is surprising given the short climb needed to reach the top. A similar view is mentioned at the unidentified Gabs Hill in Moreton Valence parish. From Hempstead, there is a broad view over the Severn valley, and at Woolstone, north of Cheltenham, Atkyns says there is 'a pleasant prospect' over the River Severn and the Vale.

From Staunton, he informs us, there is a view overlooking Monmouth and extending far to the north and west. The Buckstone above Staunton has great views to the north and south, but the view over Monmouth is from the Kymin (fig. 65), and perhaps this is the hill he meant. He also mentions Yartleton Hill or Huntley Hill, now known as May Hill, the 'highest hill in the Forest division', but does not comment on the views from

its slopes. The famous views from Symonds Yat, from the Devil's Pulpit overlooking Tintern Abbey and from Pleasant Stile above Newnham are also omitted.

In general, the gardens of the houses of the early eighteenth-century gentry were enclosed and inward looking. The Kip engravings of these houses and gardens sometimes show clairvoyees, which allowed 'peeps in' from passers-by, and also long avenues of trees that extended over the surrounding fields and led the eye outward across the estates, but their sites were usually low and protected by surrounding hills from wintry gales. However, a few houses were notable for their views. Five sited on ground no higher than their surroundings are mentioned as having 'agreeable prospects'. These are Cassey Compton looking towards Chedworth woods on the other side of the River Coln, Chavenage with a 'delightful prospect over Wiltshire', Leckhampton

Fig. 65 The view of Monmouth from the Kymin, a viewpoint just outside the county boundary.

Court with a south view over the Vale, and two properties overlooking the city of Gloucester and the River Severn, Highnam on the west of the river and Newark House at Hempstead on the east. Further south along the Severn the views from Elmore Court and from the former manor house at Fretherne were also noteworthy. Several houses Atkyns mentions are sited on much higher ground than their environs and have correspondingly spectacular vistas. These include the Wilderness above Mitcheldean overlooking the Vale to the Cotswolds, Newark Park above Ozleworth Bottom (fig. 66), Prinknash, 'with distant prospects over the Vale', and Symonds Hall to the north-east of Wotton-under-Edge. It is surprising that he does not mention the views from Sapperton Manor or Pinbury Park, the two houses he knew best. The former had a fine view down the Golden Valley – attractive at all seasons of the year but especially in spring and autumn – and the latter looks across the meadows and woodland of the upper Frome valley.

Fig. 66 Newark Park, Sir Nicholas Poyntz' hunting lodge perched high above the Ozleworth valley.

From all the viewpoints he mentions, it is the distance that could be seen, rather than the quality or diversity of scenery, which Atkyns considers worthy of comment. His book shows no awareness of picturesque beauty, nor is there detailed description of what could be seen from these locations, but his county-wide survey is the first that lists them together in one volume.

In a delightful book, *The Naturalist in Britain*, David Allen writes that towards the end of the seventeenth century, 'a cabinet of natural curiosities had come to be regarded as one of the essential furnishings of every member of the leisured classes with claims to be considered cultivated'. Sir Robert Atkyns certainly fell within the leisured class category and so too did his original readership. Fossil hunting had recently become popular and two parishes, Alderley and Nibley, have noteworthy fossils in their rocks. At Alderley, he mentions stones resembling cockles and oysters, found in the hills and presumably 'cast up in the universal flood'; and at Nibley, 'shells of mussels, cockles and star fish are found frequently in solid stones deep in the earth'. These are *Gryphea*, *Pecten* and *Clypeus* fossils, and at Awre there are pentagonal (*Pentacrinus*) stones (see plate 26). Parsons' notes also refer to pentagonal stones in Blakeney and Lassington parishes, which, he says, move in vinegar. No other sites of geological interest are mentioned, apart from the stone quarries we have listed in chapter 11. Fossils were generally thought to derive from the time of Noah's flood.

Springs are other natural phenomena Atkyns mentions in more than a dozen entries. They occur at the junction of permeable and impermeable rocks, and on the Cotswolds these are found between the Greater Oolite and the Fullers' Earth and between the Inferior Oolite and the Lias Clay. With the former, he records springs at Bourton-on-the-Hill, which he informs us fed tributaries of both the Thames and the Severn, Boxwell, where there was a 'great spring' in the woods, Broadwell and Eastleach Turville. Along the Cotswold escarpment and its indentations, springs were noted at Charlton Abbots, Prestbury, Standish and Nibley. In the parish of Cranham, where the geology is complicated by faults, the land is 'hilly and full of springs'. Some spring water was regarded as having medicinal properties. Water from the Red Well at Standish and the Red Well at Matson cured distemper, and the spring at Eastleach Turville (fig. 67) was a purging spring. Iron ore coloured the water from springs in the Forest of Dean. Many more wells could have been mentioned, including St Kenelm's Well at Sapperton, from which Atkyns' own employees would have drawn water, and Lady's Well, close to the 'bank of the delightful river' in the grounds of his father's other home at Lower Swell. Near the church in Hempstead, where Richard Atkyns was buried, is another ancient well, Our Lady's Well, which he would have also known. He refers to the two sources of the River Thames at Coberley and Coates, to the source of the River Frome at Brimpsfield and to the source of the River Leach at Hampnett. Tinning Well at Charlton Abbots is one of the sources of the River Isbourne. Some

Fig. 67 The nineteenth-century well head beside a spring and the River Leach at Eastleach Turville. Atkyns says it was a purging spring.

places lacked spring water and Rodmarton parish is singled out as having 'no running spring'.

Atkyns' travels to Cirencester inevitably brought him into contact with Roman remains. He was aware of the existence of Roman roads, such as the Fosse Way, Ermin Street, Akeman Street and the road from Gloucester to Caerleon, and also of the former Roman stations along these roads at Alvington and Stratton. Parts of the Woodchester pavement had been discovered by gravediggers several feet beneath the surface of the churchyard, and its quality and size suggested to him that it was the floor of the home of a Roman general (see plate 27). In a meadow at Cirencester another pavement had been found, 50ft by 40ft, on a hundred brick pillars and made of coloured tesserae, each 'slightly larger than a dice', and at Daglingworth a pavement of tesserae had been found in the unidentified Cave Close. As we have seen, camps such as the massive

earthworks at Bagendon and Salmonsbury were also thought to be Roman, as was the ancient tower of the church at Bourton-on-the-Water.

Of more immediate interest to Atkyns were the effects of the Civil War. He had not lived through the war, but its consequences had been his experience from childhood and members of his family had been involved in the fighting. His father's cousin, Colonel Richard Atkyns, had raised a cavalry troop, as had Sir John Kyte of Ebbrington. In many parishes he identifies men who had been loyal to Charles I and had suffered as a result. Their valour was noted, but so too the sums of money sequestered by Parliament to maintain an army and to fund government. The largest sum was £5,216 from John Dutton of Sherborne, but other very substantial requisitions were made of Sir Henry Thynn of Kempsford (£3,554), Sir Henry Poole of Sapperton (£1,994), Sir

Fig. 68 The ruins of Chipping Campden House, deliberately destroyed in the Civil War to prevent it falling into Parliamentarian hands.

Humphrey Tracey of Stanway (£1,600), Sir William Masters of Cirencester (£1,483), John Chamberlain of Stow (£1,246) and Sir Edmond Bray of Barrington (£1,191). The size of the fines reflected the assets of the Royalist families and in particular the extent of their estates. The unnecessary destruction of Sir Baptist Hicks' magnificent mansion at Chipping Campden (fig. 68), where the ruins still conveyed an impression of stateliness, was one notable act in the 'Great Rebellion', as Atkyns described the war. He also records that White Cross House at Lydney was deliberately demolished by the Wintours to prevent it falling into Parliamentarian hands, the Vineyard at Over was burnt down, the painted glass at Oddington church was ruined and the church at Lemington demolished. There had been garrisons at Berkeley, Beverstone, Cirencester, Lydney and Sudeley, with fighting from time to time in their vicinities. Several individuals involved in the Civil War are singled out for particular mention. They include Sir John Wintour, who had escaped the Parliamentary army by jumping Wintour's Leap to reach a waiting boat on the River Wye, and Thomas Pury, who was on the 'wrong side' but later made amends by rebuilding Taynton church and establishing the library in Gloucester Cathedral. Pury's house, the Grove, still stands at Taynton. Most gentlemen, Atkyns says, were loyal to the king, while farmers, tradesmen and the meaner sort were generally against. He knew on which side he would have been!

The walls of Gloucester, which had been repaired and fortified prior to the siege, had been taken down in 1660 under the orders of Charles II, and Atkyns quotes the cost of property damage to the city as £26,000. He notes that there had been battles at Cirencester, Corse Lawn, Highnam and Stow-on-the-Wold but does not record other skirmishes. The castles at Berkeley, Beverstone and Sudeley had been severely damaged in the war and the latter was slighted. One of the important aspects of the aftermath of the war was the repair and rebuilding of houses. As we have discussed in chapter 9, new houses that were built in the 1650s included Highnam Court, Sherborne House and Lower Slaughter Manor (see plate 28).

Atkyns is probably right in his assessment of the county's lack of curiosities, although other eighteenth-century writers have drawn attention to the wonder of the Severn bore, but this apparent deficiency didn't prevent him from regarding Gloucestershire and its people with great affection.

14

Complementary Views

T he best known of the travel writers who described the appearance of the county in the early eighteenth century is Daniel Defoe. The first volume of his *A Tour thro' the whole Island of Great Britain* was published in 1724, and the second in the following year. Both volumes make reference to Gloucestershire. Defoe was in his mid-sixties when these books were printed, and they were based partly on information gathered on his own extensive travels on horseback throughout the country – travels which spanned many years – and partly on various guide books and works of reference that he had consulted. His writing, based on these two sources, is so skilfully integrated that one cannot tell with certainty which comment was derived from his own observations and which from a printed source. One reference he used was John Macky's *A Journey through England*, first published in 1714, which focused on the seats of gentlemen, attractive scenery and places of public interest. But Defoe's perspective was different; he was concerned with the social and economic state of the country, and in particular with its trade and commerce. Antiquities did not interest him, but the marketing of agricultural produce did, and so too did industry, employment and the transport of goods. He was alert to signs of progress in the country's economy and made his observations from the point of view of a trader. He considered himself to be a member of the early eighteenth-century middle class and described himself, on the title page of his *Tour*, as 'gentleman'.

It is difficult to assess the accuracy of his details, but the general impression he gives of the county is likely to be reliable, and when he discusses commerce he does so with evident expertise. He had been at different times a hosiery factor and a manufacturer of bricks and tiles, in addition to his various literary enterprises, and was a moderate Dissenter. Dissent had caused the second of his two imprisonments when it had been judged that he had published inflammatory and seditious material. His background and outlook were, therefore, very different from those of Sir Robert Atkyns, and by comparing the information handled by the two, we can more easily

build an impression of the early eighteenth-century landscape and also recognise the bias of those who inevitably viewed it from their own personal or vested interests. We would expect a clearer understanding of wage labour, of road conditions, of marketing and of innovation in farming and industry from Defoe than we can extract from Sir Robert Atkyns' work.

In his first volume Defoe discusses the clothing industry in the south of the county. He lists Cirencester, Tetbury, Minchinhampton and Fairford as the principal clothing towns and mentions the increase in buildings and inhabitants that had occurred in these towns in the previous twenty or thirty years. Fairford was not identified as a clothing town by Atkyns but the others were. Defoe says that the master clothiers lived in the towns and sent wool each week by their servants to the village homes of the poor, where the women and children spun the wool. Then the yarn was collected by the same servants on their next visit and redistributed to be fitted to the weavers' looms. A recent change in agricultural emphasis, in which wheat growing had displaced sheep farming, meant that local supplies of wool for the expanding textile industry had diminished and new supplies were sought from the Midland counties of Northampton, Leicester and Lincoln. Although, in his view, the Cotswolds produced the best sheep and finest wool in England, these midland counties had larger sheep and there was little local demand for their wool for manufacturing cloth. In Gloucestershire, however, there was a great demand and Defoe reports that several hundred packs of this imported wool were sold each week at the markets of Tetbury and Cirencester. He also comments, like Atkyns, on the suitability of the water of the River Frome for dyeing scarlet cloth, the finest in the country and 'probably the whole world'. He says that clothiers 'lye all along the banks of the Stroud-Water for near twenty miles'. They were concentrated in the centre of the valley around Stroud and also in Painswick, a market town to the north. In this context he also mentions the large meeting houses that had arisen in all the 'manufacturing and trading' towns, a reference to the noticeable urban growth of Nonconformity.

With the exception of the banks of the River Thames, travelling up the Severn valley from Bristol meant that he would 'see the richest, most fertile and most agreeable part of England'. The Vale was important for dairying and the production of soft, thin Gloucestershire cheeses, which were ready for eating before those from Cheddar. Many of these cheeses went to Bristol and Bath for local consumption, some were exported overseas from Bristol and some went by land carriage to the quay at Lechlade (see plate 29), and then by barge along the River Thames to supply the London market. The whey and skimmed milk, the by-products of cheese making, were used to feed pigs, and their bacon was another major product from these rich lowland farms to be sent to London. A dominant interest of Defoe was the way in which London had become the 'pivot of commerce' for the whole country. Corn was also sent by boat to Bristol from

the northern part of the Vale, and here the hedgerows were filled with apple and pear trees. Cider was sold in the public houses, 'as beer and ale is in other parts of England, and as cheap'. Defoe says that fruit was so abundant in the hedgerows that travellers on the road could pick and eat as they pleased.

He did not visit the Forest of Dean to see its industry – the 'badness and danger of the ferries' over the River Severn prevented this. It seems that the flimsy condition of the boats and the wind and tidal flow in the estuary were equal deterrents. He also mentions the Severn bore and describes how the stern of a boat could be 'lifted by six or seven feet by the mighty wave'.

Brief, subjective pen portraits are given of the towns he passed through. Cirencester was a 'very good town, populous and rich, full of clothiers'. Gloucester was 'an ancient middling city, tolerably built, but not fine', and noted for its large stone bridge over the Severn and for its cathedral. The latter was 'an old venerable pile, with very little ornament within or without, yet well built; though plain, it makes together, especially the tower, a very handsome appearance'. He clearly had not closely inspected the stonework of the south porch or the decorative ball flower design of the windows of the south aisle. Tewkesbury was 'a large and very populous town', famous for 'a great manufacture of stockings' and with 'a great old church'. Defoe's past employment would have interested him in Tewkesbury. Lechlade was also 'a very populous large place' with an economy based on its location at the head of navigation of the River Thames, and he notes the very large barges that were able to come to its quay. Berkeley, with its 'noble, ancient castle (see plate 30), and very fine park' was 'ancient rather than pleasant or healthful'. Interestingly, both Defoe and later Rudder comment on the relative healthiness of places. Berkeley suffered from being low lying and near water.

The transport of goods by water was prominent in Defoe's survey. He says that ships of burthen could navigate the Severn to just below Gloucester, but large barges could travel on the river for another hundred miles inland, and goods imported via Bristol could reach almost to Warwick on the River Avon. Elsewhere in his tour he discusses the dredging of river beds to remove silt accumulation and the digging of new cuts to improve boat access. The state of the roads was another topic of frequent comment. Generally, roads were bad, many were unenclosed and open tracks, but there had been some recent improvements through turnpiking. In particular, the road from Gloucester to Birdlip Hill, 'formerly a terrible place for poor carriers and travellers out of Wales, was now repaired very well'. Heavy clay surfaces were the main problems for road making, being soft, poorly drained and lacking in road building materials. The funds raised by turnpike tolls could be used to improve these roads, which Defoe thought would benefit both carriers and drovers in enabling heavier loads to be carried, journeys to be made more quickly, and livestock to arrive at market in a better condition. Perishable goods such as cheese and fish could reach consumers living at a greater distance than before,

and the rent of country houses could be raised because people could travel longer distances to the cities and especially to London. The hard ground of the Cotswolds gave much better road conditions. Defoe had travelled along the Fosse Way and commented on its well-built Roman construction. Layer upon layer of road materials had been used to a depth of 6 to 8ft, and he recommended personal observation by any who doubted the accuracy of his word.

Thus, in a few scattered references in his *Tour*, Defoe succeeds in creating an image of the county that can only be painstakingly reconstructed from Atkyns' work. However, Defoe's sample was linear as he makes his tour along the county's main roads, while Atkyns gives details that enable a complete county coverage. It is rather like comparing a road book, such as Ogilby's of 1675, with an atlas map. But the *Tour* was not the only contribution Defoe made to understanding the county in Atkyns' time. He had also published as his first book *The Storm*, which is an account of the severe storm that occurred in November 1703, probably the worst the country has ever experienced. Gloucestershire was within the broad swathe of damage caused by this extra-tropical cyclone, as it crossed southern England on the night of 26 November 1703. Defoe had just been released from prison, with a dubious reputation, and was keen that the details of the storm he reported were accurate and based on eyewitness accounts. He advertised for written reports of the damage to be sent to his publishers and in all received about sixty letters. Summarising the general impact of the storm, he says that the winds were so strong that most people expected their houses to fall, and the morning after saw roads littered with tiles, stones and bricks blown from roofs and chimneys. Some churches in the county were severely damaged. He mentions those at Berkeley, Redmarley and Newent, and also both Tewkesbury Abbey and Gloucester Cathedral. The great west window of Fairford church was blown in. Many trees were uprooted. Three thousand potential ship timber oaks in the Forest of Dean, 600 specially valued tall trees at Kingscote, elms in the Severn valley and whole orchards were laid flat. At Taynton, 200 cider apple trees were blown down on one farm. He says parks were ruined, walks defaced, garden walls demolished and numerous barns destroyed – eleven at Twyning, seven or eight at Ashchurch, five at Leigh, several at Norton and the abbey barn at Tewkesbury. The tidal water of the Severn rose 8ft higher than ever known before, breaking the sea wall and flooding large areas south of Arlingham, washing away sheep and cattle and contaminating grazing land with salt water. With a total estimated damage of £200,000, the whole mood of the country was sombre – yet not a word from Atkyns, other than a reference to an inscription in Slimbridge church recording the great tempest on 27 November 1703. It was not the only storm to have a severe impact on the landscape. Pepys records in his diary on 25 February 1662: 'We have letters from the forest of Deane, that above 1000 oakes and as many beeches are blown down in one walk there.'

Another traveller, who reported on her journeying through Gloucestershire a few years before Defoe, was Celia Fiennes. She was a single lady of independent means who had, like Defoe, travelled extensively throughout the country on horseback between the years 1685 and 1712, and had recorded her observations in writing. Her *Journeys* were ostensibly written for her relations, but she probably had an eye to a wider readership. She preferred to stay with relatives on her travels but also found accommodation with family friends, such as the Foleys at Stoke Edith, near Hereford. Where this was not possible she used inns and private houses. Her original home was at Newton Toney, near Salisbury; her grandfather, the first Lord Saye and Sele, lived at Broughton Castle, near Banbury; a cousin, the Revd Pharamus Fiennes, was rector of Weston-sub-Edge (Atkyns mentions how he had improved his 'very handsome large parsonage house'), and there were other relations living in and around the county.

Also, like Defoe, she was a Nonconformist. Her father, Colonel Nathaniel Fiennes, had been an officer in Cromwell's army, and in later years her widowed mother appointed a Nonconformist as her private chaplain. Celia often mentions the meeting houses of Dissenters. She was interested in new things – new houses, new manufacturing industries, new land improvements – as well as the rooms, furnishings and gardens of the houses she visited. These she described carefully, in a matter-of-fact way, from detailed observations. She had a well-developed sense of curiosity and an enquiring mind.

Her first reported journey in the county was in 1694, when, aged 32, she travelled from London to Hailes, where she says her brother had lived. On this journey and on several others she stayed with her widowed aunt, Susanna, who lived at Moreton-in-Marsh. The journey over the Cotswolds was 'over steep stony hills' and the 'good old house' at Hailes, she refers to, had been built by the Tracys on the site of the Cistercian abbey soon after the Dissolution. Their 'better house' was at Toddington, with its deer park, through which the River Isbourne meandered (see fig. 43). She says that from the lodge she could view the whole park and surrounding land, which was 'much inclosed and woods'. Her main interest here was in the production of woad for dyeing cloth. She describes how woad was sown in dry summers on 'improved land', the low tufts of plants were carefully weeded, and a succession of leaves were cut close to the base of the plants. The leaves, she says, were of a similar colour and shape to those of scabious (see plate 31). They were ground to a paste in a horse mill, then made into balls and dried by the wind under a penthouse. The 12-acre field gave employment to two or three families of seasonal migrant workers, including men, women and children, who were accommodated in 'little huttes' that they made for the season. She adds that 'the smell of the Woade is so strong and offencive at the Mill … I could not forse my horse neare it'. Fiennes also noted that flax was grown in the district. Her return

journey via Moreton took her past the Four Shire Stone (see plate 32), a landmark mentioned by many early writers.

Two years later she was back at Moreton-in-Marsh, which she describes as a 'little neate stone built town' with good inns for travellers on the road from London to Worcester, Hereford and Wales. On this journey she also stayed with her cousin Pharamus at Weston-sub-Edge, where she notes that the parsonage was 'a neate building all stone and the walls round court gardens and yards all are of stone'. From a nearby hill, presumably Dover's Hill, she looked down on Chipping Campden and further afield to Warwick and Coventry. Campden was also 'built all of stone as is the church which is pretty, for such a little town its large'. Many of the towns she visited in other counties had timber or brick houses, hence her recording of stone buildings on the Cotswolds. Crossing the Vale of Evesham on this journey she comments on its rich earth and corn and fruit growing, and also on the heaviness of the way.

In 1698 she visited Gloucester. Because of the way it stretched out along the bank of the River Severn, it appeared to be a larger town than it was. Its low-lying situation by the river meant that it was approached from the west by a long causeway and two bridges, but the road was in good repair and the streets of the town were 'very well pitch'd large and cleane'. By 'pitch'd' she means paved. It had a 'faire Market place and Hall for the assizes'. At the 'very large good Key' ships and barges were unloading coal from Warwickshire, which was then carried through the town on sledges. The coal was brought downriver by Severn trows, and elsewhere in her *Journeys* she notes that these trows were pulled by six or eight men. The main employment she records in Gloucester was cotton spinning and then knitting it into 'stockings gloves wastcoates and peticoates and sleeves'. Like Defoe she refers to the whispering gallery of the cathedral. She also comments on the high quality of the altar cloth, and then on the view over the city from the tower, climbed by 203 steps. 'Gardens and buildings and grounds beyond' were viewed, just as the Kip engraving in Atkyns' book suggests. The River Severn provided 'fine Lamprys taken in great quantetys in their season … and the Charr fish are equally rare and valuable'. The city of Gloucester had been required to send lampreys to the king or queen at Christmas and at coronations. Char is usually found in freshwater lakes, but Celia knew her fish, and elsewhere in her *Journeys* says that 'their taste is very rich and fatt tho' not so strong or clogging as the lamprys are'.

Her descriptions of the gardens she viewed normally include references to gravel walks, grass plots, dwarf (clipped) trees, pots of flowers, statues, fountains, avenues and sometimes bowling greens, orange and lemon trees and clairvoyees. Their neat, ordered symmetry was typical for the age. Although none were described from her travels through Gloucestershire, the gardens Kip engraved for Atkyns correspond to these descriptions.

The impact of local geology on the quality of the roads is also evident from her reports, limestone giving good firm passage, while clay had roads that were almost unusable after rain. Although pack animals could be seen on many roads, particularly in industrial areas and where the roads were narrow, the general increase in wheeled traffic had contributed to a significant deterioration of road surfaces, and the latter were only improved after turnpiking.

Like Defoe, she presents a linear sample of the county's landscape, but her routes were mainly in the north of the county and she did not encounter the woollen areas around Stroud or the iron industry of the Forest of Dean, although she knew how cloth was made at Exeter and her friend, Paul Foley of Stoke Edith, was an important Forest iron master. The chief value of her lively account of her travels is that it was all based on first-hand experience; there was no consultation of historic documents or the writings of other authors, and the extent of her journeys into every English county gave a wider perspective to her observations than the merely local.

In 1779 Samuel Rudder published his *A New History of Gloucestershire*. This book was designed to update Atkyns', correcting some facts, adding new information and providing the public with a more accessible history of the county than its scarce and now costly predecessor. Rudder had been working on the book since 1767, painstakingly covering each parish, just as Atkyns had done, but in his case visiting each one, questioning the inhabitants and corresponding with the clergy and gentry. Many new developments had occurred in the county's landscape since the early years of the century, but much remained the same and in this sense Rudder's work can be used to complement the picture of the countryside we have derived from *The Ancient and Present State of Glostershire*.

Rudder's work was not well received by all readers, at least in the first instance. Although he was a locally respected tradesman in Cirencester, a printer, shopkeeper and auctioneer, he was the son of a Uley pig killer, without the social cachet of Atkyns (fig. 69). He describes himself as editor, rather than author, of the *New History* and for documentary records relied heavily on Atkyns'. He copied the full Latin text of *Domesday Book* and corrected many of Atkyns' interpretations of place names. But there were no equivalent illustrations to Kip's fine engravings, and by now many of the houses Kip had drawn had been pulled down and their gardens totally changed with new landscaping fashions. Rudder generally followed Atkyns in the layout of his book but with one important difference – he gave introductory descriptions of the county's three major physical divisions, imparting a sense of geography which is missing in *The Ancient and Present State of Glostershire*.

East of their steep escarpment, the Cotswolds have an extensive, gently undulating relief. The air is healthy, but Rudder thought it was perhaps a little too thin and cold in the higher and more exposed parts for people with a frail constitution. The hills were

Fig. 69 The memorial tablet to Samuel Rudder in St John's Church, Cirencester.

traditionally famous for their flocks of sheep, but Rudder reports a huge improvement in agricultural productivity in the past forty years, resulting from the introduction of new crops and well-considered rotation systems. By implication, the traditional two-field system of alternating cereals and fallow predominated before this, although in some of these huge open fields there were smaller areas or 'hitchings' where turnips or

peas were grown in the fallow year. He says earlier landowners preferred sheep farming because its lower labour requirement freed men for warfare and for other forms of service, and there was a very profitable sale of wool to Flanders. But the bounty on corn exports, introduced in 1689, had encouraged a return to arable farming. He also identifies sainfoin as a valuable introduction, growing well on stony soils, lasting seven or eight years from the time of sowing, and used both for direct grazing and for mowing. It was also known to improve soil fertility, and crop yields on the Cotswolds were now almost as high as those of the Vale. This was especially significant in that land rents were much lower. By this date Gloucestershire was the leading county for sainfoin, some was sown with barley or oats in the spring, but with dry summers it was preferable to sow it with wheat in the autumn, so that the plants could be well established before any water shortages occurred. Where sheep farming continued, Cotswold ewes were being crossed with Leicester rams to produce larger animals. This, too, seems an innovation made possible by enclosure, for in small enclosed fields animal breeding could be more carefully managed than on the common land of the downs in the early eighteenth century.

Rudder also refers to the discovery of coal in well diggings near Cirencester, at Barnsley, Siddington and Stratton, and suggests that this should be investigated further in the light of the high cost of coal in the area. (One of the arguments for the Thames-Severn canal, a few years later, was to provide cheaper coal for places along its route.)

On the Cotswolds were the preferred places of residence of the nobility and gentry, an interesting observation, and we note that most of Kip's engravings are of Cotswold houses.

The Vale was the most fertile and agriculturally productive part of the county. Both Rudder and Defoe thought this to be the case, and both suggested that it was at least equal to the best land in the whole country. Most produce was common to the rest of England, but there were a few specialities, namely cheese and cider. Cheese was mainly produced in the hundred of Berkeley, stored on the farms for a length of time depending on the size of the cheeses, which ranged from 10lb to 28lb, and then sold at local fairs or exported from the county via Bristol and Lechlade. Rudder mentions that bacon also came from these farms and again found markets in Bristol and London. Many types of cider were produced, depending on the varieties of apple grown and the type of soil, and perry was also made. In addition to its emphasis on dairying and fruit growing, the Vale was noted for high yields of grain.

The Vale was warmer than the Cotswolds and generally healthy, although people living beside the Severn were vulnerable to ague. Here, too, were estates of some of the nobility and gentry. Rudder also observed that the local landowners were responsible, with some parish assistance, for flood protection, and were required to maintain the sea walls and drainage channels.

The oak trees growing on the clay soils of the Forest were thought to be the best in the world for ship timber. Rudder claims that the wood did not splinter like that of other countries. He also says that the cider produced here from the Styre apple was the best in the country. But the Forest was chiefly important for its mining of iron ore, coal and ochre. Miners earned more than other labourers, coal reserves were inexhaustible, and there was a flourishing iron industry using iron ore, charcoal and cinders to produce pig iron. Water power was used to work the bellows of the furnaces and the hammers at the forges. He thought that more care was needed in conserving the trees and recommended a replanting programme. He was well aware of the long history of disputes over rights of use of the Forest, but considered that the area was self-sufficient in its food supply.

Significant landscape changes had occurred between 1712 and 1779. Many parishes had seen their open fields disappear with Parliamentary Enclosure; hedges had been planted and dry stone walls built; new farmhouses and barns had appeared away from the villages, and new cropping systems had been introduced. The leading families no longer moved from one country house to another during the year, but became rooted in one property while the others were downgraded or demolished. Garden design fashions had changed, with the Dutch or French style giving way to the rococo and then to the English landscaped garden. Industrial growth continued both in the woollen centres and iron workings, turnpike roads were becoming common and plans were being discussed for canal construction. Captain Henry Skillicorne had laid out the Well Walk in Cheltenham and the town's growth as a spa had begun. Many of the comments Celia Fiennes had made about Epsom and Tunbridge Wells could now equally apply to Cheltenham. Yet despite these developments, much of what Rudder saw and recorded was not different from Atkyns' time.

It will be appreciated that both Fiennes and Defoe were travellers and viewed the county as outsiders. Rudder and to a lesser extent Atkyns were residents, living within the county, and had insiders' perspectives. For the latter two it was home, the place within which their own lives unfolded, and for Atkyns a county for which he was full of admiration. In this respect we must allow Sir Robert the final words:

No County in England is better supplyed with all manner of Necessities; no County can better subsist by itself; the Land is fruitful, and the Inhabitants are prosperous and deserving; the Clergy are learned, laborious, and exemplary; the Nobility and gentry are prudent and loyal; and the Commonalty are an honest and industrious People.

What more could one want?

Index

[Grid references are included in brackets and most of these refer to the parish church of the settlement, unless the feature is at some distance away from it.]

Printed in Great Britain
by Amazon

19055200R00118